1

THE LO.

www.

B

THE COMPLETE BOOK OF
DRAWING SKILLS

THE COMPLETE BOOK OF
DRAWING SKILLS

Inspiring instruction from the world's
best-selling drawing teacher

Barrington Barber

ARCTURUS

ARCTURUS

Arcturus Publishing Limited
26/27 Bickels Yard
151–153 Bermondsey Street
London SE1 3HA

Published in association with

foulsham

W. Foulsham & Co. Ltd,
The Publishing House, Bennetts Close, Cippenham,
Slough, Berkshire SL1 5AP, England

ISBN: 978-0-572-03392-7

This edition printed in 2007
Copyright © 2007 Arcturus Publishing Limited/Barrington Barber

Author: Barrington Barber
Editor: Ella Fern
Design: Sylvie Rabbe

British Library Cataloguing-in-Publication Data: a catalogue
record for this book is available from the British Library

Printed in China

CONTENTS

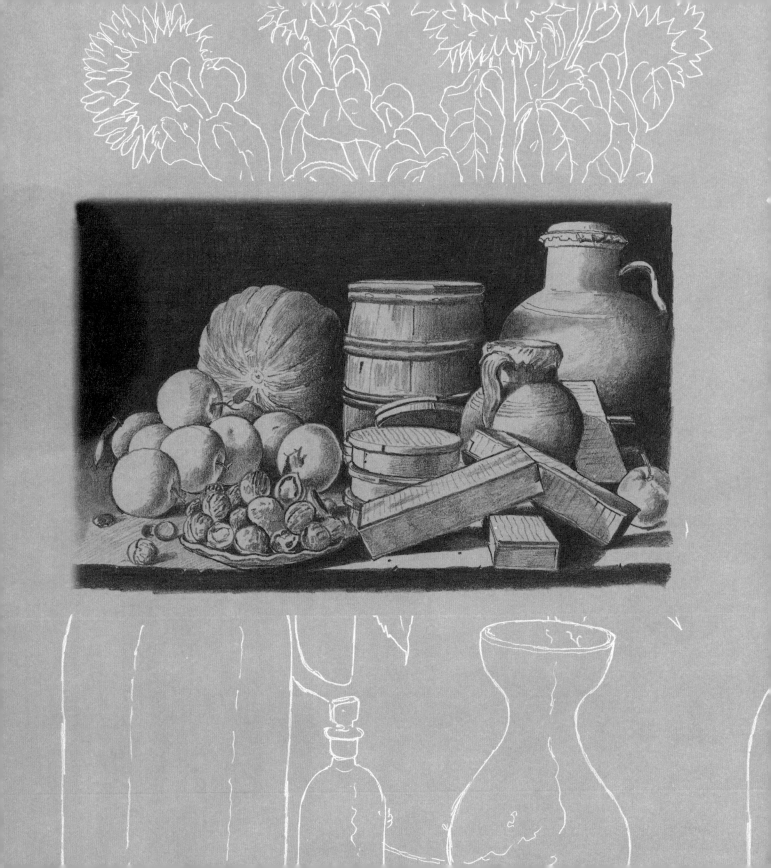

INTRODUCTION

In this book, I aim to encourage you to look deeply into the art of drawing and to bring an investigative approach to what you do. By delving right into the heart of the drawing process – looking at the workings of visual perception and our experience of the world around us – we understand better how to express ourselves on paper. This method is combined with examples of work by successful artists from down the ages and a step-by-step approach to the major subject areas of drawing – still life, the natural world, portraits and figure drawing.

Understanding the nature of the drawing process will equip you with confidence from the outset. It will help you not to be put off by difficulties, because they can be overcome with a little persistence and a lot of practice. Practise regularly, and don't mind making mistakes in the process.

Making contact with other artists will help you hone your skills, too. Your best critics will be other students of art because they speak from their own experience. Go to art shows and galleries as often as you can and see what the competition is up to. The experience will help to push your work further in the right direction. Above all, don't give up. Steady hard work often accomplishes more than talent.

WHAT YOU WILL DISCOVER

In the following sections we will be looking at all sorts of drawing; some you will be familiar with, and some will be new to you. Many of my examples are close copies of the work of first-rate artists, who provide a wealth of ideas and methods that can be learnt from. Some of the drawings are my own and I hope they will also teach you something. In considering the drawings of master artists and how they were done, I have tried to relate them to our experience of drawing and suggest ways of improving your abilities.

Topics such as drawing the natural world and the human body are looked at in some detail, as well as particular difficulties like movement and perspective. Detailed on the facing page are the major themes running through the book and how they can help you develop your drawing skills. Included in this Introduction also, just as a taster, are examples of drawings that exemplify some of these themes.

Line and style: The loose and yet controlled line evident in the copy of Matisse odalisque (below) can take years to perfect, but there is no reason why you should not try to produce something similar now – it will enormously improve your drawing skills.

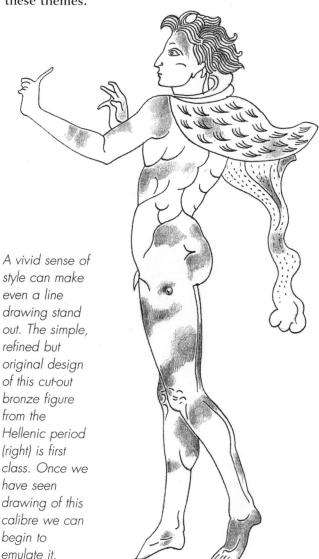

A vivid sense of style can make even a line drawing stand out. The simple, refined but original design of this cut-out bronze figure from the Hellenic period (right) is first class. Once we have seen drawing of this calibre we can begin to emulate it.

MAJOR THEMES

• The work of artists who found ways of seeing the world anew (pages 14–45). In their masterful hands what might seem an ordinary situation suddenly becomes full of promise and life.

• Devices and approaches that may help us to improve the accuracy of our drawing (pages 46–71). We'll also consider how to analyze the mass of information thrown at the retina.

• Form and shape – how to break down what you see and use this to produce an effect of dimension (pages 72–99).

• Assessing the design, the choice of subject matter and techniques that will best capture what you wish to convey in your work (pages 100–15).

• Still life drawing (pages 116–45). A good starting point for tackling form and composition.

• Studying the natural world (pages 146–83). Here you will find exercises in drawing everything from plants and trees to waterfalls and seascapes.

• Portrait drawing (pages 184–217). Learning to capture the essence of your fellow human beings is one of the most rewarding aspects of drawing.

• Understanding the structure of the human form (pages 218–59). Learning to draw it as you see it and discard your preconceptions.

• Caricature (pages 260–71). Although this is not a major part of art it does encapsulate the sharp vision that an artist needs in order to see past the obvious.

• The various styles and techniques of drawing (pages 272–99). Experiment with the wide range of materials available to the draughtsman.

• Learn how to appreciate and learn from the art of others (pages 300–4).

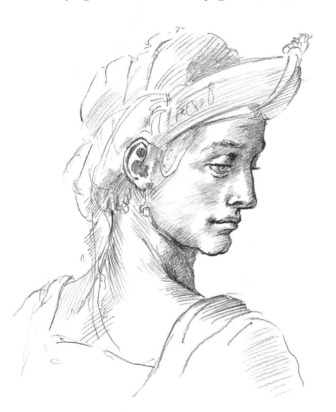

Different approaches: Careful refined pencil drawing (left), a copy of a Michelangelo; and an immediate and unpremeditated drawing in pen, line and wash, original by Guercino.

HOW YOU WILL LEARN

It is hoped you will have a great time with the suggestions in this book. Having taught art now for many years – and practised it even longer – I can say with confidence that if you want to learn to draw well there is nothing to stop you.

Some of the styles and techniques will suit you immediately whereas with others you may find yourself having to work hard. Don't worry if you don't instantly get on with some of them. See them as a challenge to your obvious intelligence; if you want to draw, you must be very intelligent, no matter what your academic record. You will

discover that just trying a new technique will bring improvement in the other methods you use. Difficult exercises firm up our talent. When you succeed at them, give yourself a pat on the back, because it means you are really getting involved with your art. That, ultimately, is what counts, and what raises your skill levels.

Above all, remember that your own will and desire to draw and the normal use of your senses are all that are required to start the deeper investigation into the visual world that this book hopes to encourage.

Different effects with chalk: Both of these drawings are in the classical manner, but notice how different they look. In the copy of the Vouet (left) the carefully modulated toning makes us very aware of the aesthetic value.

In the copy of the Caracci (right) you can see that the drawing was made quickly. Most of the tonal lines go in the same direction and the figure looks solid and convincingly muscular.

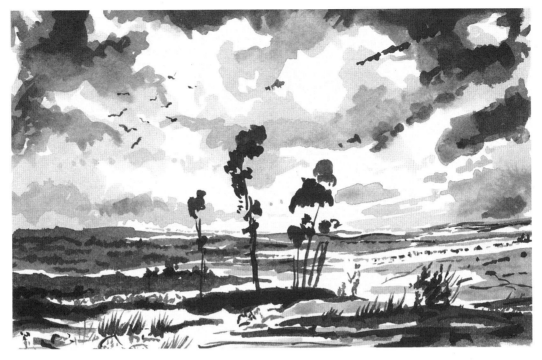

Different effects with brush and ink: These two landscapes appear quite different although a very similar technique was used for both.

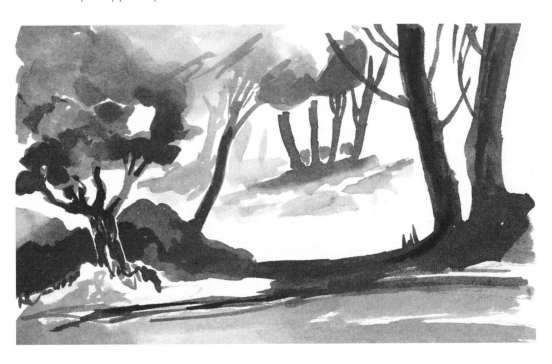

DRAWING YOUR WORLD

Before we begin, I would like you to bear in mind a few points that I hope will stay with you beyond the period it takes you to absorb the contents of this book. It concerns methods of practice and good habits to keep up.

One invaluable practice is to draw regularly from life. That is, drawing the objects, people, landscapes and details around you. These have an energy and atmosphere that only personal engagement with them can capture. Photographs or other representations are inadequate substitutes and should only be used as a last resort as reference (see caption on opposite page).

Always have a sketch book or two and use them as often as possible. Constant sketching will sharpen your drawing skills and keep them honed. Collect plenty of materials and tools – pencils, pens, rubbers, sharpeners, ink, paper of all sorts – and invest in a portfolio to keep your drawings in.

Keep a sketch pad always with you – you never know when you'll stumble across a scene that you want to put down on paper.

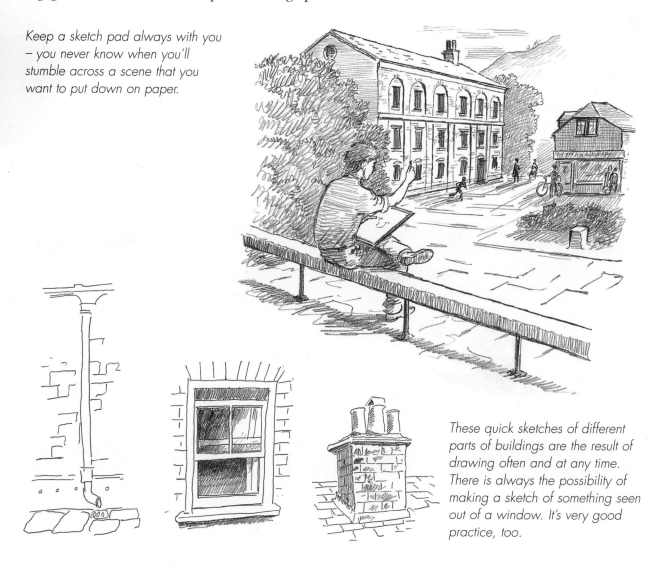

These quick sketches of different parts of buildings are the result of drawing often and at any time. There is always the possibility of making a sketch of something seen out of a window. It's very good practice, too.

Don't throw away your drawings for at least a year after you've finished them. At that distance you can be more objective about their merits or failings, and have a clear idea of which ones work and which ones don't. In the white-hot creative moment you don't actually know whether what you've done is any good or not. You are too attached to your end result. Later on you'll be more detached and be clearer in your judgement.

Build a portfolio of work and sometimes mount your drawings. Then, if anyone wants to see your work, you will have something to show them. Don't be afraid of letting people see what you have done. In my experience, people always find drawings interesting. Have fun with what you are doing, and enjoy your investigations of the visual world.

When drawing from life is not possible, use your own photographs of objects or scenes of interest. This is better than relying on other people's shots, because invariably your visual record will remind you of what it was about that image you wanted to capture.

One of the most important lessons I hope you will take from this book is the value of simplicity. Successful drawing does not demand a sophisticated or complex approach. Look at this sketch. Its quality derives from a simple approach to shapes and the assimilation of their graphic effects into one picture. I had to make an effort to keep those shapes basic and simple. Always try to do the same in your drawings.

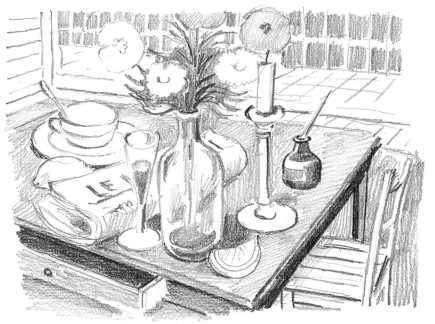

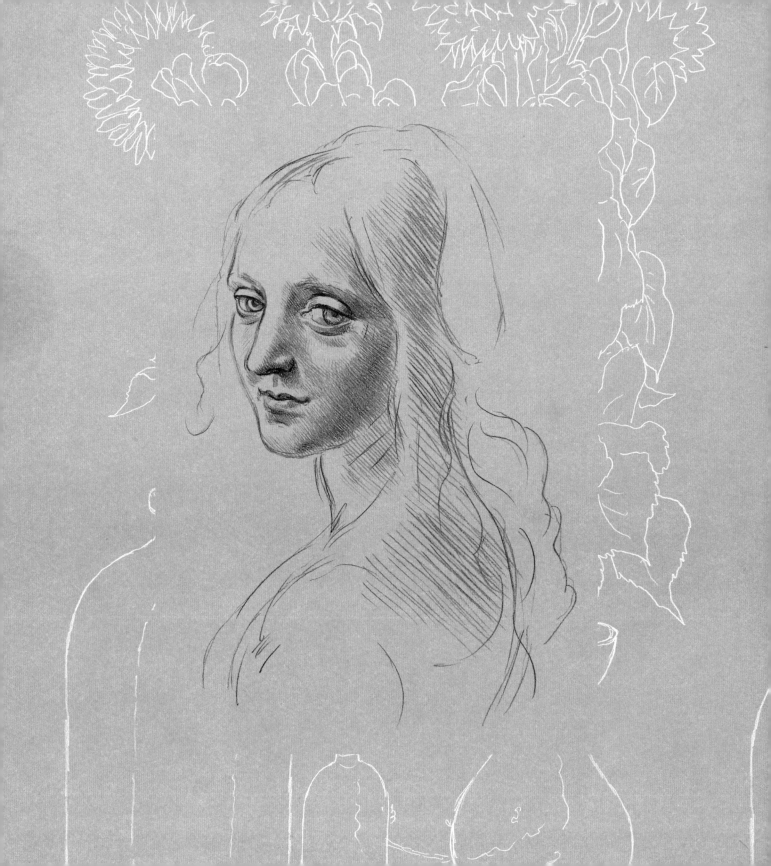

DRAWING FROM THE MASTERS

The point of this section is not to encourage you to blindly copy the methods of Raphael or Leonardo or any of the other great masters whose works we'll be looking at. The most important aspect of drawing of this quality is the acute observation that it requires. Master artists observe the world around them with great accuracy. I have deliberately not provided captions for the images reproduced here, because I want you to regard this section as an exercise in looking.

From these examples I want you to begin to understand how to put technique at the service of your observations by varying the length and pressure of your strokes. Eventually, after a lot of practice, you will find that you can judge exactly how heavy, light, long or short your strokes should be to achieve a specific effect. If all goes well, you'll also find that you get quite fast at it. One of the bonuses of studying drawing and painting is that our vision becomes more refined and we begin to drop the prejudices and preconceptions that normally accompany our view of the world – a skill that is abundantly in evidence in the work of the artists in this section.

ANCIENT GREEK ART

These Greek vase drawings, some of the earliest known (dating from around 510 BC), are so sophisticated and elegant they might have been drawn by Picasso or Matisse, except that Matisse would not have been as exact and Picasso would probably not have been as anatomically correct.

The simple incised line appears to have been done easily and quickly and yet must have been the result of years of practice. Yet more remarkable is that these drawings were not done on flat paper but on the curving surface of a vase or krater. The economy of line is a lesson to all aspiring artists.

LEONARDO DA VINCI (1459–1519)

When we look at a Leonardo drawing we see the immense talent of an artist who could not only see more clearly than most of us, but also had the technical ability to express it on paper. We see the ease of the strokes of silverpoint or chalk outlining the various parts of the design, some sharply defined and others soft and in multiple marks.

Leonardo regulates light and shade by means of his famous *sfumato*, a technique by which an effect of depth and volume is achieved by the careful modulation of light to shadow. There is elegance in the way he puts in enough tone but never too much.

To arrive at this level of expertise requires endless practice. However it is worth persevering with practising techniques because they enable you to produce what you want with greater ease. Techniques need to be mastered and then forgotten. All this will take time.

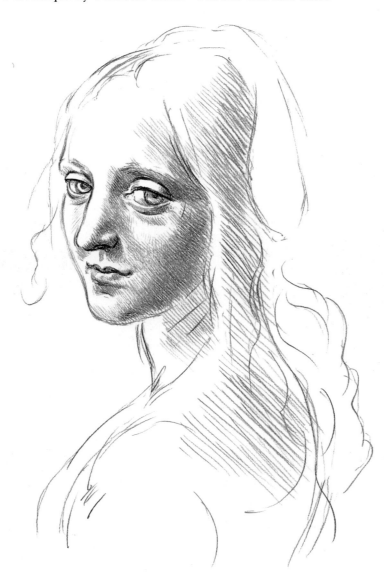

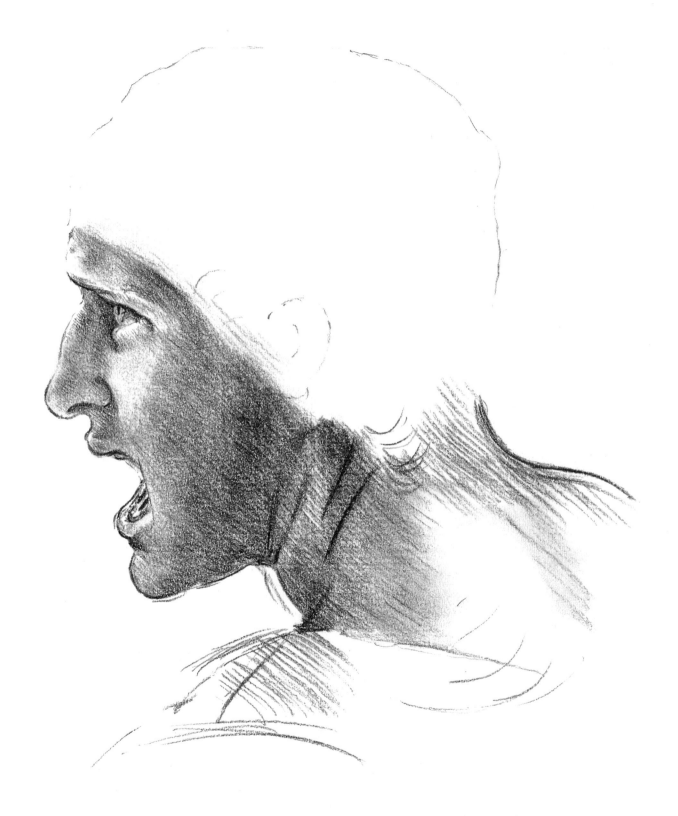

RAPHAEL (RAFFAELO SANZIO) (1483–1520)

The perfection of Raphael's drawings must have seemed quite extraordinary to his contemporaries, even though they had already seen the works of Filippo Lippi, Botticelli, Michelangelo and Leonardo. His exquisitely flowing lines show his mastery as a draughtsman; notice the apparent ease with which he outlines the forms of his Madonna and Child, and how few lines he needs to show form, movement and even the emotional quality of the figures he draws. His loosely drawn lines describe a lot more than we notice at first glance. It is well worth trying to copy his simplicity, even though your attempts may fall far short of the original. The originals are unrepeatable, and it is only by studying them at first hand you will begin to understand exactly how his handling of line and tone is achieved.

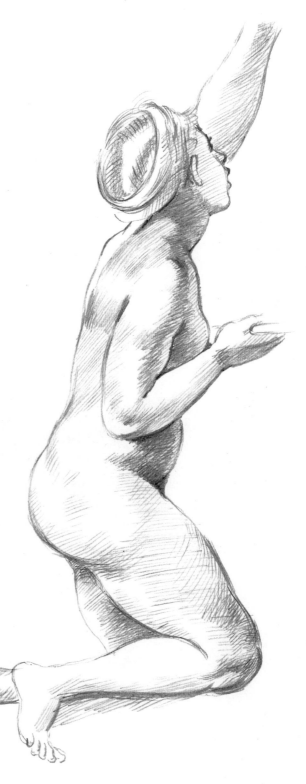

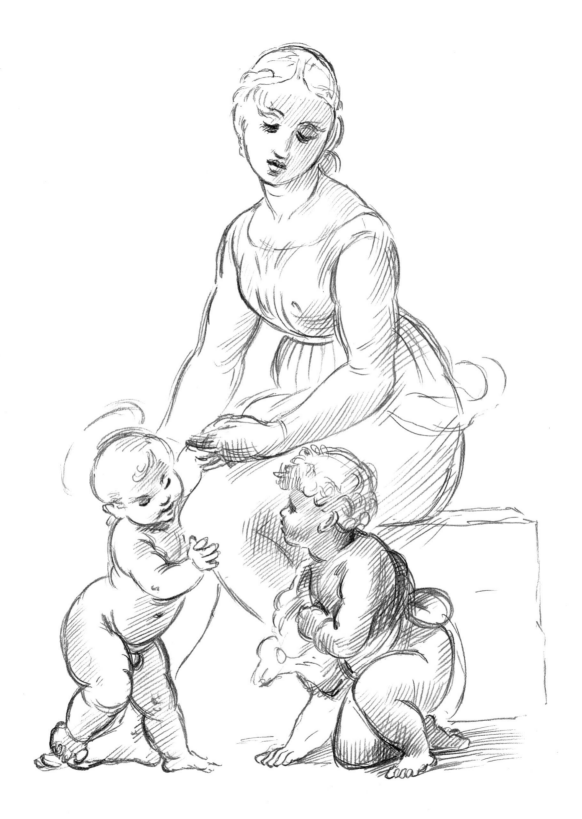

MICHELANGELO BUONARROTI (1475–1564)

Michelangelo is arguably the most influential figure in the history of art. Study his drawings and then look at the work of his contemporaries and the artists who followed him and you will see how great was his influence. The copies shown here incorporate the original techniques he introduced. In the pen and ink drawing the style is very free and the shapes very basic, suggesting figures in motion; the ink drawing with traces of chalk is still pretty sketchy but more considered, allowing the viewer to discern character and type of costume. The final example is a very exact drawing, the careful *sfumato* in black chalk giving a clear definition of the arrangement of the flexing muscles under the skin. Michelangelo's deep knowledge of anatomy enabled him to produce an almost tactile effect in his life drawing. He shows clearly that there are no real hollows in the human form, merely dips between the mounds of muscles. This is worth noting by any student drawing from life and will give more conviction to your drawing.

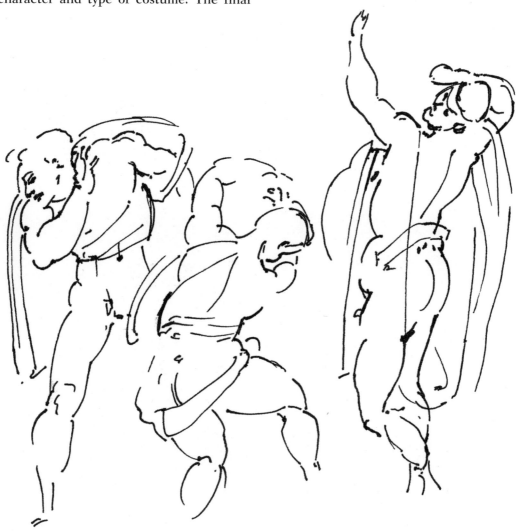

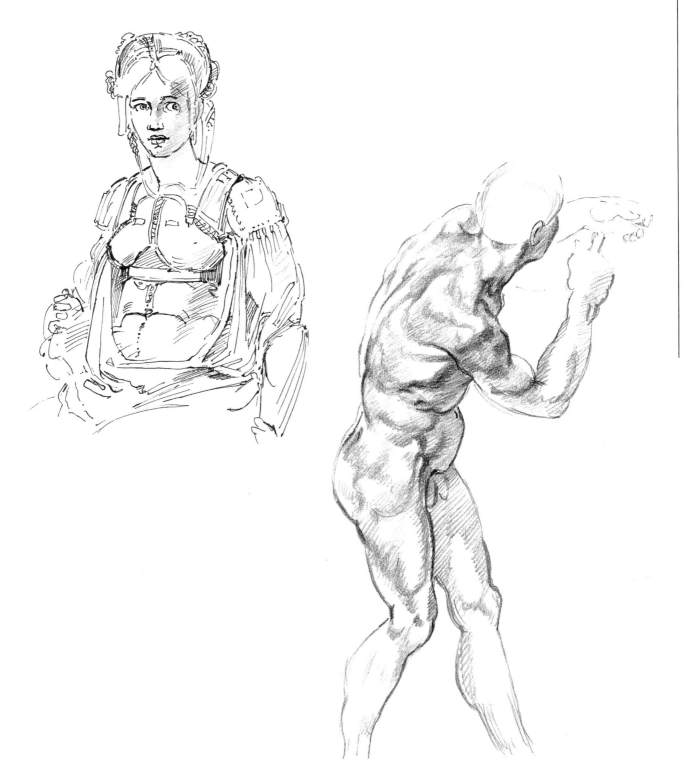

HANS HOLBEIN THE YOUNGER
(1497/8–1543)

Holbein left behind some extraordinarily subtle portrait drawings of various courtiers whom he painted during his time as court painter to Henry VIII. These works are now in the Queen's Collection (most of them at Windsor, but some are in the Queen's Gallery at Buckingham Palace), and are worth studying for their brilliant subtle modelling. These subjects have no wrinkles to hang their character on, and their portraits are like those of children, with very little to show other than the shape of the head, the eyes, nostrils, mouth and hair. Holbein has achieved this quality by drastically reducing the modelling of the form and putting in just enough information to make the eye accept his untouched areas as the surfaces of the face. We tend to see what we expect to see. A good artist uses this to his advantage. So, less is more.

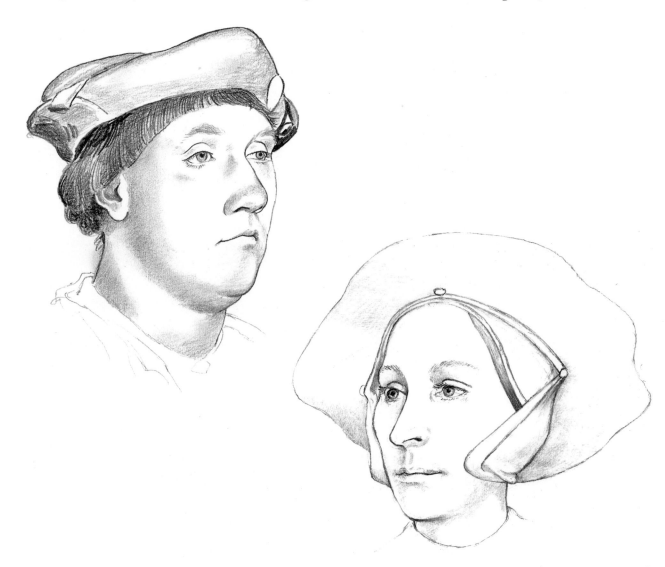

PETER PAUL RUBENS (1577–1640)

Now let us look at the beautiful delicately drawn chalk drawings of Rubens who, like Titian, was referred to as a prince of painters. Before he produced his rich, flowing paintings, full of bravura and baroque asymmetry, he would make many informative sketches to clarify his composition. These sketches are soft and realistic, with the faintest of marks in some areas and precise modelling in others.

The rather gentle touch of the chalk belies the powerful composition of the figures. When completed the paintings were full and rich in form. The artist's understanding of when to add emphasis and when to allow the slightest marks to do the work, is masterly.

Rubens was one of the first landscape painters, although he did this type of work only for his own satisfaction. His drawings of landscapes and plants are as carefully worked out and detailed as those of any Victorian topographical artist.

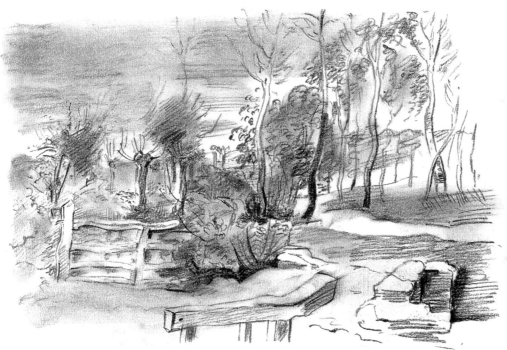

REMBRANDT (HARMENSZ VAN RIJN) (1606–69)

The drawings of Rembrandt probably embody all the qualities that any modern artist would wish to possess. His quick sketches are dashing, evocative and capture a fleeting action or emotion with enormous skill. His more careful drawings are like architecture, with every part of the structure clear and working one hundred per cent. Notice how his line varies with intention, sometimes putting in the least possible and at other times leaving nothing to chance. What tremendous skill!

To emulate Rembrandt we have to carefully consider how he has constructed his drawings. In some of his drawings the loose trailing line, with apparently vague markings to build up the form, are in fact the result of very clear and accurate observation. The dashing marks in some of his other, quicker sketches show exactly what is most necessary to get across the form and movement of the subject. Lots of practice is needed to achieve this level of draughtsmanship.

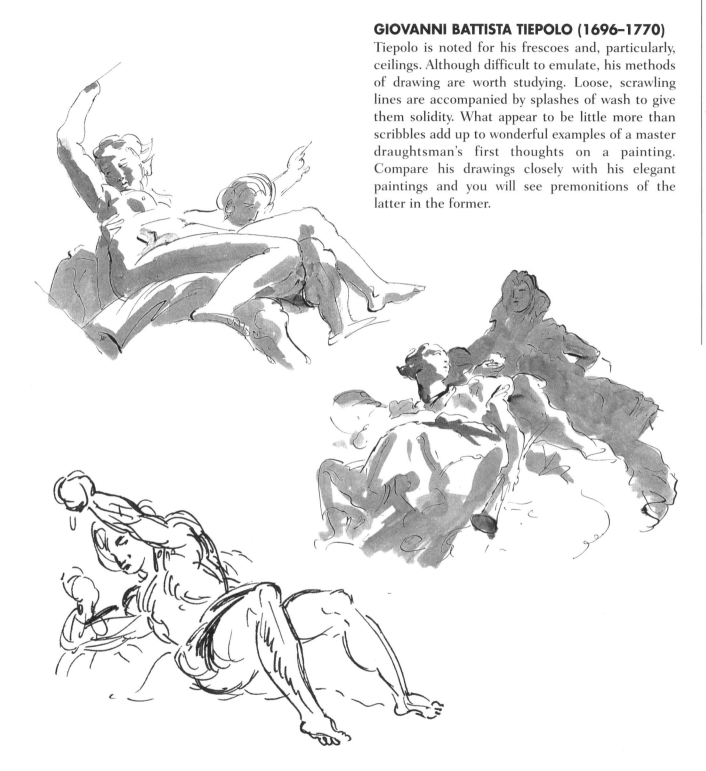

GIOVANNI BATTISTA TIEPOLO (1696–1770)

Tiepolo is noted for his frescoes and, particularly, ceilings. Although difficult to emulate, his methods of drawing are worth studying. Loose, scrawling lines are accompanied by splashes of wash to give them solidity. What appear to be little more than scribbles add up to wonderful examples of a master draughtsman's first thoughts on a painting. Compare his drawings closely with his elegant paintings and you will see premonitions of the latter in the former.

JEAN-ANTOINE WATTEAU (1684–1721)

One of the most superb draughtsmen among the French artists of the 18th century, Watteau painted remarkable scenes of bourgeois and aristocratic life. His expertise is evident in the elegant and apparently easily executed figures he drew from life.

Like all great artists he learnt his craft well. We too can learn to imitate his brilliantly simple, flowing lines and the loose but accurate handling of tonal areas. Notice how he gives just enough information to infer a lot more than is actually drawn. His understanding of natural, relaxed movement is readily seen. You get the feeling that these are real people. He manages to catch them at just the right point, where the movement is balanced but dynamic. He must have had models posing for him, yet somehow he infers the next movement, as though the figures were sketched quickly, caught in transition. Many of his drawings were the basis of subsequent paintings.

JEAN-AUGUSTE-DOMINIQUE INGRES
(1780–1867)

Ingres was, like Raphael, noted for his draughtsmanship. Even when unfinished, his drawings have a precision which is unusual. He is thought to have made extensive use of the *camera lucida* (see page 51), but nevertheless the final result is exceptional by any standards.

The incisive elegance of his line and the beautifully modulated tonal shading produce drawings that are as convincing as photographs. Unlike Watteau's, his figures never appear to be moving, but are poised and static.

The student who would like to emulate this type of drawing could very well draw from photographs to start with, and when this practice has begun to produce a consistently convincing effect, then try using a live model. The model would have to be prepared to sit for a lengthy period, however, because this type of drawing can't be hurried. The elegance of Ingres' drawings was achieved by slow, careful drawing of outlines and shapes and subtle shading.

EUGENE DELACROIX (1798–1863)

The great Romantic French painter Delacroix could draw brilliantly. He believed that his work should show the essential characteristics of the subject matter he was portraying. This meant that the elemental power and vigour of the scene, people or objects should be transmitted to the viewer in the most immediate way possible. His lively drawings are more concerned with capturing life than including minuscule details for the sake of it. He would only include as much detail as was necessary to convince the viewer of the verisimilitude of his subject. As you can see from these examples, his loose powerful lines pulsate with life.

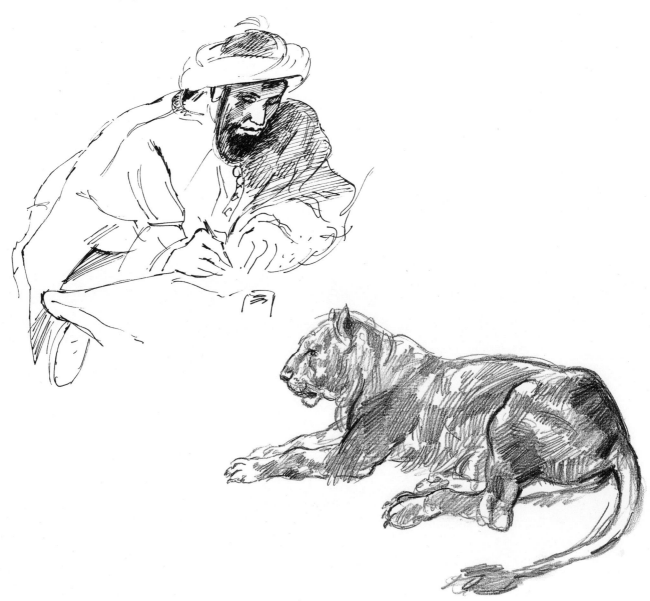

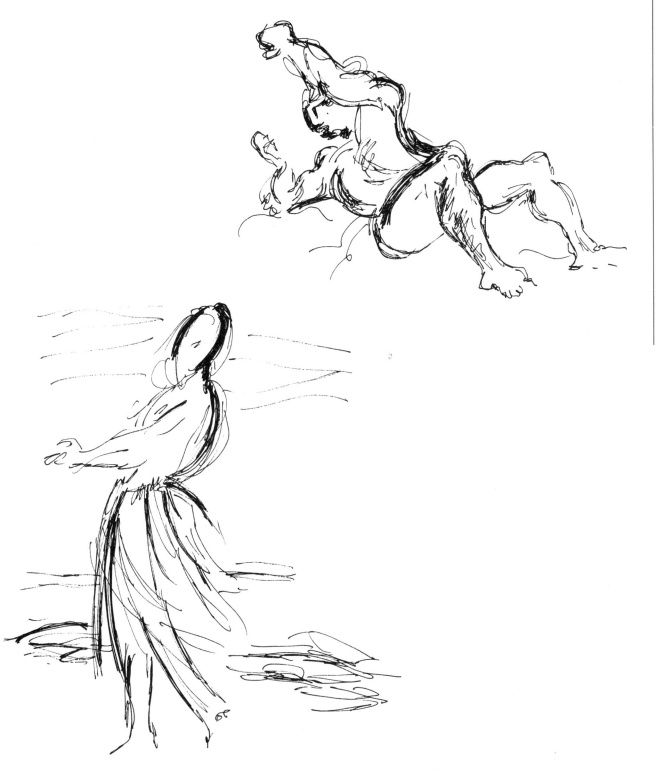

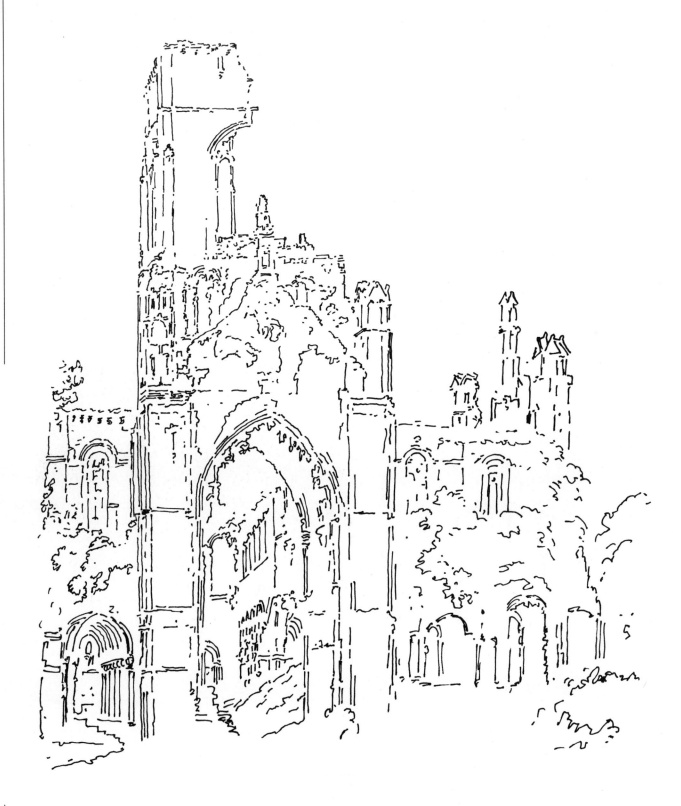

JOSEPH MALLORD WILLIAM TURNER
(1775–1851)

Turner started his career as a topographical painter and draughtsman and made his living producing precise and recognizable drawings of places of interest. He learnt to draw everything in the landscape, including all the information that gives the onlooker back the memory of the place he has seen. This ability stayed with him, even after he began to paint looser and more imaginative landscapes. Although the detail is not so evident in these later canvases, the underlying knowledge of place remains and contributes to their great power.

The outline drawing of the abbey (shown left) is an early piece, and amply illustrates the topographic exactitude for which the artist was famous in his early years. The second example is much more a painter's sketch, offering large areas of tone and flowing lines to suggest the effect of a coastal landscape.

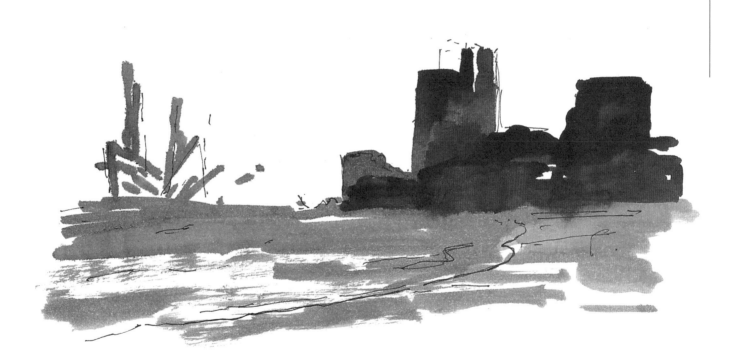

EDGAR DEGAS (1834–1917)

Degas was taught by a pupil of Ingres, and studied drawing in Italy and France until he was the most expert draughtsman of all the Impressionists. His loose flowing lines, often repeated several times to get the exact feel, look simple but are inordinately difficult to master. The skill evident in his paintings and drawings came out of continuous practice. He declared that his epitaph should be: 'He greatly loved drawing'. He would often trace and retrace his own drawings in order to get the movement and grace he was after. Hard work and constant efforts to improve his methods honed his natural talent.

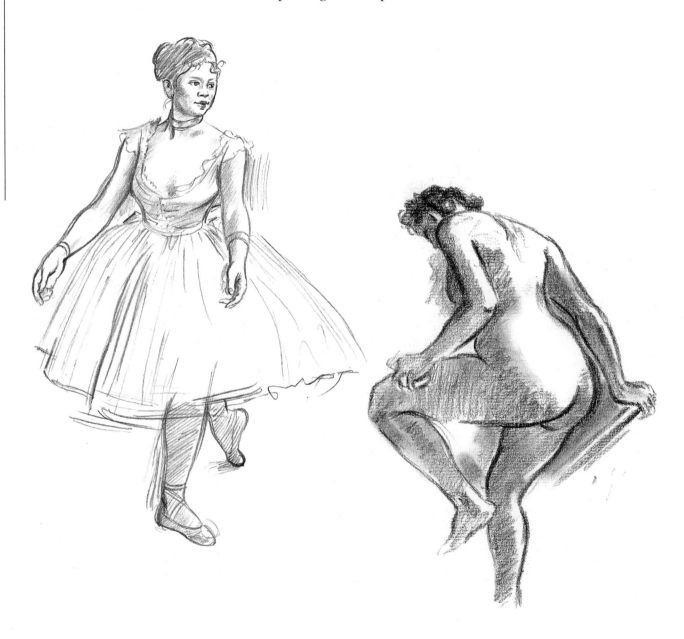

PIERRE AUGUSTE RENOIR (1841–1919)

Renoir's pictures of young women, dressed or undressed, are some of the most charming drawings of the female form ever produced. He always had the painter's eye and sacrificed any detail to the main effect of the picture. When he did include a detail, it was extremely telling and set the tone for the rest of the picture. His drawings and paintings of late 19th-century Paris are imbued with an extremely happy atmosphere, which has captured the imagination of artists ever since.

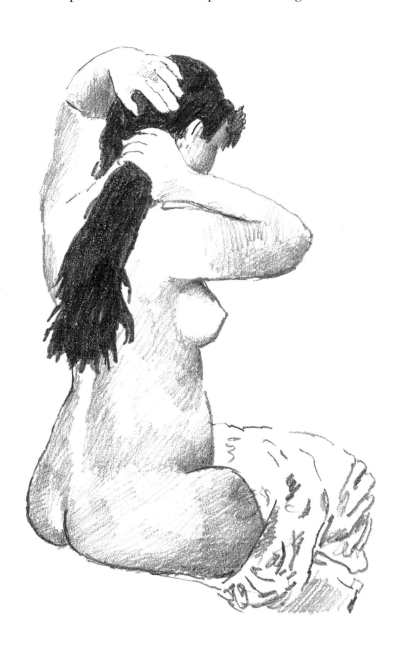

GEORGES SEURAT (1859–91)

Seurat's style of drawing is very different from what we have seen so far; mainly because he was so interested in representing a particular mass or shape that he reduced many of his drawings to tone alone. In these pictures there are no real lines but large areas of graduated tone rendered in charcoal, conté or thick pencil on faintly grainy textured paper. Their beauty is that they convey both substance and atmosphere while leaving a lot to the viewer's imagination. The careful grading of tone is instructive, as is how one mass can be made to work against a lighter area.

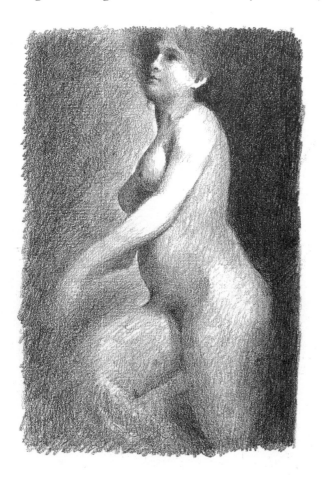

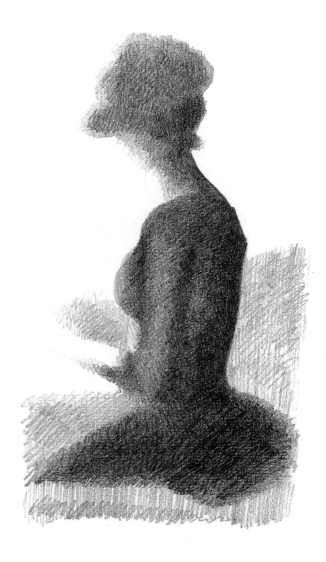

PAUL CEZANNE (1839–1906)

Cézanne attempted to produce drawings and paintings that were true to the reality of form as he saw it. He is the structural master-draughtsman without parallel. His great contribution to art was to produce a body of work that saw the world from more than one viewpoint. The influence of this approach on modern art was immeasurable, since the Cubists were inspired by Cézanne's example to try to draw the objective world from many angles.

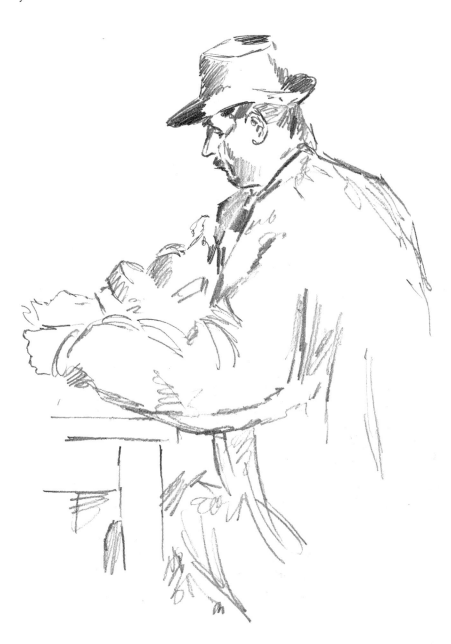

HENRI MATISSE (1869–1954)

Even without the aid of bright, rich colours Matisse could invest his work with great sensuality. His drawings are marvellously understated yet graphic, thanks to the fluidity of line. Awkwardness is evident in some of them, but even so you never doubt that they express exactly what he wanted.

There are no extraneous marks to diffuse the image and confuse the eye. As he got older and suffered from arthritis in his hands, Matisse resorted to drawing with charcoal on the end of a long stick. Despite this handicap, the large, simple images he produced possess great power.

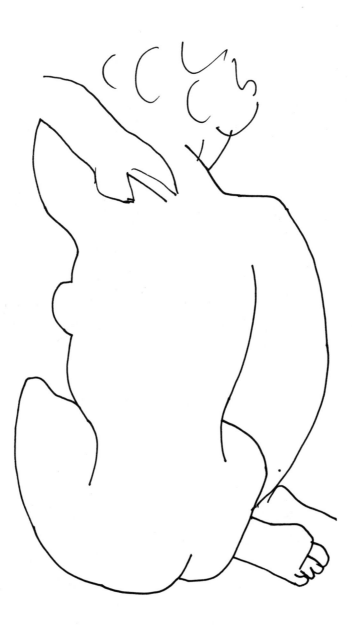

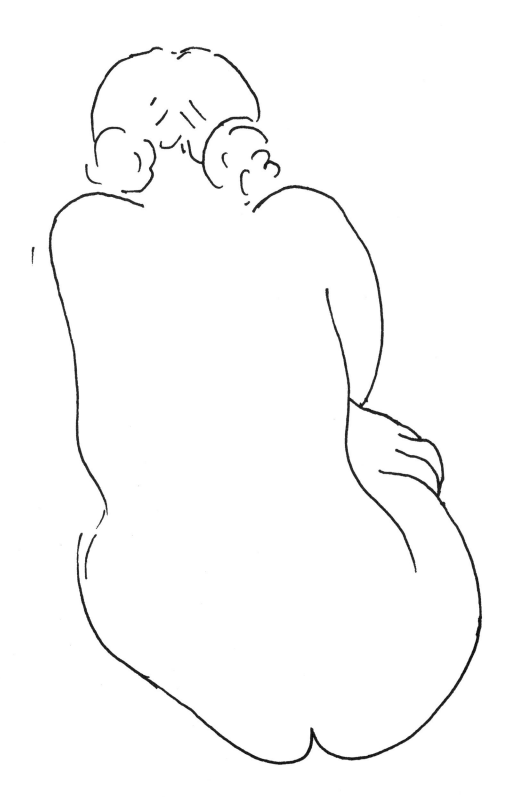

PABLO PICASSO (1881–1973)

Picasso dominated the art world for the greater part of the 20th century. He took every type of artistic tradition and reinvented it, demonstrating that a master-artist can break all the rules and still produce work that strikes a chord with the casual observer. The image below, for example, is an interesting hybrid among the other examples shown here: two pieces of toned paper cut out for the neck and face with the features and hair drawn in with pencil.

Although he distorted conventional shapes almost out of recognition, the final result was imbued with the essence of the subject he was illustrating. He experimented in all mediums, but in his drawings we can see the amazing dexterity with which he confounded our preconceptions and gave us a new way of viewing art. His sketchbooks reveal his wide range of abilities and are an inspiration to all artists.

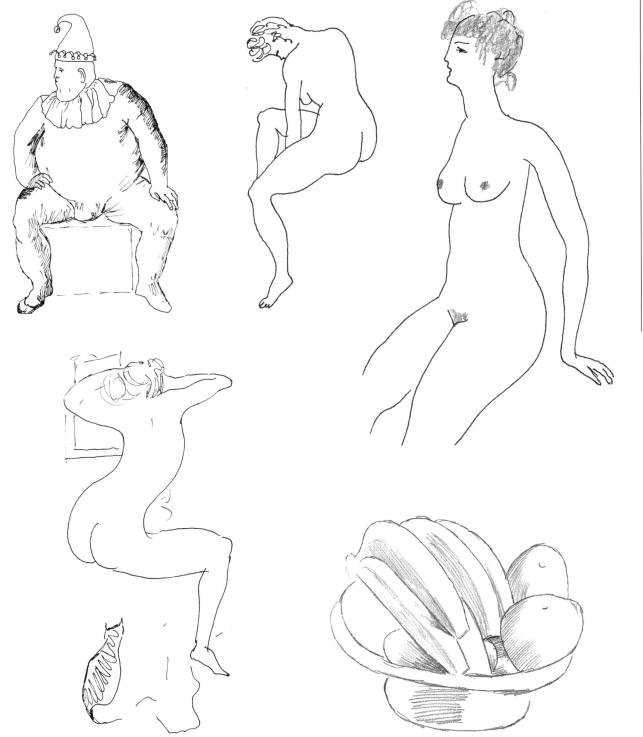

HENRY CARR (1894–1970)

The English illustrator and painter Henry Carr was an excellent draughtsman, as these portraits show. He produced some of the most attractive portraits of his time because of his ability to adapt his medium and style to the qualities of the person he was drawing. The subtlety of the marks he makes to arrive at his final drawing varies, but the result is always sensitive and expressive. A noted teacher, his book on portraiture is well worth studying.

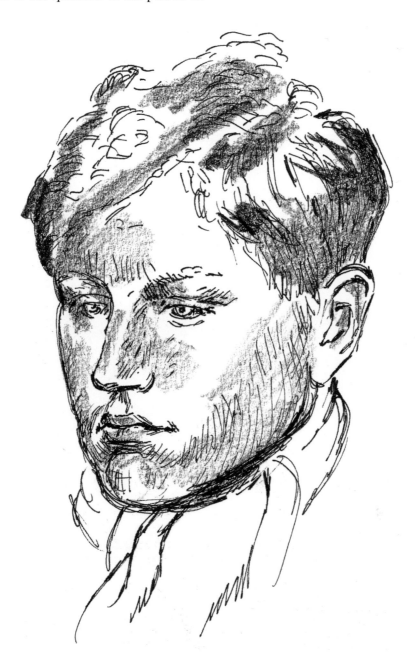

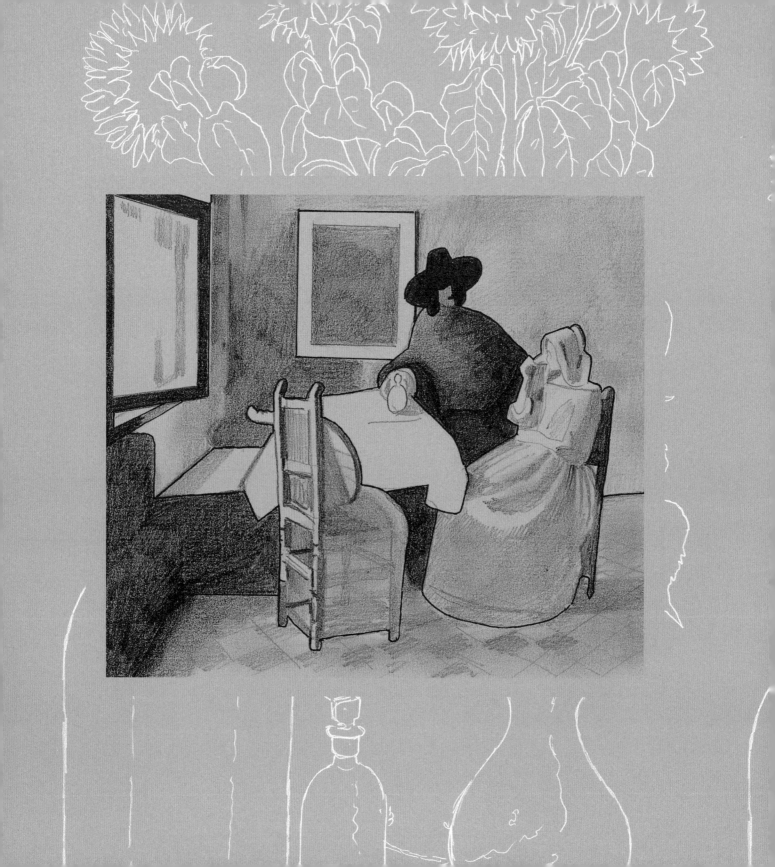

THE EXPERIENCE OF DRAWING

In the following pages I introduce some of the main techniques and devices of drawing. As you have learnt from the masterful drawings of the previous section, there is no substitute for observation. Look long and hard at anything that you wish to draw and ask yourself the question, 'What am I seeing?' Don't just give yourself answers like 'a landscape', 'a teapot', 'a human being' etc, because such answers close down your observation. Look instead at colour, shape, form, texture, outline and movement. Keep looking, even when you think you know what you're looking at. Nothing stays the same for more than a few seconds; the light changes, for example, giving you a new version of the object, even if it's only a still form. You'll find there is infinite variety, even in familiar scenes that we see every day.

Here we look at a range of subjects as they really are: agglomerations of shapes. As well as the shapes of the things themselves, you will notice the shapes between things. While we will be tackling some of these themes in more depth later the book, it is important to hone your powers of observation and adopt the right overall approach early on. Look at what you see without preconception. Try to notice everything and don't regard one part of the whole view as superior to the rest.

ANALYZING SHAPES

Ordinarily when you look at a scene, object or person, your eyes will first register the shapes in an objective way and then your mind will supply information that enables you to recognize what you are seeing. The names, concepts or labels the mind supplies are not helpful to you as an artist, however, and you need to ignore them if you are to see objectively the shapes that are actually there.

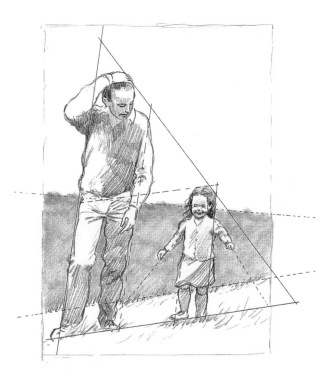

Observing a subject in geometric terms helps to simplify our approach to drawing. Look at this very simple picture. Both figures can be contained in a triangle. To the right of the little girl the space can be cut off along her right side so that she and her father's legs fit into a parallelogram. The space under her left arm, extending to her father's foot, makes another triangle.

One way of getting a more objective view is to analyze the shapes you are looking at in terms of their geometry. For example, a circular object seen at any angle forms an ellipse, and if you know how to draw an ellipse correctly you will get a good image of the object. Anything spherical is just a circle with toning, to fool the eye into believing in the object's sphericality.

The spaces between objects are often triangles or rectangles. Objects within a group can be seen as being at different angles to each other: a leg may be propped up at an angle of 45 degrees from the upright torso, and the lower leg may be at right-angles to the thigh.

This sort of visual analysis is very useful for you, the observer, to undertake and will help the accuracy of your work. Once you recognize the angles you are drawing, you will find it difficult to draw them badly.

MEASURING PROPORTIONS

Another useful form of analysis is to employ some common unit of measurement to get the proportions of different objects in your drawing right. For example, the shape and size of a door or window can give you a basic unit of measurement with which to measure the other units in a composition. In figure drawing, the head is a useful unit for measuring the human body (see page 220). If you use a form of analysis, just remember that the unit has to remain constant throughout the composition, otherwise the proportion will not be right.

Rule of thumb is one of the most common units of measurement (see opposite page). The logic of this method is that your arm will not grow any longer during the time it takes to complete your drawing, so no matter how many measurements you take, your measuring device will remain at the same distance from your eye. Remember, though, that if you move your position you will have to start again because every proportion may alter.

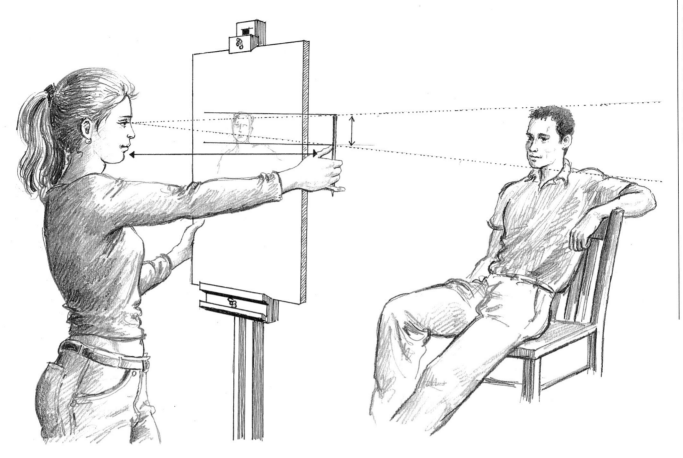

Using rule of thumb

Here the rule of thumb measurement is used to gauge the proportions of a figure. The arm is outstretched and the pencil held upright in line with the drawing board. The measurement taken (of the head, in this instance) is called 'sight-size'.

Once the measurement is taken it can be transferred to the paper. As long as you measure everything in your scene in this way, staying the same distance from the model and keeping the pencil at arm's length when measuring, the method will give you a fairly accurate range of proportions.

This method is of limited value to beginners, however: the drawing will be too small and beginners really need to draw large in order to correct their mistakes more easily. Experienced artists will be able to translate the proportions into larger measurements when drawing larger than sight-size.

For more detail on drawing figures in proportion, see pages 220–5.

TECHNICAL AIDS

Photographs and slides can be used by artists to render a scene accurately. The old masters used tools such as the *camera obscura* and *camera lucida* – literally, 'dark room' and 'light room' – to ensure the accuracy of their perspective and proportion. Another device used by artists of old to help this sort of technical analysis was a draughtsman's net or grid. This was a screen with crossed strings or wires creating a grid of regular squares through which the artist could look at a scene. As long as the artist ensured that his eye was always in the same position each time he looked through the screen, and as long as a similar grid was drawn on his paper, the main composition could be laid out and each part related correctly.

These methods are not ends in themselves, however, and although they provide the main outlines of a composition, they cannot give the subtle distinctions that make a work of art attractive. To capture these, the artist has to use his own eye and judgement.

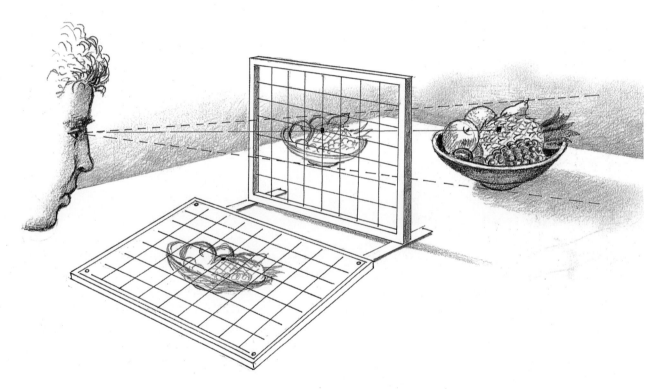

The draughtsman's net or grid is a construct for use in the Renaissance manner. Usually artists make them themselves or have them made by a framemaker. The squares can be either marked directly onto glass or indicated by stretching thin cords or wires across a frame. The grid is then set in a stand through which the object is viewed.

Patience is required to transfer the image of a subject viewed in this way onto paper: it is very easy to keep moving your head and thus changing your view in relation to both the frame and the subject. The trick is to make sure that the mark on the object and the mark on the grid where two lines meet are correctly aligned each time you look.

Canaletto and Vermeer are just two of the artists who used the *camera obscura* in their work. It has the same effect as the *camera lucida*, although achieving it by different means. Used by painters for landscapes, cityscapes and interior scenes, the device was a tent or small room with a pin-hole or lens in one side, which cast an image of the object outside onto a glass screen or sheet of paper, which could then be traced. It was an excellent device for architectural forms as long as one ignored the outer limits of the image, which tended to be distorted.

In a camera lucida or lucidograph a prism is used to transfer an image onto paper or board. This enables the artist to draw around the basic shape to get the proportions correct.

The technique was well adapted for use in small areas of drawing and it was used extensively by Ingres and possibly Chardin and Fantin Latour.

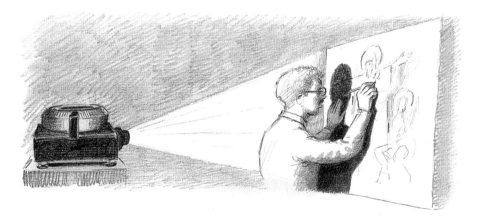

A slide-projector can give a similar effect to a lucidograph, although of course it allows you to use a much larger format. It has been used extensively by

artists who want to reproduce master paintings or enlarge their own work. Its only drawback is the difficulty of keeping your shadow out of the way.

PROPORTIONS

After some practice you will find you can remember the basic proportions of the human face seen from the front and the human body seen standing erect in full view (see chapters on Portrait Drawing and Figure Drawing). You will find other subjects much more variable, however. For those you will need to use a system to help you ensure that the different parts of your composition are in proportion to each other. This is particularly true when there is a lot of perspective depth in a scene, requiring you to show the relationship between the objects closer to you and the objects further away. Even in landscapes, where a certain amount of cheating (politely called 'artistic licence') is allowable because of the tremendous variation in proportions depending on your viewpoint, it is necessary to have some method of organizing the proportions of trees to houses to people and to far-away objects on the horizon. Even more important than ordering these variables is an accurate assessment of the angle of objects to your eye-level.

When the eye-level is low, smaller, closer objects dominate the view much more than when the eye-level is high. Trees on the skyline can look bigger or nearer when they are silhouetted against the light, because they have more definition. If there is a large object in the centre of your composition, it will tend to grab the eye. There is even a proportional effect in colour and tone. A very bright or very dark object standing in sharp contrast to the background grabs the attention, and even if this object is quite small it will appear larger than it is.

A well-defined silhouette on the skyline set against a light sky will dominate a scene and appear closer than it really is.

A bright, light object standing out against a dark-toned background will dominate a scene despite its small size.

FORESHORTENING

When drawing objects or people seen from one end, the parts of the object nearer to your eye will appear much larger when compared to those at the further end. Many beginners find this truth quite difficult to grasp and disregard the evidence of their own eyes. However, it is easy enough to make a simple measurement to help convince the mind of what the eye actually sees. This subject of foreshortening is covered in more depth in the Figure Drawing chapter under the heading 'Figures in Perspective' (page 242).

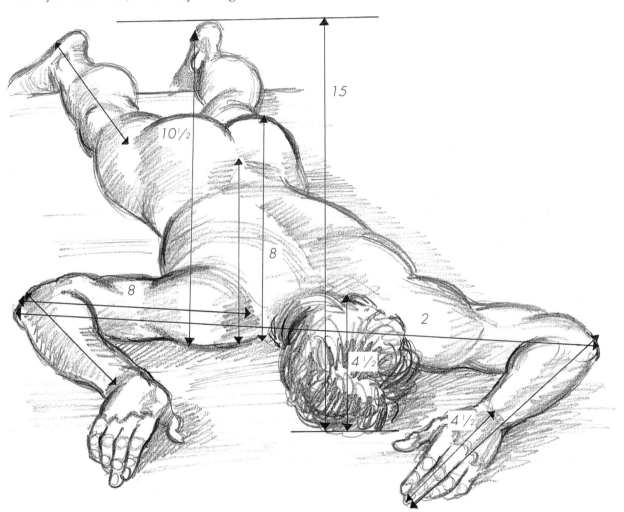

The strange proportions of foreshortening

Note the depth of the head (4 ½ units), which is the same as the open hand, and the foreshortened forearm and foreshortened leg. At 8 units the torso is only just less than twice the size of the head. The full length of the body from shoulder to ankle (10 ½ units) is just over twice the head. The upper arm is the same length as the torso (8 units). The distance from elbow to elbow (23) is longer than the distance from head to heel (15).

THE EFFECT OF DIFFERENT EYE LEVELS

These three drawings show how the effect of a picture is altered by the relationship of figures to the horizon or eyeline. In the first two pictures the viewer is standing and in the last the viewer is seated. This change in the relationship of the figures to the horizon-line has had quite an effect on the composition, and has changed its dynamic.

You can see in galleries of paintings how artists have used this dynamic, particularly the Impressionists – look at examples of the work of Degas and Monet.

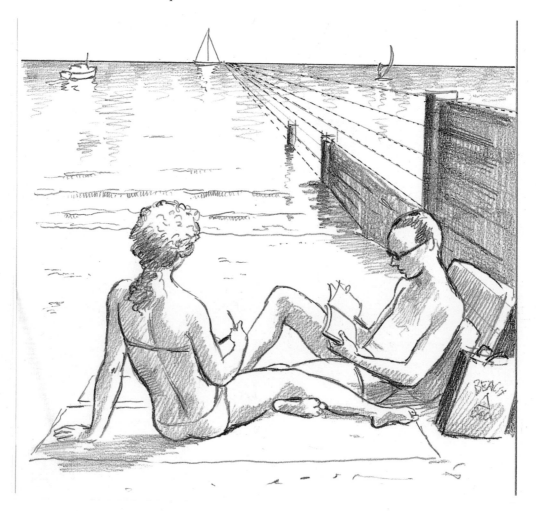

In the first picture the eye level is considerably higher than the people reclining on the beach. The viewer has a sense of looking down on the figures, which appear to be part of the overall scene and are not at all dominant.

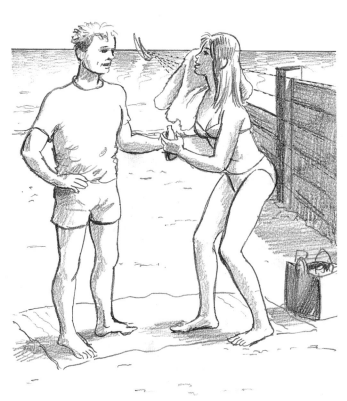

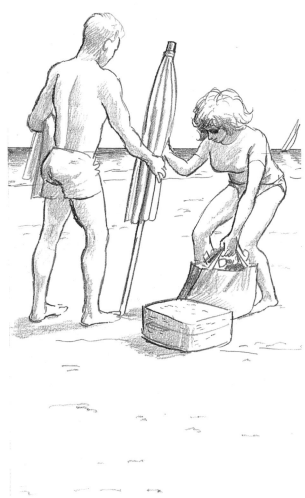

The eye level of these two standing figures is the same as ours, making them appear more active. We are standing, as are they. (Note that the line of the horizon is at the same level as their eyes.)

Here the eye level is much lower than that of the two figures; even the girl bending down is still head and shoulders above our eye level. The figures now appear much more important and powerful in the composition.

AREAS OF DARK AND LIGHT

In all three drawings shown here, notice how the light areas outline the dark shapes and dark areas outline the light shapes. You will find that some shapes run into each other to make one large one and this is often easier to draw than a multitude of smaller shapes.

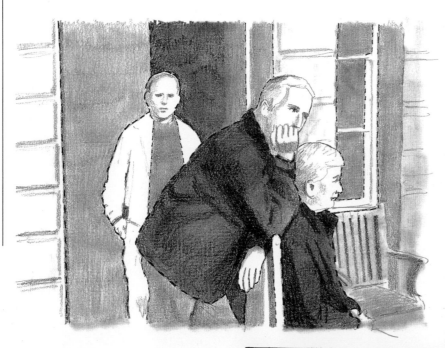

Large geometric shapes such as walls, doors and windows (left and opposite page), can provide a natural grid for a picture, making it easier to place other shapes, such as figures or, in an outdoor scene, trees.

In this drawing, based on a Vermeer, the simplified forms of the figures show clearly against the large expanse of the wall and floor. The framed picture helps to place the figures, as does the table and chair. The window, the source of light, is dominant against the dark wall.

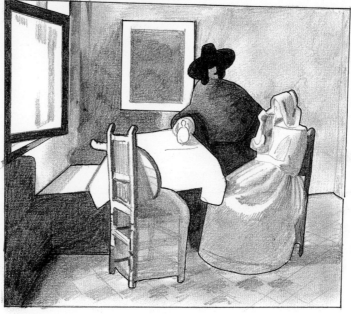

ANGLES

Look at the angles in the figure shown below. As long as you can visualize a right angle (90 degrees) and half a right angle (45 degrees), and possibly a third (30 degrees) or two-thirds (60 degrees) of a right angle, you should have no difficulty making sense of them. Let's break them down:

The wall in relation to the horizontal base on which the figure is resting is a right angle (90 degrees) (A). But what about the rest of the angles shown?

B the angle of the torso to the horizontal base.
C the angle between the thigh and the horizontal base.
D the angle between the thigh and the lower leg.
E the angle between the lower leg and the horizontal base.
F the angle of the head to the torso.
G the angle of the head to the wall.

All these questions need to be answered. Just ask yourself – is it a full right angle, or just less, or just more? Is it nearer a third or nearer a half right angle? Accurate answers to these questions will help you to envisage the structure of the drawing on the page correctly.

ANSWERS:
B A bit more than 45 degrees, perhaps 60.
C About 45 degrees.
D A bit less than 90 degrees (almost a right angle).
E About 45 degrees.
F About 120 degrees (one right angle plus a third).
G A bit less than 30 degrees.

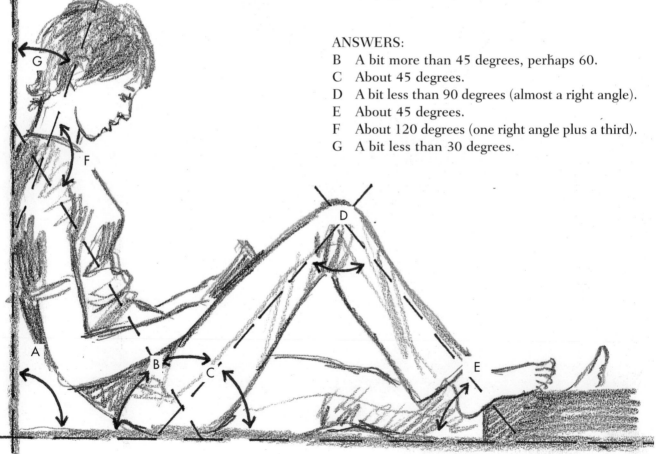

RELATING TRIANGLES AND RECTANGLES

The lines in the next drawing may look complex but they are in fact a way of simplifying a grouping by pinpointing the extremities of the figures. Adopting this method will also help you to hold the composition in your mind while you are drawing.

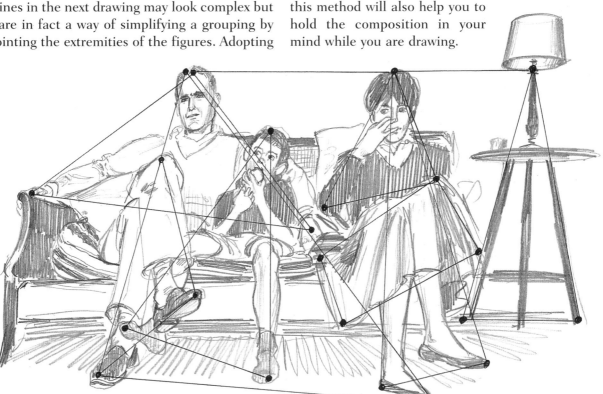

Let's identify the triangular relationships in this fairly natural composition: the father's head to his lower foot and to the mother's lower foot; also his head to his hands; the boy's head with his feet; the father's knees and feet; the mother's skirt shape and the relationship of head to elbow to knee. The table and lamp form a ready-made triangle.

Triangles and angles simplified

You don't have to be a great geometrician to understand systems based on angles and triangles. When it comes to triangles, just note the relative sizes of their sides: in an equilateral triangle all three sides are equal (and all angles are equal); an isosceles triangle has two equal sides; and in a parallelogram the opposite sides are equal in length and parallel.

Angles are even simpler. An angle of 90 degrees looks like the corner of a square. Half a right angle is 45 degrees, and a third is 30 degrees. These are the only angles you'll need to be able to recognize. All the others can be related to them, and thought of in terms of more or less than 30, 45 or 90 degrees.

HUMAN ARCHITECTURE

Learning to relate the skeleton and muscular structure of the body to the outer appearance is an important part of Figure Drawing (see pages 218–59). You will need to study the structure of the body in detail if you really want your drawings to look convincing. The diagram below gives you some idea of the complexity of detail involved.

The Renaissance artists, of course, learnt about anatomy from dissected human and animal bodies. However, for most of us, books on anatomy are quite good enough to give the main shapes, although an articulated model skeleton (which quite a few artists and doctors have) will give more detailed information.

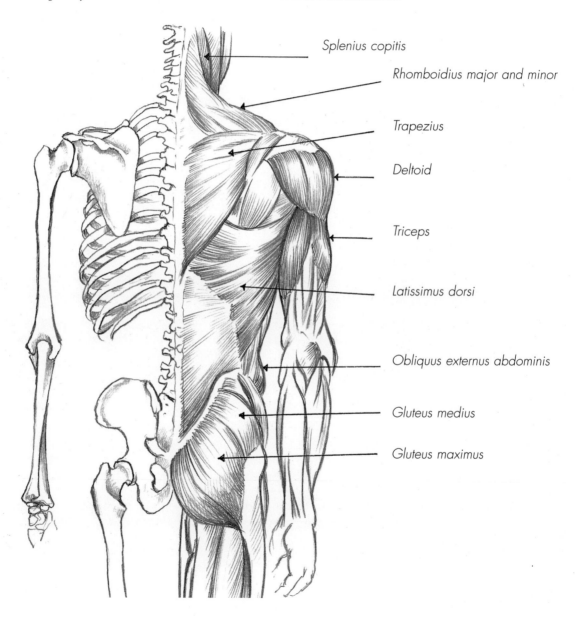

Splenius copitis

Rhomboidius major and minor

Trapezius

Deltoid

Triceps

Latissimus dorsi

Obliquus externus abdominis

Gluteus medius

Gluteus maximus

Bones of the skull

Frontal

Parietal

Temporal

Zygomatic

Occipital

Maxilla

Mandible

Nasal

THE HEAD

The head is defined mostly by the shape of the skull underneath its thin layer of muscle, and to a lesser extent by the eyeballs. The rather flat groups of muscles on the skull produce all our facial expressions, so it is very useful to have some idea of their arrangement and function, especially when you want to draw portraits (see Portrait Drawing on pages 184–217).

Muscles of the head

A. *Corrugator (pulls eyebrows together)*
B. *Frontalis (moves forehead and eyebrows)*
C. *Temporalis (helps move jaw upwards)*
D. *Orbicularis oculis (closes eye)*
E. *Compressor nasi (narrows nostrils, pushes nose down)*
F. *Quadratus labii superioris (raises upper lip)*
G. *Zygomaticus major (upward traction of mouth)*
H. *Levator anguli oris (raises angle of mouth)*
I. *Orbicularis oris (closes mouth, purses lips)*
J. *Masseter (upward traction of lower jaw)*
K. *Buccinator (lateral action of mouth, expels fluid or air from cheeks)*
L. *Risorius (lateral pulling on angle of mouth)*
M. *Depressor anguli oris (downward traction of angle of mouth)*
N. *Depressor labii inferioris downward pulling of lower lip)*
O. *Mentalis (moves skin on chin)*

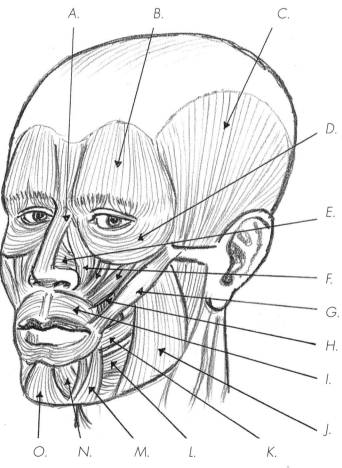

A. B. C. D. E. F. G. H. I. J.

O. N. M. L. K.

ELLIPSES

An ellipse is a flattened circle seen from an oblique angle. Ellipses on the same level above or below the eye level will be similar in proportion. Several circular objects on a circular base will have the same proportions, as you will see if you look at the drawing below.

The lampshade, base of the lampstand, table top, and top and bottom of the glass are all ellipses related to the same eye level. They will be very similar in proportions of width to height although of different sizes.

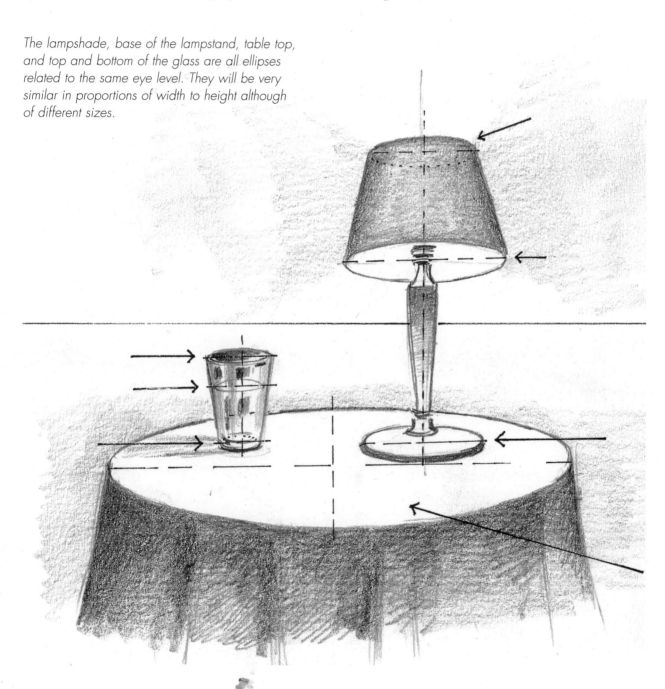

USING A COMMON UNIT OF MEASUREMENT

A large subject such as a street scene, in which proportions and perspective have to be taken into account, can be difficult to draw accurately unless you use some system of measurement.

For the urban scene shown below, I chose an element within the scene as my unit of measurement (the lower shuttered window facing out of the drawing) and used it to check the proportions of each area in the composition. As you can see, the tall part of the building facing us is about six times the height of the shuttered window. The width of the whole building is twice the height of the shuttered window in its taller part; and six times the height of the shuttered window in its single-storey part near the edge of the picture.

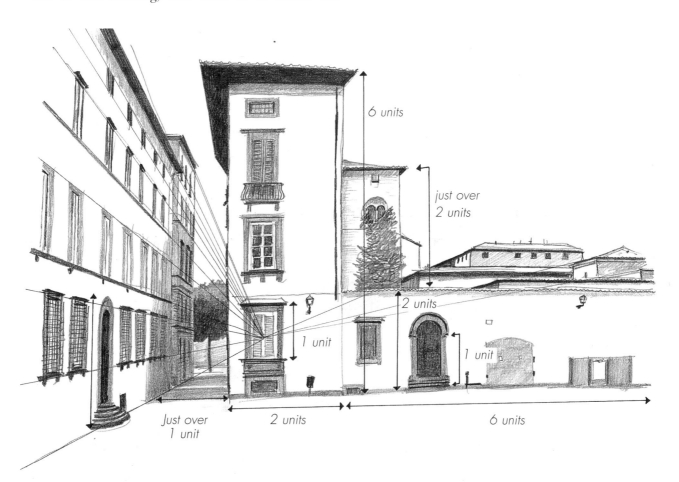

6 units

just over 2 units

2 units

1 unit

1 unit

Just over 1 unit

2 units

6 units

Keeping measurement in perspective

A unit of measurement enables us to maintain the accuracy of our drawing, but it is only meant to provide a rough guide. Once you are used to drawing you will find the eye an extraordinarily accurate instrument for judging proportion and size. Sometimes we just need to check to make sure we've got them right, and at such times units and the like come into their own.

PERSPECTIVE

There are many things to be borne in mind with perspective. The main point is that it is impossible to put down exactly what we see in the two dimensions of drawing and painting. A certain amount of adjustment and artistic licence has to be allowed. A flat map can't replicate the world's surface, which is curved, and so will have to sacrifice either area shape or area proportion. When we look at something ordinarily, our eyes scan the scene. However, when we look at a picture, our vision is drawn as though from one point. This means that the outside edges of the cone of vision (as it's called) will not be easily drawn with any accurate relationship to the centre of vision. The artist, therefore, has to limit his area of vision to one that can be taken in at one glance. The artist must also be aware of his own eye-level or where the horizon really is, however much it is obscured by hills, trees or buildings. The actual cone or field of vision is about 60 degrees, but the artist will limit his picture to much less unless he is going to show distortion.

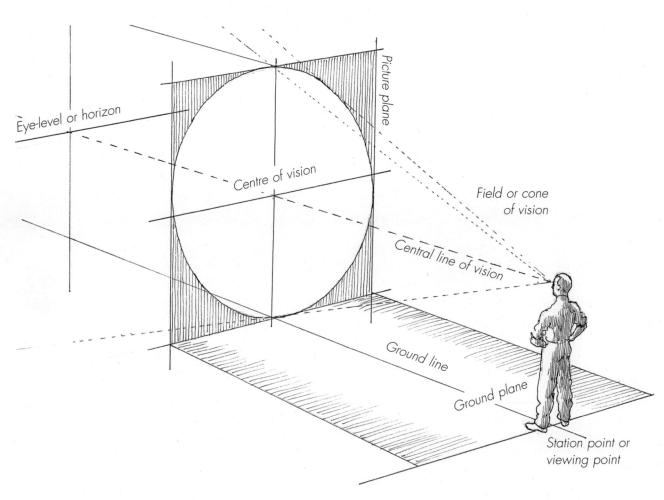

Eye-level or horizon

Picture plane

Centre of vision

Field or cone of vision

Central line of vision

Ground line

Ground plane

Station point or viewing point

RELATIONSHIPS IN THE PICTURE PLANE

In this example we look at the relationships between the tree, post and flowers and the horizon line. The height of the tree in the picture appears not as high as the post, although in reality the post is smaller than the tree. This is due to the effect of perspective, the tree being further away than the post. The horizon line is the same as the eye level of the viewer.

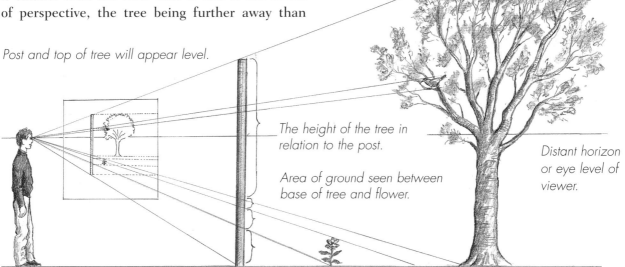

Post and top of tree will appear level.

The height of the tree in relation to the post.

Area of ground seen between base of tree and flower.

Distant horizon or eye level of viewer.

Distance between bottom of tree and bottom of post.

AERIAL PERSPECTIVE

When you are drawing scenes that include a distant landscape as well as close up elements, you must give the eye an idea of how much air or space there is between the foreground, middle ground and background. In this drawing these areas are clearly delineated. The buildings and lamp-posts close to the viewer are sharply defined and have texture and many tonal qualities. The buildings further away are less defined, with fewer tonal variations. The cliffs behind this built-up area are very faint, without much variation in tone.

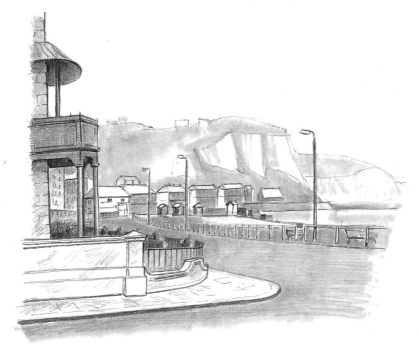

PERSPECTIVE: ALBERTI'S SYSTEM

The Renaissance architect and scholar Leon Battista Alberti (1404–72) put together a system of producing perspective methods for artists, based on Filippo Brunelleschi's (1377–1446) discoveries in the science of optics. His system enabled a new generation of painters, sculptors and architects to visualize the three dimensions of space and use them in their work.

With Alberti's system the artist has to produce a ground plan of rectangles in perspective and then build structures onto this base. To do this he has to work out a way of drawing up the plan relating to the rays of vision and the eye level or horizon, so that measured divisions on the plan can be transferred into an apparent open window onto the scene being depicted. The viewpoint of artist and viewer is central and on the eye level line, and this gives the picture accurate depth and dimension.

Using Alberti's ground plan
Once you have produced the ground plan grid, with the eye level and vanishing point, you can then decide the height of your object or building – in the example shown right, it is 5 units of the floor grid. Using a compass, describe two arcs to connect verticals drawn from the four corners of the proposed building to the

edges of the top of the structure; draw horizontal lines for the near and far edges, and lines connected to the vanishing point for the two side edges.

The projections of front and side elevations shown here give a very simple structure. Alberti's system can be used to determine the look of far more complex structures than the one illustrated.

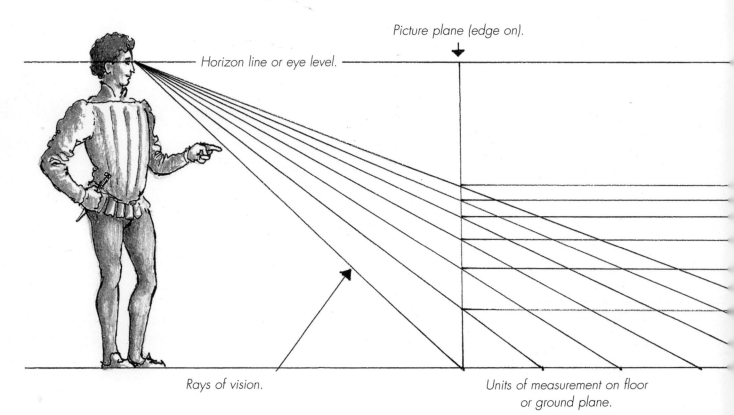

Picture plane (edge on).

Horizon line or eye level.

Rays of vision.

Units of measurement on floor or ground plane.

Producing Alberti's ground plan

The ground line is measured in units that are related to a vanishing point on the horizon and can be seen as related to the picture plane. A simple diagonal drawn across the resulting chequered pavement can be used to check the accuracy of the device.

Once the pavement effect has been produced, any other constructions can be placed in the space, convincing the viewer that he is looking into a three-dimensional space. This only works because of the assumptions we make about size and distance. If the lines of perspective are disguised to look like real things, such as pavements and walls, the eye accepts the convention and 'sees' an image understood as depth in the picture. Of course, all details have to conform in order to convince.

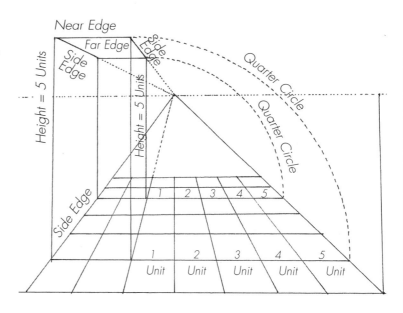

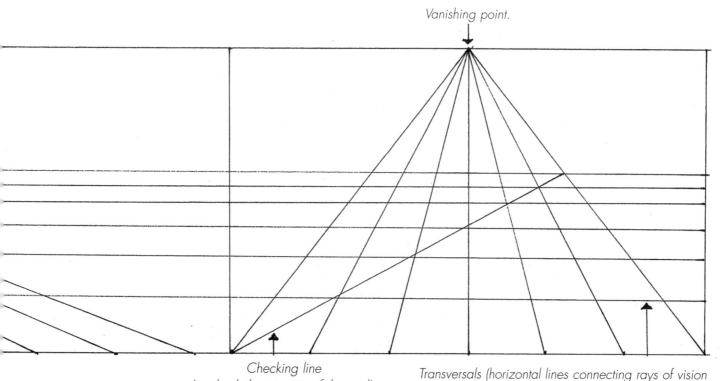

Vanishing point.

Checking line
(to check the integrity of the grid).

Transversals (horizontal lines connecting rays of vision
from picture plane to perspective construction).

PERSPECTIVE: FIELD OF VISION

The system we look at next is quite easy to construct. You don't need mathematical training to get it right, just the ability to use a ruler, set square and compass. Although the picture does not actually have depth, the eye is satisfied that it does, because it sees an area of squares which reduces geometrically as it recedes into the background.

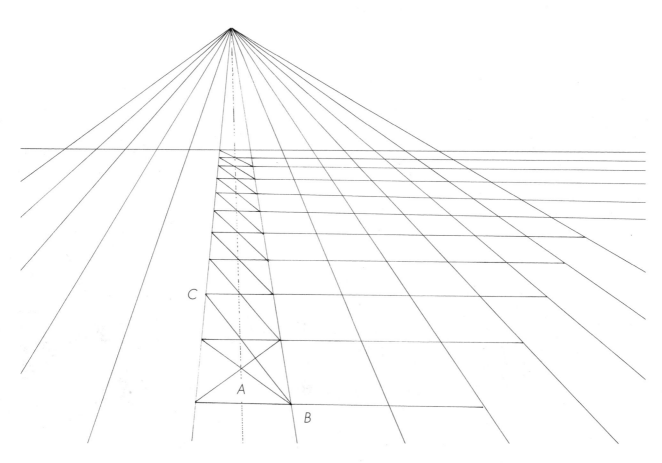

Constructing an area of squares

Any square portions, such as paving slabs, tiles or even a chequerboard of fields, can be used to prove the illusion of depth in a picture.

Take one slab or square size (A), draw in diagonal lines and from the crossing point of these diagonals mark a construction line to the vanishing point. In order to get the next rows of paving slabs related to the first correctly and in perspective, draw a line from the near corner (B) to the point where the construction line to the vanishing point cuts the far edge of the square. Continue it until it cuts the next line to the vanishing point (C) and then construct your next horizontal edge to the next paving slab. Repeat in each square until you reach the point where the slabs should stop in the distance. Having produced a row of diminishing slabs, you can continue the horizontal edges of the slabs in either direction to produce the chequerboard of the floor. Notice the impressive effect you get when you fill in alternate squares.

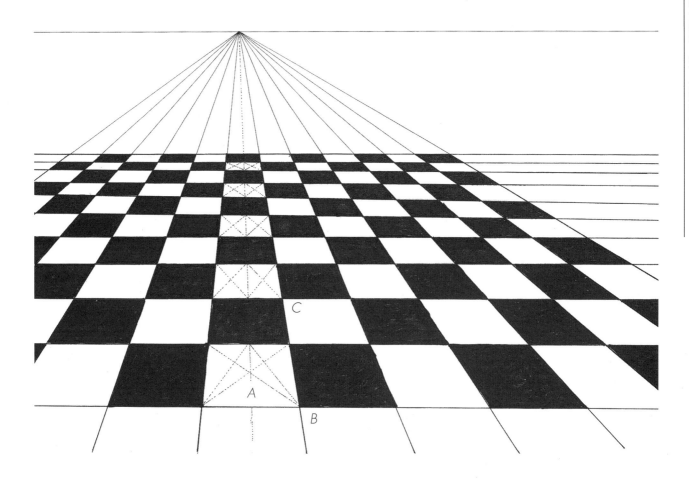

More about chequerboard

The sort of chequerboard floor or pavement you have been learning about has often been used in paintings to help the illusion of depth. In early Renaissance pictures it was thought to be amazingly realistic. These days we are a bit more used to seeing such devices and so other effects have been brought into play to help us accept the illusion of dimensionality. However, do experiment with the chequerboard ground – it's very simple and very effective. And don't forget to incorporate the lessons you've learnt about the relationship of figure to the horizon or eyeline: if you place figures or objects on it, make sure that as they recede into the picture – standing on squares that are further back – they diminish in size consistent with your eye level (see pages 54–55).

ADDING TO YOUR VOCABULARY

To round off this section, I would like to emphasize how invaluable it is to build up a rich vocabulary. A practising artist must be ready to draw at any time. If you want to excel at drawing, sketching has to become a discipline. Get into the habit of seeing things with a view to drawing them. This means, of course, that you'll have to carry a sketchpad around with you, or something that you can jot your impressions in. You'll find yourself making sketches of unrepeatable one-offs that can't be posed, as I did with the sketches shown here.

A quick note, even if not very accurate, is all you need to make a worthwhile addition to your vocabulary of drawing. Often it is impossible to finish the sketch, but this doesn't matter. Some of the most evocative drawings any artist produces are quick, spontaneous sketches that capture the fleeting movement, attitude, angle of vision or view of a movement. They are often the drawings you return to again and again to use in compositions or to remind yourself of an atmosphere or place.

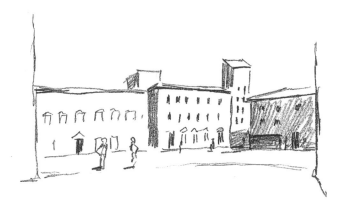

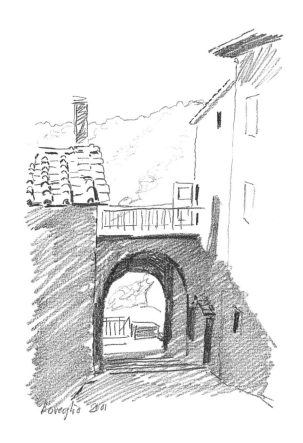

When drawing scenes with large areas of building, it is useful to simplify the areas of light and shade to make it more obvious how the light defines the solidity of the buildings. In both these examples a large area of shadow anchors the whole composition and gives it depth and strength.

In the first drawing we are aware that the open area with buildings around it is a square; in the second we are in no doubt that the very dark area is an arch through a solid building. In both examples the light and shade help to convince.

Don't forget your sketchbook

A pocket-sized book with hard covers and thinnish paper is generally the best for most quick sketches, being simple to use and forcing you to be economic with your lines, tones or colours. A clutch pencil or lightweight plastic propelling pencil with a fine lead is ideal; preferably carry more than one. A fine-line pigment liner is also very useful and teaches you to draw with confidence no matter how clumsy the drawing.

Continual practice makes an enormous difference to your drawing skill and helps you to experiment in ways to get effects down fast and effectively. If you're really serious you should have half a dozen sketchbooks of varying sizes and papers, but hard-backed ones are usually easier to use because they incorporate their own built-in drawing board. A large A2 or A3 sketchbook can be easily supported on the knees when sitting and give plenty of space to draw. Cover the pages with many drawings, rather than having one on each page, unless your drawing is so big that it leaves no room for others.

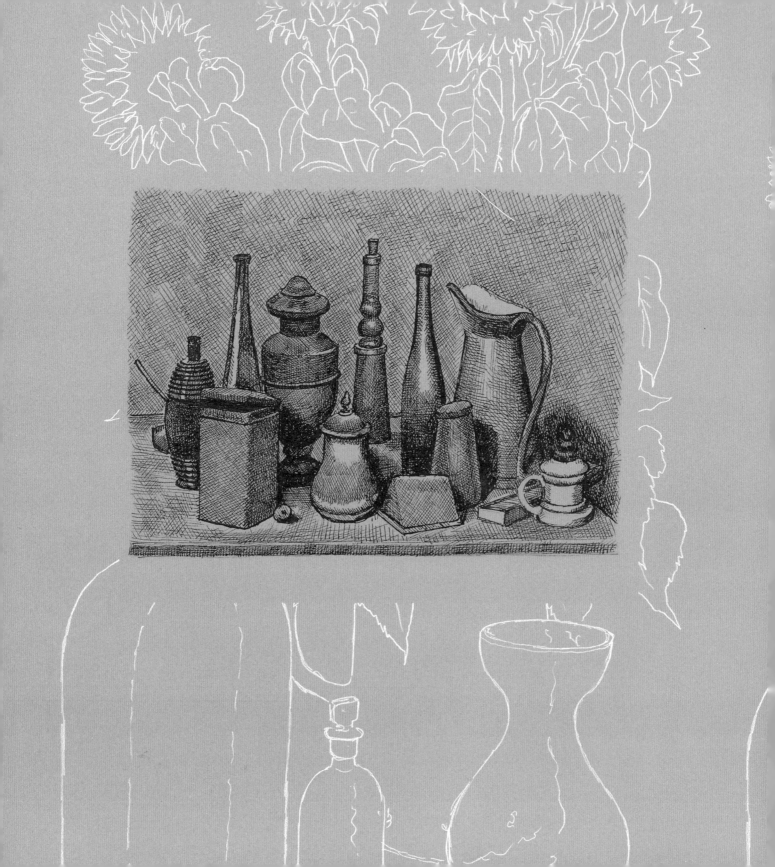

FORM AND SHAPE

In this section we break down the process of visual perception to its fundamentals. What the eye sees is shape, colour, light and shade, and not much else. However, the mind goes to work on the experience, relates it to other experiences and translates the shape and form into something we recognize, such as a man, woman, horse, dog, tree, house or whatever.

Shape is the outline visual impression we have of an object. Because we get used to seeing objects in certain positions we tend to see what we expect to see rather than what is actually there. In fact shape changes constantly, depending on our position in relation to it.

Form is the three-dimensional appearance of an object or body; in other words, the spatial area it inhabits. Form is difficult to draw because of the problems of representing three dimensions on a flat surface. To make our representations realistic, we have to find ways of expressing shapes in space.

This section is intended to help you use your eyes more experimentally, to look beyond your expectations and your normal process of recognition. Keeping this approach in mind when tackling specific subjects like still life and portraiture will mean your drawings are more likely to be successful, lending them depth and accomplishment.

ARCHITECTURAL FORMS

The brain has two sides; right and left. Science tells us that if we could activate the right side of the brain when we draw, our drawings would be more accurate, because it is this side which processes all our visual impressions. If this side was fully engaged when we drew, we would look at shapes as shapes and not draw what we expect the shape to be.

One way of tricking the brain is to hold an image upside down and then try to draw it. You will find your brain connecting with the image on a purely visual level: the left, or verbal, side of the brain connects with normal recognition but once this is broken the right side takes over.

I have tried this exercise with both adults and children and found it to be most effective. Children are particularly good at it and find it much easier to switch back and forth between the two sides. Adults always want to 'know', and so are constantly engaging the verbal side.

The series of exercises over the next few pages is designed to help you try to switch off that left side.

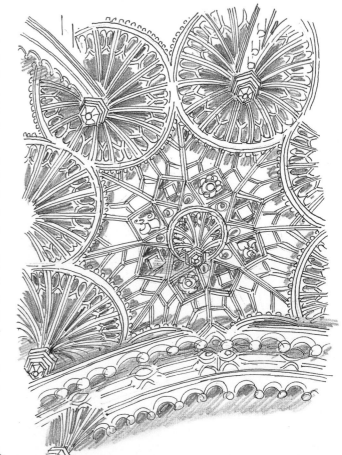

Gothic (above) and Islamic (left) vaulting share some similarities in terms of the shapes used in their creation, but you could not mistake one type for the other. Look at these two examples, noting their similarities and differences.

Although form tends to follow function, this does not mean it is straitjacketed by the relationship. Many variations are possible, and this is where choice comes into play. We compare images by being aware of the implications of a form. Our decision to use a form in a picture is based on an assessment of suitability.

Aesthetic and social requirements for living change over time and these can bring about great differences in 'look'. The medieval home (above) was functional for its time, but does not share the sharp, clean-cut lines of its modern counterpart.

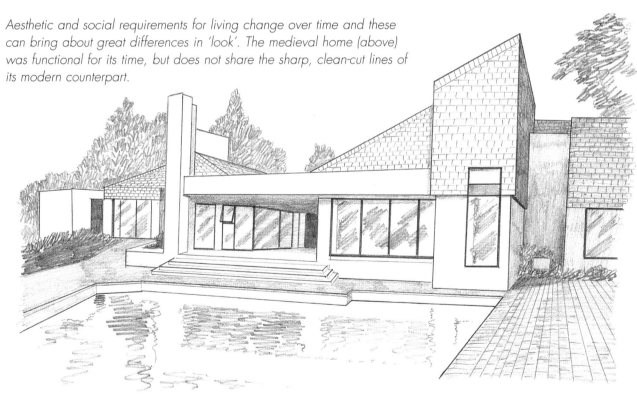

SHAPE RECOGNITION

Let's look at a few shapes in silhouette. What clues to identity are carried in these simple outlines? The American Mustang, the British Spitfire and the German Stuka are all Second World War low wing monoplane fighter aircraft. They are easy to tell apart and to identify because of the particular details evident in their main frames. Similarly, the Harrier jump-jet and Sea King helicopter shown on the facing page are not difficult to differentiate from other types of aircraft.

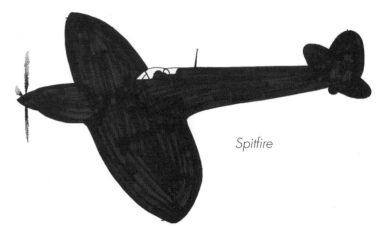

Spitfire

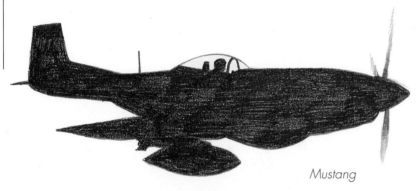

Mustang

All three of these fighter aircraft were produced about the same time. Each was intended to be the best of its type. The Mustang was the most effective.

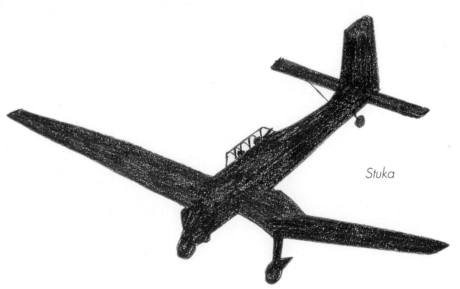

Stuka

Both of these types of aircaft take off vertically but possess different means of achieving it.

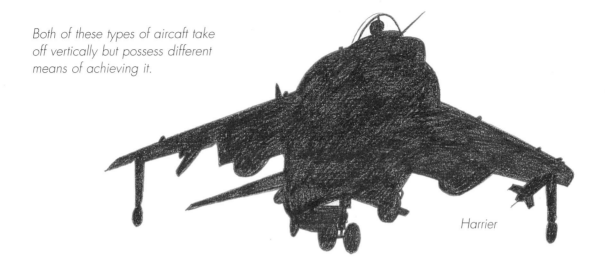

Harrier

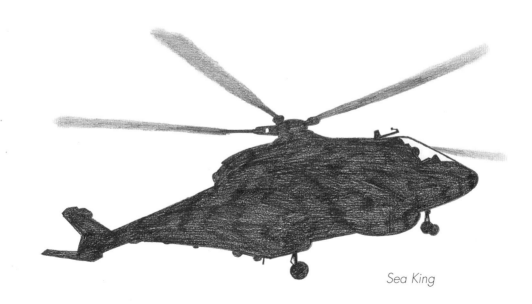

Sea King

Our ability to recognize shapes is learned in childhood as we become aware of the wider world. Our visual vocabulary grows according to the means at our disposal. All the silhouettes on this spread arouse memories of my childhood, and the hours I spent poring over them in my picture books.

If we are to draw well, we must have the ability to connect shapes and yet differentiate between them. If we are unable to do this, we will end up producing drawings that have as much character as the images on street signs.

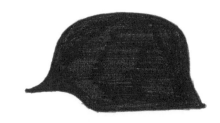

Second World War German Army helmet.

Both types of helmet provided protection for the head in battle but had rather different weaponry to contend with.

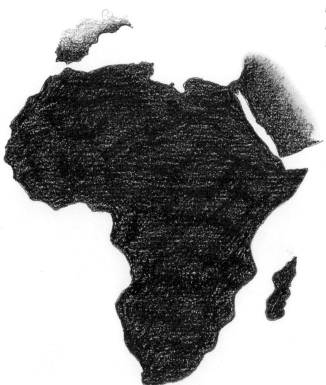

The continent of Africa as seen from a spacecraft. This is so familiar to us from maps that one is surprised by the accuracy of those early map makers, who did not have the benefit of cameras or spacecraft and yet gave us the correct shape.

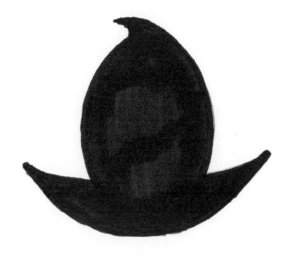

The characteristic shape of a 16th-century Spanish Morion helmet.

The Santa Maria,
Columbus's craft.

These two ships have similar functions but evolved in
different places with slightly different technologies.
The shape of each is characteristic, and you would
be unlikely to mistake one for the other.

A Chinese junk.

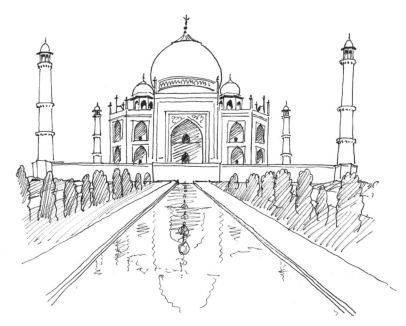

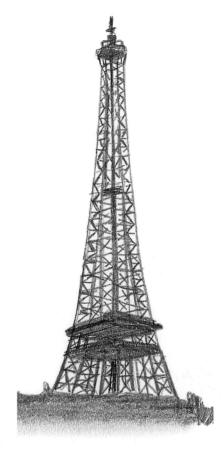

SYMBOLS AND ASSOCIATIONS

Some buildings become the signatures of places or legends, because of the association made with them. If we see a picture of the Eiffel Tower, we immediately think 'Paris'. When we see an image of the Taj Mahal, even a sketchy drawing such as the one shown, associations of India or the East come into our minds. Similarly, Cervantes' creation Don Quixote will forever be associated with Spanish windmills. There are many other examples of images which are indelibly associated with places, things or ideas. How many can you think of?

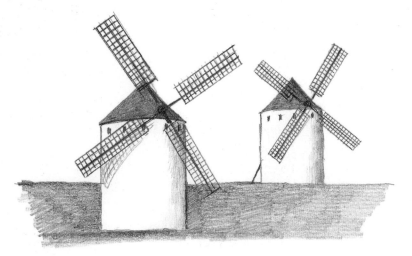

Instinctive recognition is an odd effect of partly seeing and partly expecting. When you are trying to draw the shape of something, it becomes clear that it has characteristics that help to define its role. Its shape enables it to do what it does.

The shape of the most aggressive predator in the ocean is very well-known to us from our experience of films and photographs. There is no mistaking its formidable shape, even in silhouette. How is it that the outline of a white swan on a dark background is so peaceful, while that black, shark shape is so full of sinister power? Because we know how these shapes affect the viewer and the associations they attach to them.

As artists we can use this knowledge to convey messages in our pictures. This isn't as easy as it sounds if we wish to make our picture work properly. It demands an awareness of shapes and their associations for viewers across broad and disparate areas of life.

Archetypal images of opposites: danger and serenity.

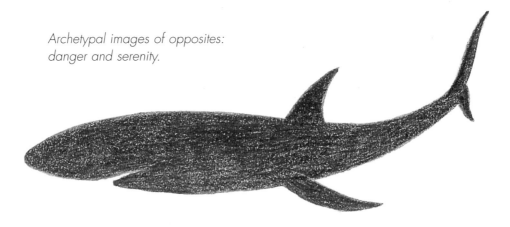

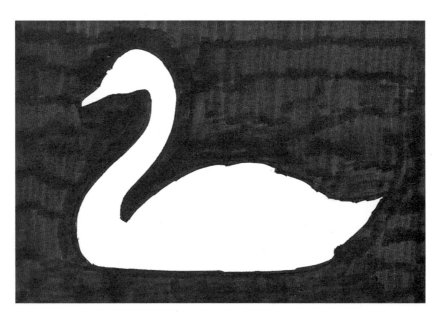

CREATING FORM

Our fairly sophisticated recognition system has to be persuaded to interpret shapes as three-dimensional form. One way of doing this is to produce an effect that will be read as form, although in reality this may only comprise an arrangement of lines and marks. Let's look at some examples.

A diagrammatic form is often given in atlases to represent the world. Why is it that this particular arrangement of lines inside a circle makes a fairly convincing version of a sphere with its latitude and longitude lines? We don't really think it is a sphere, but nevertheless it carries conviction as a diagram.

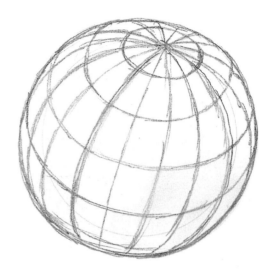

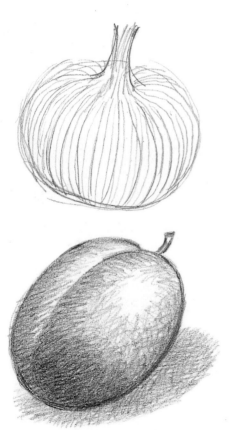

Let's go a stage further. In this drawing of a bleached out photograph of an onion the reduced striations or lines make the same point. We recognize this kind of pattern and realize that what we are looking at is intended to portray a spherical object which sprouts. We can 'see' an onion.

So is this a round fruit? No, of course not. But the drawn effect of light and shade is so familiar from our study of photographs and film that we recognize the rotund shape as a piece of fruit.

Visual conditioning
We have been educated to accept the representation of three-dimensional objects on a flat surface. This is not the case in all parts of the world. In some remote areas, for example, people cannot recognize three-dimensional objects they are familiar with when they are shown a photograph.

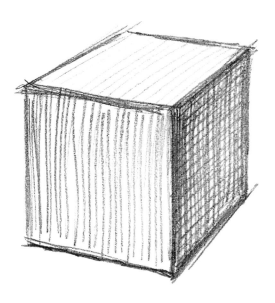

When we look at this hexagonal divided into parallelograms of light, dark and medium tones, we want to interpret it as a cube or block shape.

These rather scribbled lines and marks can be seen as a leaping cat-like creature and a human form engaged in sporting activity. Of course they are not really those things, but there are enough clues to prompt our ever-ready memory to remind us of forms we have seen. The mind quickly fills in the details even when a form is rudimentary.

APPROACHES TO FORM

So what methods can we use to portray form convincingly so that the onlooker sees a solidity that is in fact merely inferred? Well, on these pages we have the human figure – probably the most subtle, difficult but most satisfying subject for drawing – and some details of the eye. These show different ways of analyzing form. Every artist has to undertake his own investigations of form. They involve methods of looking as well as methods of drawing, and through practising them you educate the eye, hand and mind.

We can draw lines around the sections of a form to give us a sort of computerized vision of the dimensions of the shape – as in this recumbent figure.

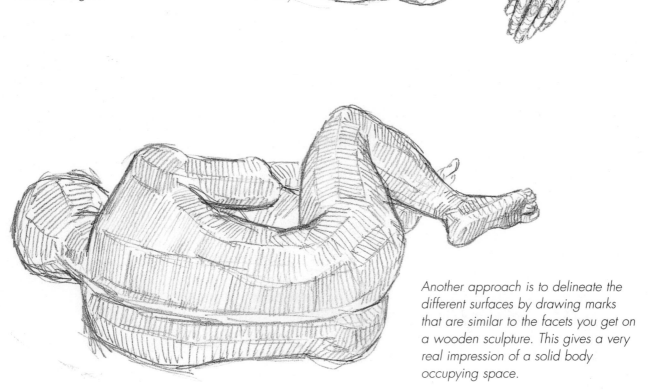

Another approach is to delineate the different surfaces by drawing marks that are similar to the facets you get on a wooden sculpture. This gives a very real impression of a solid body occupying space.

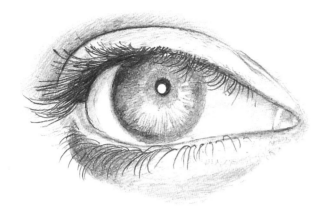

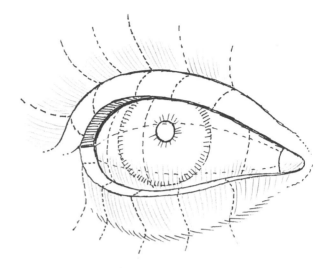

In a close-up like this, every detail of the form of the eye is shown. It is a very good exercise to take something as obvious as one of our own features, and view it closely in a mirror. Try this yourself: study the form of your eye and then try to draw its every wrinkle or hair or reflection. Note how the lids appear to curve around the smooth ball of the eye itself and how the eyelashes stick out across the lines of the eyelid and the eye.

This could be the under-drawing of the first picture: the diagrammatic form of the main part of the eye with indications of its curves and edges.

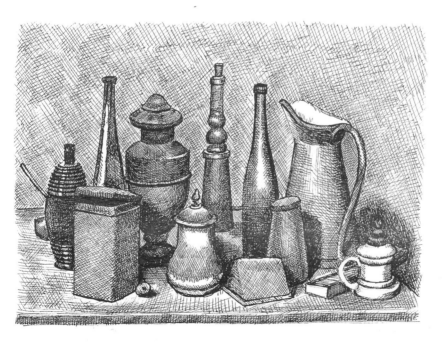

The Italian painter Giorgio Morandi had a particular and unusual vision of form. His etchings of still-life subjects have a dark solidity about them, as in this example. He achieved this effect by piling on fine lines of cross-hatching which create very substantial, dramatic darks and lights.

As we have already seen with the diagram of the globe on page 82, lines that are built into a diagram can give us all the visual clues we need to an object's shape. In the natural world these lines are often provided for us. Where they do not occur naturally, artists have invented them to help their exploration of form.

In the self-portrait and the view of the village of Estaque shown on this page, Cézanne has somehow managed to show form in space; that is, give an effect of solidity or depth by his rather sparse shading and markings of the shape. He has not shown the classical shade and light relationship, but he hasn't entirely left them out either.

In this self-portrait the area of darkest tone helps to give the impression of the important areas of form, especially around the eyes and nose. The large tonal areas down one side of the forehead and beard help to connect the main protuberances of the face with the generally rounded shape of the head. With great economy of drawing, Cézanne is able to convince us that we are seeing a three-dimensional head.

The economy evident in Cézanne's self-portrait is even more pronounced in the landscape below. Large areas of blank space are limited by faint markings showing the main blocks of buildings. A few heavier markings here and there emphasize the shadows or intensity of colour in the scene. This rather minimal way of denoting solid masses in space gives a very strong sense of the space between the buildings in the foreground and those further away. If you decide to show form in this way, be careful not to put in too many lines or heavier marks. Fewer marks seem to produce greater awareness of form in the viewer.

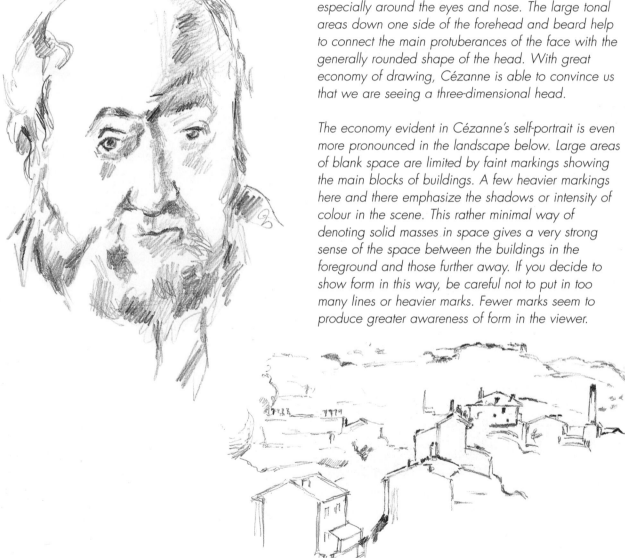

These shells are structured in such a way as to provide their own contour lines, the striations or growth lines which indicate their natural evolution. Even without light and shade, the clearly seen lines proceeding around the form of the shell give us a good idea of how the shell is shaped. They offer a useful exercise in understanding shapes.

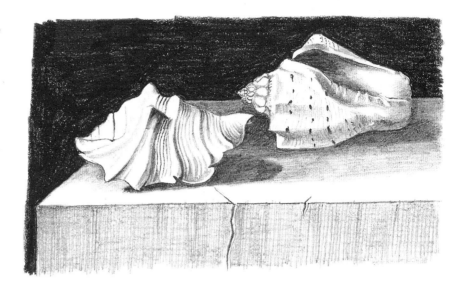

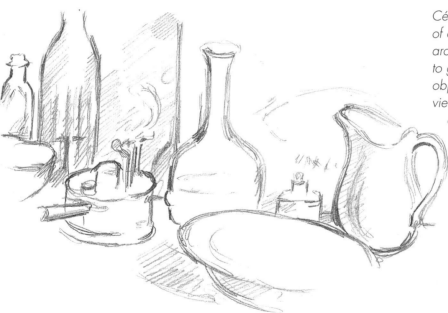

Cézanne tried to discover the form of objects by drawing multiple lines around their edges. He was trying to give multiple views of his objects, such as you get when you view something from many slightly different angles. In this example his lines suggest that you can actually see round the edges of the objects.

Cubism

The Cubists (artists such as Braque, Picasso, Léger and Ozenfant) took Cézanne's analysis one stage further by attempting to draw objects from contrasting viewpoints – from the side, front, above, below, and so on. In the process they had to fragment their images to be able to show these various approaches in one picture. This led to the typical cuboid sets of images for which they were named. These artists were successful in changing how we look at the world, although their methods are rarely employed now.

The most formidable task confronting any artist is how to draw the three-dimensional human form convincingly. There are many ways of doing this. Over the next couple of pages we consider three fairly obvious ones. (See pages 218–59 for more on figure drawing).

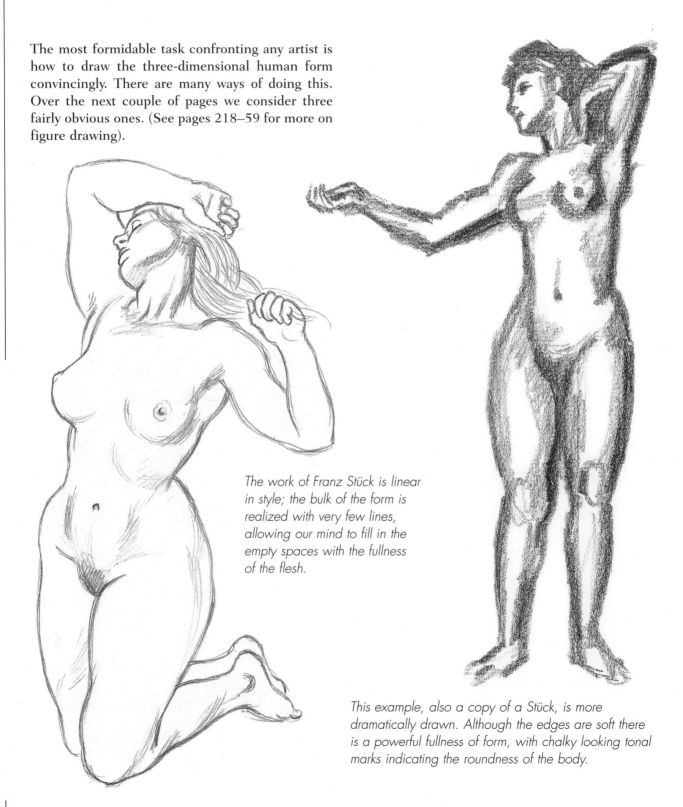

The work of Franz Stück is linear in style; the bulk of the form is realized with very few lines, allowing our mind to fill in the empty spaces with the fullness of the flesh.

This example, also a copy of a Stück, is more dramatically drawn. Although the edges are soft there is a powerful fullness of form, with chalky looking tonal marks indicating the roundness of the body.

Otto Greiner's approach to form is essentially that of the classical artist, as this copy shows, with the light and shade carefully and sensitively handled. It's an effective if slow and painstaking method, but well worth mastering.

Notice how some lines on the drawing follow the contours around the form and sometimes go across it.

Lines around the contours.

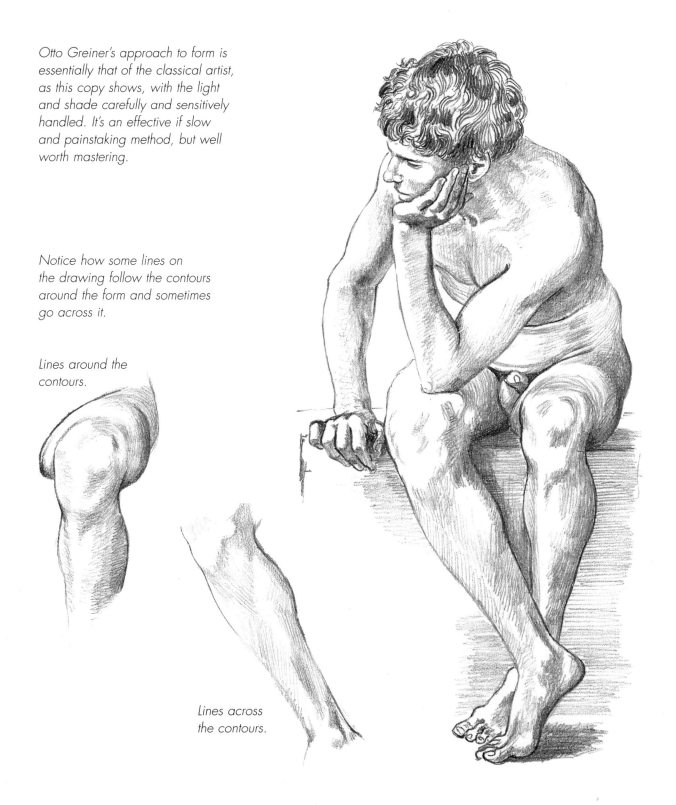

Lines across the contours.

These copies of two heads by David Hockney show varied methods of using tone to show form. As a consequence of the different treatment, the effect he has achieved in each drawing is very marked.

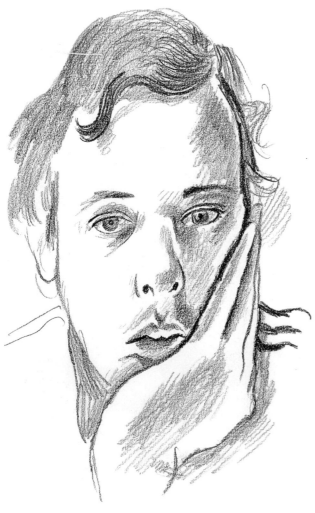

The handling in the drawing on the left is comparatively sensitive, elegant and very economical, with just enough form showing to enable the viewer to make sense of the shape.

This self-portrait (right) is a much more rugged affair. The dominant tonal area gives us a very generalized feel of the shape of the head, thereby sacrificing individual characteristics to achieve a more dimensional effect.

Whereas even on the craggiest face all the surfaces move smoothly into each other, on a building each surface is distinct from the next. Most buildings are rectilinear, cuboid or cylindical and do not have ambiguous curves. The shapes tend to be much simpler than those found in natural form. As a consequence it is much easier to show mass.

Here we have two examples of drawings in which the aim is to communicate something of the materiality and form of the buildings.

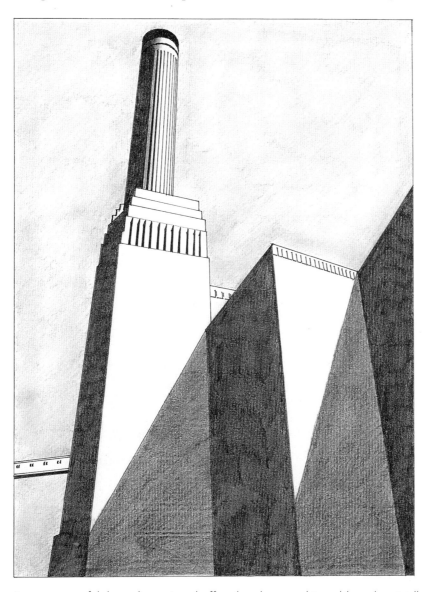

This drawing captures the elegant balancing forms of classical architecture as practised by Christopher Wren, with spaces through the form and much articulation of the surfaces to create a lightness in the stone structure as well as visual interest.

A very powerful three-dimensional effect has been achieved here by vividly portraying the massive simplicity of the building's design with sharply drawn shadows and large light areas.

UNIVERSALS IN FORM

Both Ewan Uglow and Geoffrey Elliott produce figures that represent universals in form. Uglow's drawings cannot be said to represent unique, identifiable persons, and Elliott is obviously more interested in the general forms inhabiting the landscape than trying to reproduce individuals. Both approaches teach us that to draw well you don't have to produce an intimate portrait. Good drawing can be purely an expression of aesthetics and an experience of form.

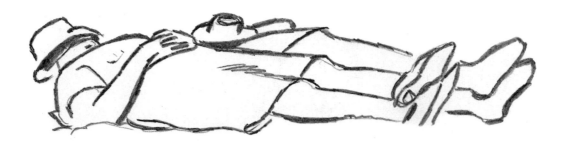

These reclining figures are from Geoffrey Elliott's sketchbook of drawings of people on a beach in Sussex. Like Uglow's figures, they are universal in form, but personal qualities emerge despite the absence of obvious emotional expression or movement.

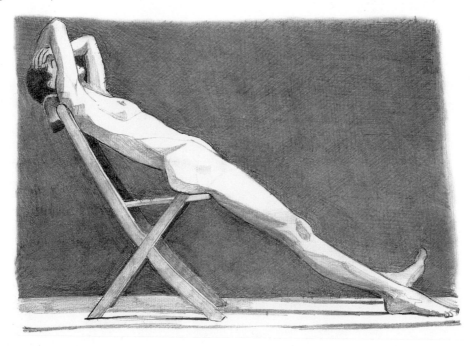

Euan Uglow's masterly way of producing a figure is extremely accurate but time-consuming; he has been known to spend years on just one painting. Uglow built up this nude figure from hundreds of painstakingly measured marks on canvas or paper to produce an effect of monumentality.

EXERCISES IN SIMPLIFYING FORM

An object's real shape can be investigated by drawing it from many different angles. For this exercise, we look at a boot, but it could be any object of your choosing. A model can be used for the same exercise. Try drawing him or her from different viewpoints, sometimes standing, sometimes sitting, etc. You will find this detailed investigation into shape very worthwhile.

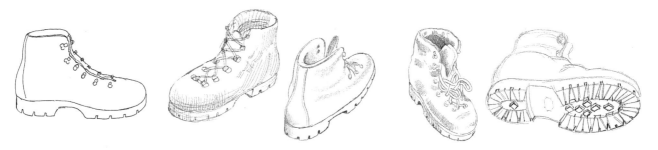

To begin, select an angle from which the object is clearly identifiable. When you have done this, change its position, and continue changing it until you have seen and drawn the object from many different angles

– from above, below, on its side, from the front, the back. Continue until you feel that you know how the shape works.

With a still figure it is a good idea to reduce it to its simplest geometric shapes. For example, if the figure is seated on a chair the arrangement could be seen as a rectangular block with a tall tower-like part projecting above. Alternatively, a person sitting with knees up to their chin and arms around their legs produces a wedge-like shape.

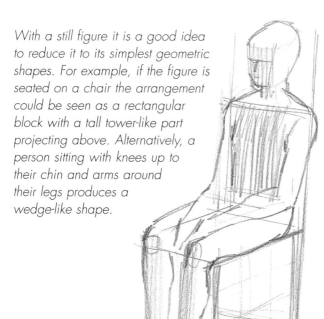

Such simplification can greatly assist the business of getting the proportions and the position of the figure correct. Once you have drawn the simple solid geometrical shape, you can draw into it knowing that this is your ground plan.

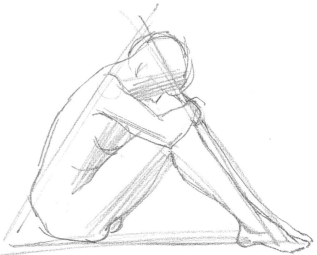

ELEMENTAL SHAPES

The elemental shapes of the natural world (looked at in depth on pages 146–83) are as expressive as they are defining, and they can be difficult to master. Whatever you do, don't retreat from the problems thrown up by your attempts. All are resolvable if you put in a bit of effort.

A good way to start is by selecting various symbols of the elements and studying them closely.

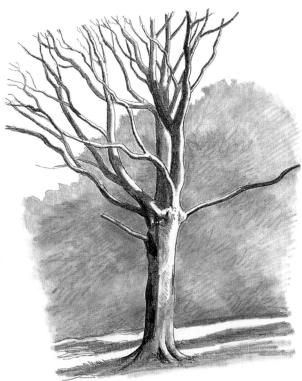

Earth can be shown by grains of soil or even a turf. Easier still is to choose a tree as your symbol, one whose branches can easily be seen. Winter is, of course, the best time to get a clear view of the architecture of deciduous varieties, which offer the most interesting shapes.

Water is an even harder form to understand than earth. First, try drawing some still water spilt onto a reflective surface, such as a mirror. Careful, detailed study will be necessary to really reveal its properties. Draw the outline of the shape first, look at the tonal qualities and then at the reflection in the water. This is not difficult as long as you draw everything you can see.

Moving water provides an even harder challenge. You will need to spend some time watching it and some time simplifying what you see. Eventually, though, you will begin to see the shapes it makes. Sometimes photographs can help in this respect. Don't be too subtle in your initial attempts.

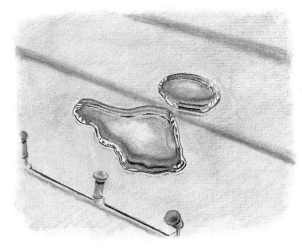

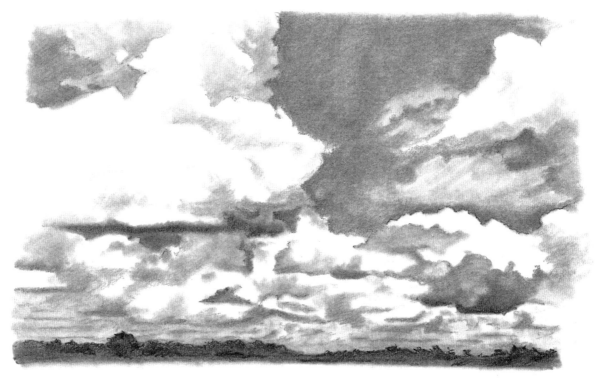

How do you draw what can't be seen? With air, the most obvious way is through the medium of clouds. Beautiful masses of water vapour hanging in the air, forming loose shapes, can describe air very effectively, especially when you see a whole procession of clouds stretching back to the horizon, as here. Try to draw a similar skyscape.

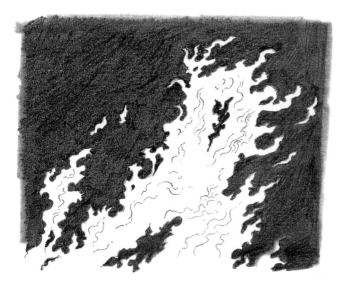

Fire is a really tricky subject. Start with a candle flame before you tackle the flickering flames of a big blaze. You can use photographs for reference, but unless you look closely at a real fire you won't get the feeling of movement or be aware of the variety of shapes.

The early Japanese and Chinese artists had very good ways of drawing flames.

INDIVIDUAL EXPRESSION: PICASSO

It's not just the physical forms in a drawing that can be emphasized by careful manipulation of mark making. Pablo Picasso was a master at communicating qualities that are not so obvious.

In these drawings copied from his sketchbooks, we see three different ways that marks can both correspond to form and put across more emotional messages than its mere existence in space. They show how an innovative artist can bend the rules to recreate form.

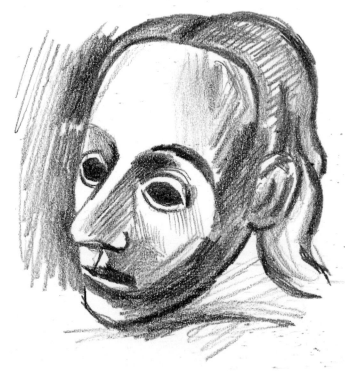

This formal head with an enigmatic expression has the appearance of an African carved wooden mask. The drawing derives its power from the way Picasso has handled the simple surface shapes. There is no attempt to produce the subtler gradations of form. Both flat and curved surfaces have simple modulations.

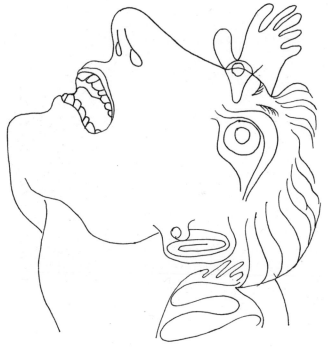

Here the outline form is an amazing example of a line doing a lot of work to show movement, emotion and spatial dimension. The particular distortions of the forms convey a feeling of substance in a vivid almost rubbery way. The outline is not formal but wiry and energetic and gives a strong impression of drama and emotion.

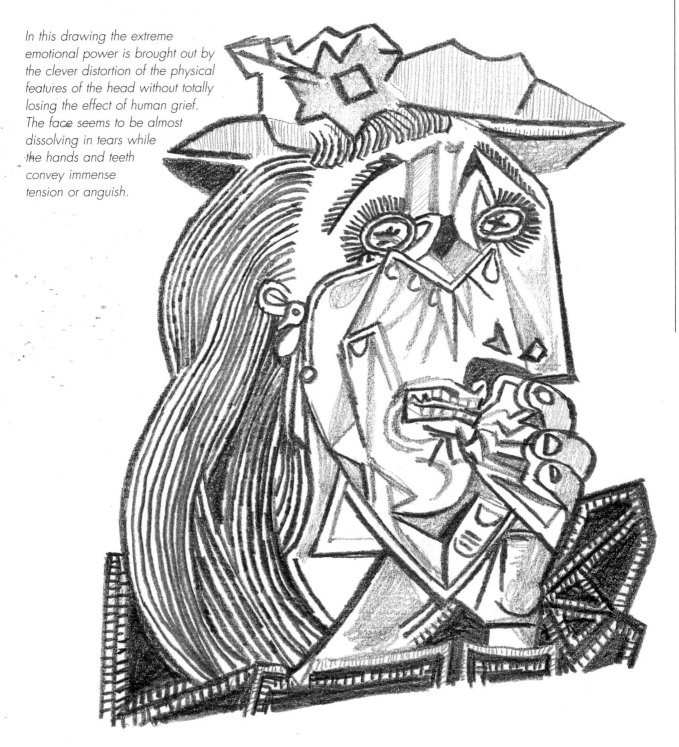

In this drawing the extreme emotional power is brought out by the clever distortion of the physical features of the head without totally losing the effect of human grief. The face seems to be almost dissolving in tears while the hands and teeth convey immense tension or anguish.

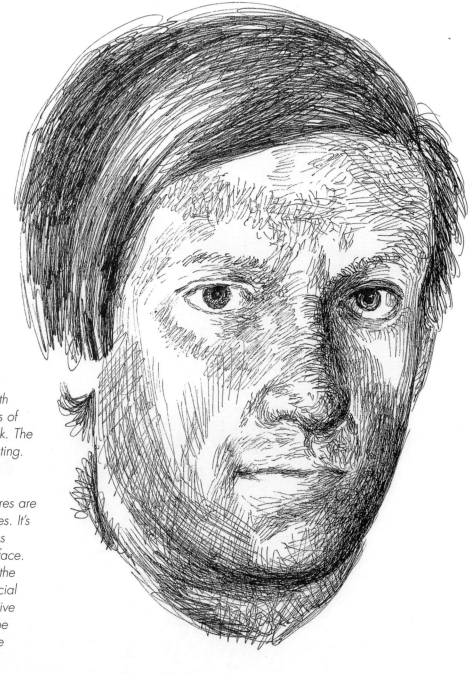

Multiple lines of varying length seem to describe the contours of this powerful self-portrait in ink. The technique used is very interesting. Instead of being built up with successive layers of smooth, controlled hatching, the features are drawn with hook-like wiry lines. It's almost as though the artist has drawn directly onto his own face. Each mark helps to describe the curve of the surface of the facial features. The method is effective because he has not tried to be economical with his lines. The scribbly-looking marks give a coarse texture, the effect of which is to increase the feeling of substantiality.

Here Picasso's style is fairly formal but the scratchy, blotty ink technique seems the result of quick drawing of a rather poised subject with little movement in the head itself. The form is realized extremely economically by the splatter of marks, which give a generalized feeling of solidity without any detail. The artist's approach produces a rather statuesque effect.

This image is distorted by its emotional intensity but reads very well as a convincing, solid face and head. Picasso sacrificed accuracy of shape for intensity of feeling and expression. Despite this, the head doesn't look unreal and is a powerful portrayal of emotions in a human face.

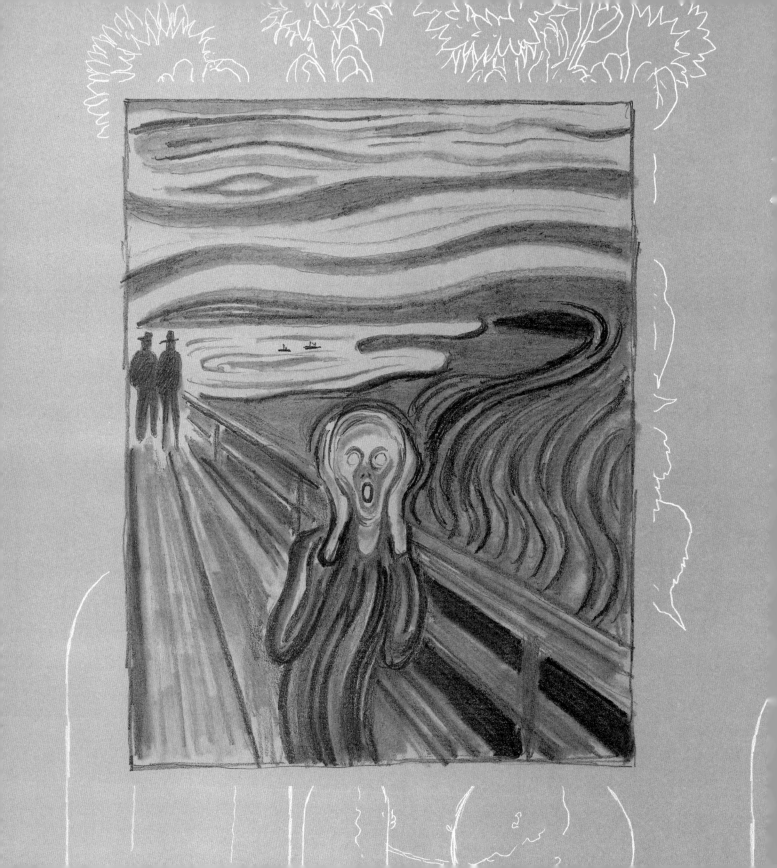

ASSESSING WHAT WORKS

When we embark on designing and drawing a composition, we instinctively look for the best way to express our experience. If we are drawing directly from nature, we may arrange our subject or our own position in order to get the best possible view. We may have to alter the lighting with artificial means or move to a place where the light is more conducive to the effect we wish to produce. The object we choose initially for a still life may not be quite right and we may take some time selecting the right one, polishing it, putting it in different positions and organizing the shapes to get the best possible arrangement.

A landscape obviously can't be moved around but most artists adjust parts of it to suit their composition. If a tree is in the 'wrong' place it can be left out of the picture or moved around on the canvas without too much difficulty.

When it comes to portraits, apart from getting the best light, background and profile, you can also look at clothes, hairstyle and accessories. The decision to draw just the head, head and shoulders, half length or full length also affects the final result. Every picture needs careful consideration to bring out its full potential. Sometimes you'll need to change your approach at least once to get a drawing right.

EMPHASIS AND LOCATION

Over the next six pages we look at compositional methods over a range of genres from landscape to still life. The examples included are in different styles and in time extend from the Renaissance to the 20th century. All of them contain devices designed to draw you in and ensure you understand the point of the drawing. The diagrams are included to indicate the narrative flow and show you how the visual attention is attracted from one part of a picture to another.

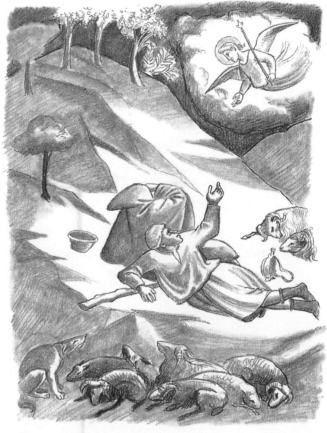

In this straightforward narrative (a copy of Taddeo Gaddi's mural of the Annunciation to the shepherds, in Santa Croce, Florence), we see the shepherds reacting to a bright light in the middle of the picture, on a

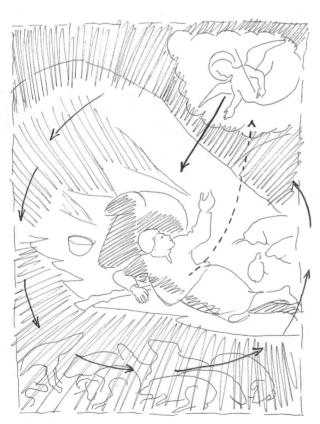

steeply sloping hill with some trees at the top. In the top right-hand corner there's an area of dark sky and an angel floating out of a brightly-lit cloud, pointing to the shepherds. Down at the bottom, there's a small flock of sheep with a dog looking on. The position of the angel swooping downwards and the shepherds angled across the centre of the picture give an unambiguous, almost strip-cartoon version of the story. The brightness of the angel tells us of his importance, and the position and actions of the shepherds mark them out as central characters. Everything else in the picture is just a frame to convince you that this is outdoors and a fitting context for the shepherds.

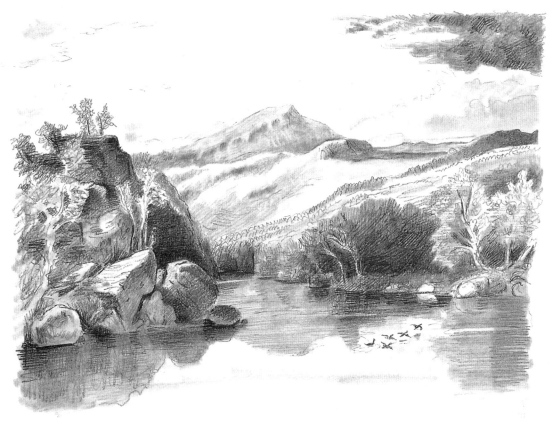

This is a copy of a landscape by the 19th-century American painter John Kensett. Rocky, wooded banks curve into the picture at about centre-stage. To help the viewer Kensett has included a group of wildfowl just about to take off from the water. The viewer's attention is immediately grabbed by this movement, and by the detail of the foreground rocks. The inward curve of the water pulls your eyes to the distant mountain peak, rearing up above the surrounding hills. Kensett uses these devices to get us to look at the whole landscape.

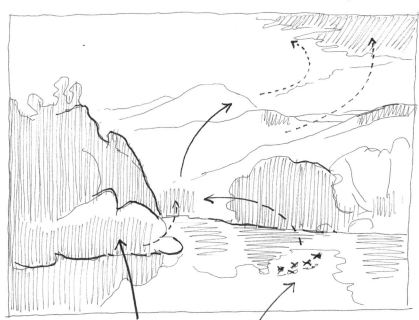

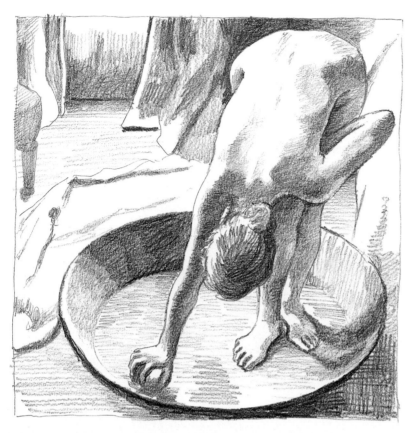

The view taken by Degas here is quite extraordinary. We see the upper part of the girl, upside-down as she bends to pick up a sponge. The tub acts as a large, stable base shape and the towel and chair on the floor lead us to the window indicated in the background. Just over half the picture is taken up with this unusual view of quite a simple action and gives an interesting dynamic to the composition. It looks almost as if we have caught sight of this intimate scene through an open door. We are close, but somehow detached from the activity, which helps to give the picture a statuesque quality.

Degas has found a very effective way of creating interest just by the arrangement on the canvas. Ordinary, but extra-ordinary.

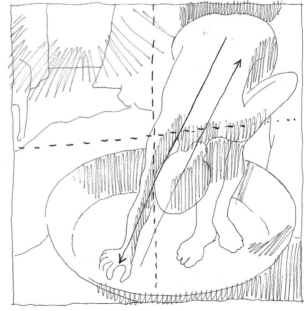

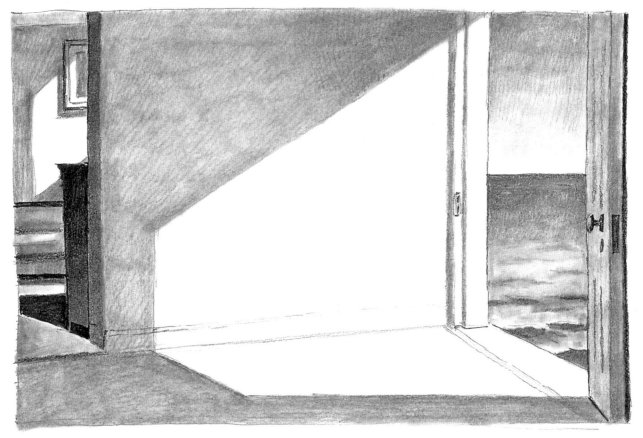

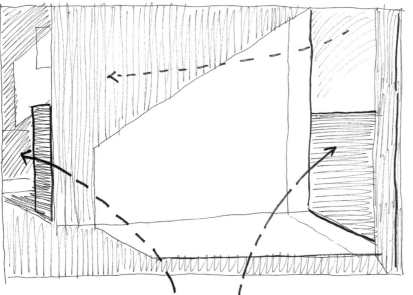

Like Degas, the American painter Edward Hopper was keen to depict everyday life as he saw it. In this picture, there is no dramatic situation, and not one figure, although the open door suggests that someone may be nearby. The composition is very still, despite the waves on the near surface of the sea glimpsed through the door. It seems we are looking at a depiction of a timeless summer's day – bright, still, and balanced by the shadow and the light. The composition is peaceful and oddly mysterious at the same time.

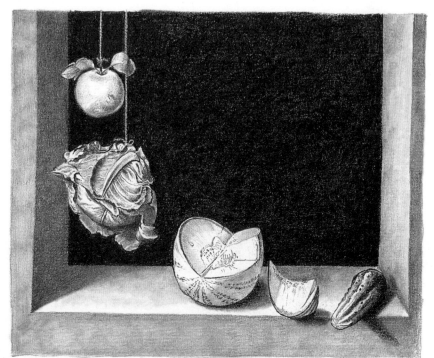

The Spaniard Juan Sánchez Cotán found an effective, dramatic way to arrange and light quite ordinary objects in this still life. The dark background, the dangling fruit and cabbage, the cut melon and aubergine on the edge of the ledge produce an almost musical sweep of shapes, all highlighted dramatically. Would Cotán have seen fruit and vegetables arranged like this in late-16th or early-17th century Spain, or did he create this design himself specifically for his painting? Either way, the arrangement is very effective and injects drama into the mundane.

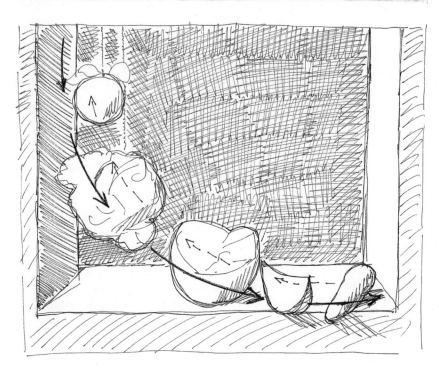

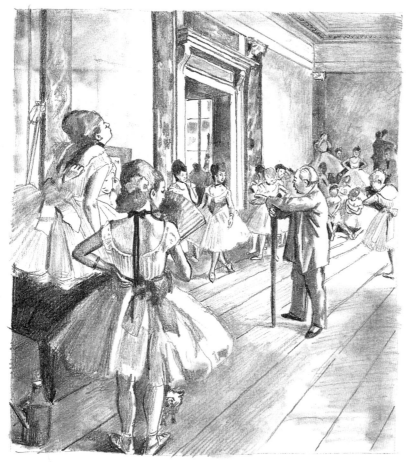

We return to Degas to finish this section. We are in a 19th-century dance studio, with a master continuing to instruct his pupils as they rest. All the attention is on the master with his stick, which he uses to beat out the rhythm. The perspective takes you towards him. The way the girls are arranged further underlines his importance. The beautiful casual grouping of the frothy dancers, starting with the nearest and swinging around the edge of the room to the other side, neatly frames the master's figure. He holds the stage.

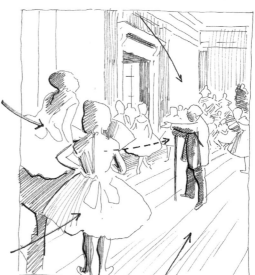

SYMBOLS AND ASSOCIATIONS

The face is the most obvious barometer of human feeling. However, it is possible to show moods or emotions in other ways – the position or movement of a body can be powerful indicators, for example – and not just rely on the obvious. An even more interesting approach is to let nature be a mirror, and transfer human emotions onto natural features. Consider the examples you will see over the following pages.

The head of Michelangelo's 'David' in Florence symbolizes the defiance of that city towards the hostile autocracies by which it was surrounded. A small but rich and inventive state, Florence was a free republic whose citizens and guilds had a voice in government. Michelangelo's statue of the shepherd boy who kills the giant warrior Goliath, is a powerful symbol of the independence of that city and its determination to protect its status.

A breaking wave used as a metaphor for exhilaration is not new. In this example the impact might have been greater and the feeling of exhilaration emphasized if there was a figure of a surfer under the wave.

A beautiful still lake with reflections and calm skies seen in morning or evening light, gives the feeling of serenity, especially with the small native boat being propelled smoothly, without haste, across the surface of the water.

This image symbolizes serenity partly by situation and partly by technique. The artist has made efforts to excise any disturbances from the picture.

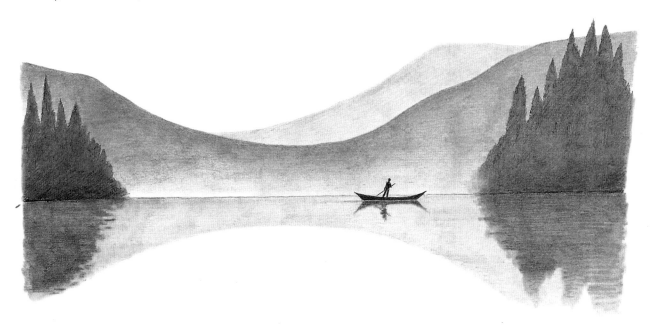

EXTREMES OF EXPRESSIVITY

Here we look at three very different ways of being expressive. The face as a measure of emotional expression is an obvious way to show the mood of a picture by association, but as you will see from these drawings, there are faces and faces. The galloping horse and jockey is a more abstract example of how to produce a visceral response.

Satisfaction

Despair

Happiness

Intensity

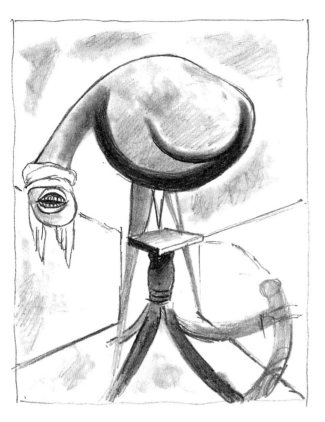

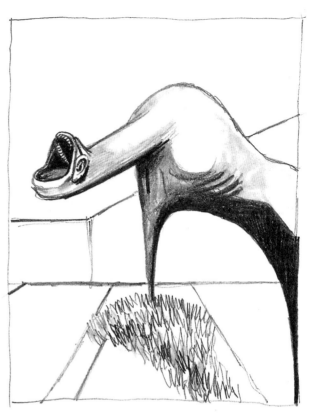

Francis Bacon's figures at the base of his 'Three Studies for a Crucifixion' seem to represent a raw, blind fury or perhaps even revenge. Bacon himself identified the figures as representations of the Furies who, in classical mythology, torment evil-doers before and after death. Although not classical studies, they have the timeless quality that defines classical myth.

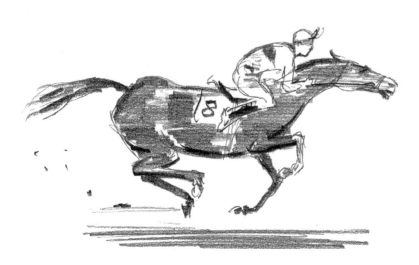

This image is an attempt to convey the idea of speed. The racehorse and jockey are glimpsed pounding down a course, dirt flying up behind. The idea is reinforced by how the image is drawn: the rider with stirrups short, behind raised out of the saddle, the horse's neck stretched, tail streaming, powerful legs bunched up to take the next stride. The economical use of lines also suggests that the image is moving past us at speed.

The gentle lyricism in Marc Chagall's drawings could not be further from the feeling of unease, almost revulsion, that we met in Francis Bacon's work. Chagall used a charming, playful way of drawing in much of his work. Most of his paintings have either lyrical or joyful associations in their design, colour or the technique he employed. He chose to portray the magical quality of life and touch our emotions in subtle ways.

Chagall's picture of the circus (opposite) has an almost childlike sense of fun, emphasized by the rather naive handling of the drawing. Everybody seems to be having a good time, even the clowns and acrobats, but without becoming disorderly or too exuberant.

The picture of a poet reclining above, produces an air of gentle melancholy. This is partly due to the rather odd position of the figure, which is lying along the base of the picture, and partly due to the dark trees and almost ghostly toy-like animal shapes grazing in the paddock.

Edvard Munch's 'The Scream' is an expressive image that is now read as a symbol of the angst and despair experienced by modern man. The area depicted in the painting was favoured by suicides, and was close to slaughterhouses and a lunatic asylum where Munch's sister was incarcerated. The artist wrote of the setting:

'the clouds were turning blood red. I sensed a scream passing through nature.'

The original painting has a blood red sunset in streaks of red and yellow, with dark blues and blacks in the large dark areas to the right. The swirling lines, skull-like head and open mouth produce a strong effect.

'The Kiss', by Viennese artist Gustav Klimt, shows the power of desire in a very graphic manner. The heavily ornamented clothing, while revealing very little of the flesh of the lovers, increases the tactile quality in the work. The firm grasp of the man's hands on the girl's face and head, her hands clinging to his neck and wrist, and her ecstatic expression tell us of the force and intensity of their sexual desire.

Expressing yourself

All of the images we have looked at in the last few pages try to convey to the viewer a feeling or idea that is not being expressed in words. Indeed, in many of the examples, it would be very difficult to express precisely the effect they have. It is not easy to get across a concept by visual means, but with a bit of practice it is possible. Try to produce such an image yourself, using the approaches and methods we've been looking at. When you've finished, show it to your friends and listen to their reactions. If your attempt is suggestive of the idea you wanted to convey, they will quickly be able to confirm it.

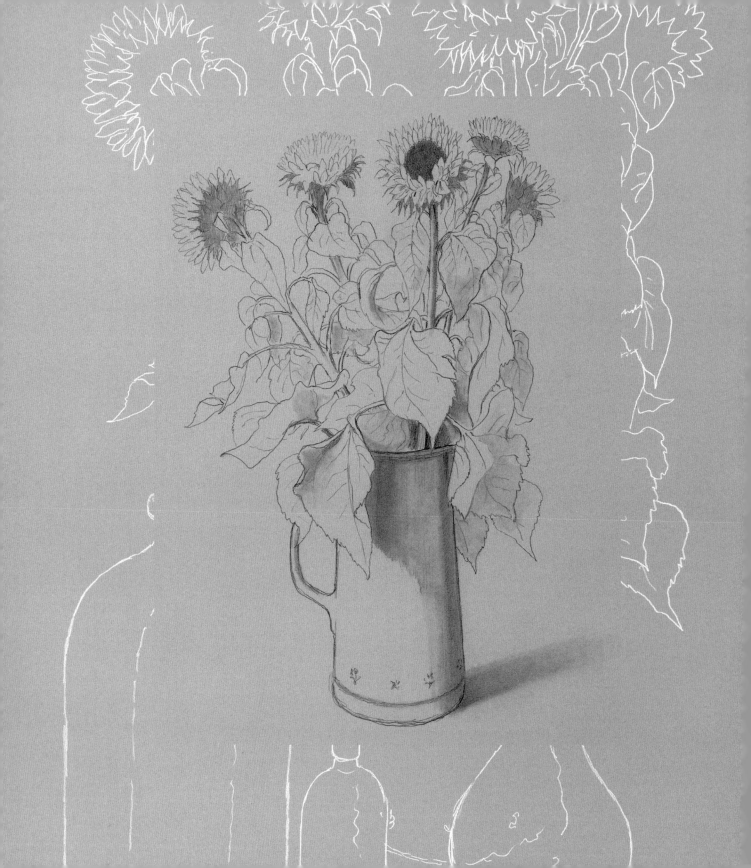

STILL LIFE DRAWING

Still life is a very well-practised area of drawing and painting and has been the route by which many artists have learnt about techniques and style. It is the most easily available of art's themes and doesn't require a model or a fine day. Unlike people, the objects of a still life don't move and they don't ask for rests. As a subject for novice artists, still life is ideal because any objects can be used and you can take your time in order to draw them correctly. The artist has only to look around his home to find all he needs for an enjoyable drawing session to keep his hand and eye in.

Drawing still life opens your eyes to the possibilities of quite ordinary items becoming part of a piece of art. Around any house there are simple everyday groups of objects that can be used to produce very interesting compositions. If you follow my suggestions, you will quickly learn how to choose objects and put them together in ways that exploit their shape, contrasting tones and sizes, and also the materials that they are made of. We deal first with drawing objects, building up from simple shapes to more complex, before moving on to tackle the drawing of still-life arrangements and contrasting materials.

SIMPLE OBJECTS

To begin the process of tackling still life drawing, I have chosen a couple of simple examples: a tumbler and a bottle. Glass objects are particularly appropriate at this stage because their transparency allows you to get a clear idea of their shape.

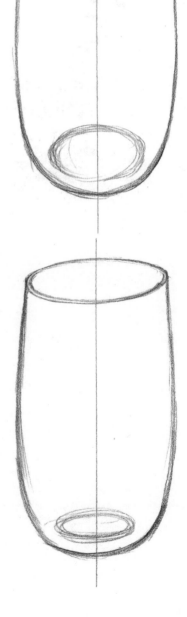

In pencil, carefully outline the shape. Draw the ellipses at the top and bottom as accurately as you can. Check them by drawing a ruled line vertically down the centre. Does the left side look like a mirror image of the right? If it doesn't, you need to try again or correct your first attempt. The example has curved sides and so it is very easy to spot when the curves don't match.

Now shift your position in relation to the glass so that you are looking at it from higher up. Draw the ellipses at top and bottom, then check them by drawing a line down the centre. You'll notice this time that the ellipses are almost circular.

Shift your position once more, this time so that your eye-level is lower. Seen from this angle the ellipses will be shallower. Draw them and then check your accuracy by drawing a line down the centre. If the left and right sides of your ellipses are mirror images, then your drawing is correct.

You have to use the same discipline when drawing other circular-based objects, such as bottles and bowls. Here we have two different types of bottle: a wine bottle and a beer bottle. With these I want you to start considering the proportions in the height and width of the objects. An awareness of relative proportions within the shape of an object is very important if your drawings are to be accurate.

After outlining their shapes, measure them carefully, as follows. First, draw a line down the centre of each bottle. Next mark the height of the body of the bottle and the neck, then the width of the body and the width of the neck. Note also the proportional difference between the width and the length. As you can see, in our examples the proportions differ a lot.

The more practice at measuring you allow yourself, the more adept you will become at drawing the proportions of objects accurately. In time you will be able to assess proportions by eye, without the need for measuring. To provide you with a bit more practice, try to draw the following objects, all of which are based on a circular shape although with slight variations and differing in depth.

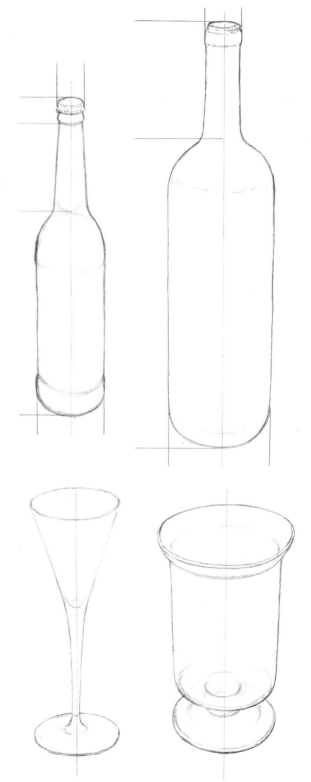

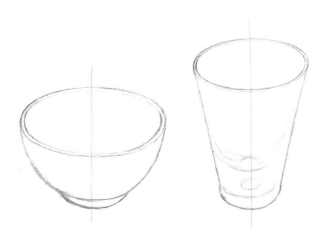

RECTANGULAR OBJECTS

Unlike some other types of drawing, you don't need to know a great deal about the perspective we looked at on pages 64–69 to be able to produce competent small-scale still lifes. You will, however, find it useful to have a basic grasp of the fundamentals when you come to tackle rectangular objects.

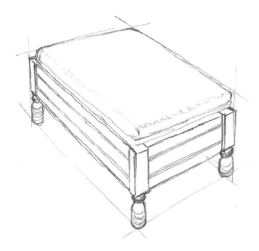

After studying the diagram, try to practise the basic principles of perspective by drawing a range of rectilinear objects. Don't be too ambitious. Begin with small pieces, such as books, cartons and small items of furniture.

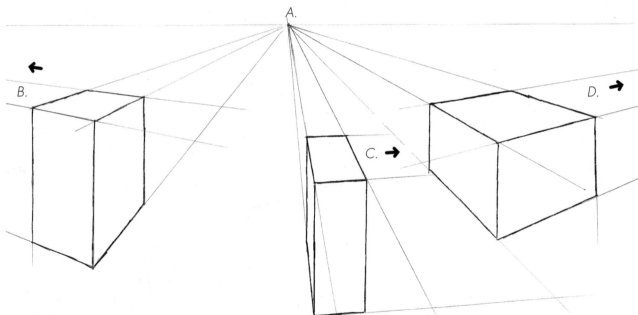

Perspective can be constructed very simply by using a couple of reference points: eye level (the horizontal line across the background) and (A.) one-point perspective lines (where all the lines converge at the same point).

The perspective lines relating to the other sides of the object (B. C. D.) would converge at a different point on the eye-level. For the sake of simplicity at this stage, they are shown as relatively horizontal.

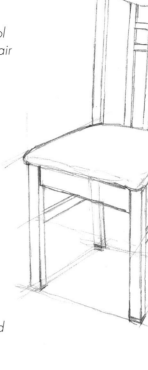

You will find that different objects share perspectival similarities – in my selection, compare the footstool with the pile of books, and the chair with the carton.

The wicker basket and plastic toy box offer slightly more complicated rectangles than the blanket box. With these examples, when you have got the perspective right, don't forget to complete your drawing by capturing the effect of the different materials. Part of the fun with drawing box-like shapes comes in working out the relative evenness of the tones needed to help convince the viewer of the solidity of the forms. In these three examples, use tone to differentiate the lightest side from the darkest, and don't forget to draw in the cast shadow.

SPHERICAL OBJECTS

You shouldn't find it difficult to practise drawing spherical objects. Start by looking in your fruit bowl, and then scanning your home generally for likely candidates. I did this and came up with an interesting assortment. You will notice that the term spherical covers a range of rounded shapes.

Although broadly similar, none of the examples is identical. You will also find variations on the theme of surface texture. Spend time on these exercises, concentrating on getting the shapes and the various textural characteristics right.

For our first exercise, I chose an apple, an orange and a plum. Begin by carefully drawing in the basic shape of each fruit, then mark out the main areas of tone.

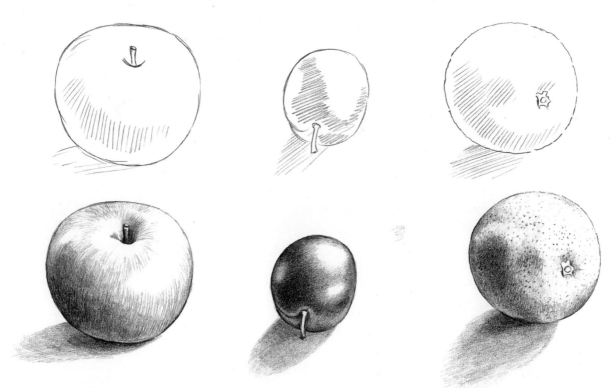

Take the lines of tone vertically round the shape of the apple, curving from top to bottom and radiating around the circumference. Gradually build up the tone in these areas. In all these examples don't forget to draw the cast shadows.

To capture the silky-smooth skin of a plum you need an even application of tone, and obvious highlights to denote the reflective quality of the surface.

The orange requires a stippled or dotted effect to imitate the crinkly nature of the peel; build this effect up over the basic patches of tone.

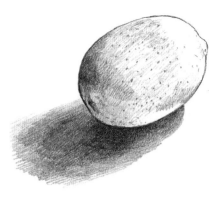

The surface of an egg, smooth but not shiny, presents a real test of expertise in even tonal shading.

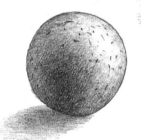

The texture of a lemon is similar to that of the orange, though its shape is longer.

The shading required for this round stone was similar to that used for the egg but with more pronounced pitting.

The perfect rounded form of this child's ball is sufficiently shiny to reflect the light from the window. Because the light is coming from behind, most of the surface of the object is in shadow; the highlights are evident across the top edge and to one side, where light is reflected in a couple of smaller areas. The spherical shape of the ball is accentuated by the pattern curving round the form.

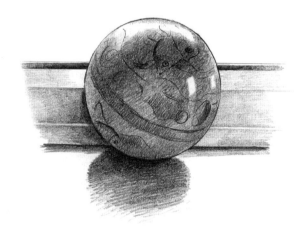

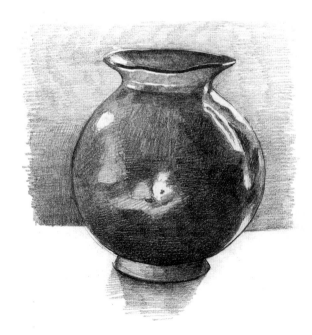

The texture of this pot is not uniform and so the strongly contrasting dark and bright tones are not immediately recognizable as reflections of the surrounding area. The reflections on the surface have a slightly wobbly look.

123

UNUSUAL SHAPES

When you have learnt to draw simple shapes effectively, the next step is to try your hand at more complicated versions of these shapes. In this next selection, the first set of examples have an extra part or parts jutting out from a main body, in the form of spouts, handles and knobs. Finally, we look at more subtle changes in shape across a range of objects.

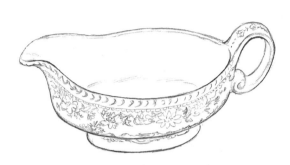

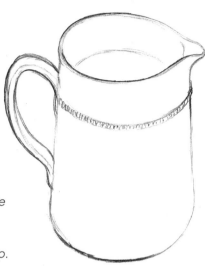

These two items provide some interesting contrasts in terms of shape. Note the delicate pattern around the lip of the sauce-boat which helpfully defines the shape of *the outside against the plain white surface of the inside. The main point about the jug is the simple spout breaking the curve of the lip.*

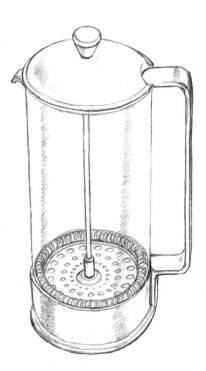

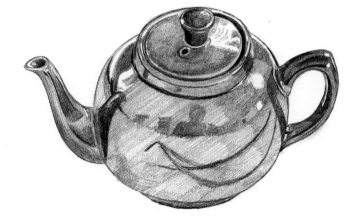

With our next pairing, of teapot and cafetière, the most obvious point of contrast – apart from the relative sizes and shapes of the spouts and handles – is the texture. The cafetière is very straightforward, requiring only that you capture its cylindrical shape and show its *transparency. The teapot is more interesting: a solid spherical shape with a dark shiny surface and myriad reflections. When you practise drawing this type of object ensure that the tones you put in reveal both its surface reflections and underlying structure.*

In the following examples there is a hint of continuous form rather than bits being added on.

The shape of this metal mixer tap is not complicated and should present few problems.

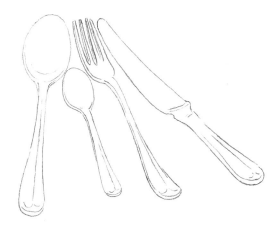

A set of cutlery presents quite elegant shapes. The principal difficulty here is rendering accurately the proportion between the business end and the handle of each item. I grouped them close together to help contrast the shapes and make them easier to get right.

Once you are happy with the accuracy of your outline drawings, you can enjoy the process of carefully putting in the tonal reflections. With any shiny metallic object the contrast between darks and lights will be very marked, so ensure that you capture this effect with your use of tone.

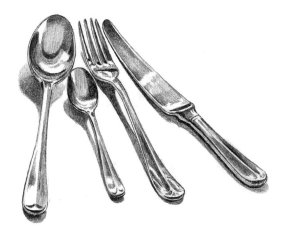

UNUSUAL SHAPES: GROUP PRACTICE

In perspective terms, one object by itself doesn't tell you as much as several grouped together. I have selected a few tools for this next exercise, arranging them so they fan out with either the working ends or the handles towards you. Sharply defined shapes such as these are relatively easy to draw, so long as you take care over getting the proportions right. Note carefully the angles at which they appear to be lying on the surface. Their proportions are not quite the same as they would be if they were held straight in front of the eye.

To begin this type of drawing you have to take some form of measurement to ensure that you don't make the length of the head or handle of each tool longer or shorter than it should be. When you are sure of the proportions and perspective, draw each tool in outline as accurately as you can, defining the edges clearly.

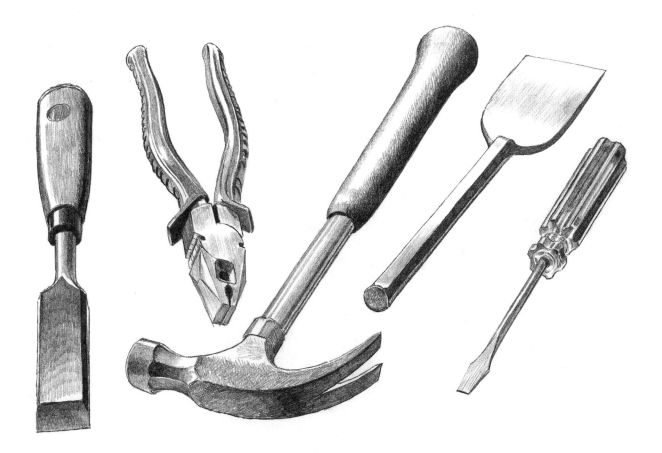

Clarity of definition is very important when drawing objects that have been designed to do a job. If your outline drawings are not accurate the addition of tone will not make them any better. Assuming that your outlines are spot-on, proceed to put in the tones, denoting differences between the various materials of which the tools are made: for example, the sharp contrasts between dark and light in metallic parts and the more subdued tones for parts made of rubber, plastic or wood.

UNUSUAL SHAPES: PRACTICE

The subject matter for still-life compositions is massive, so the more varied your experience of drawing different kinds of objects, in terms of shape, size and texture, the wider will be the possibilities open to you. As with any kind of drawing you have to work up a body of experience before you can get the best out of it.

This basketwork chair could easily be the centre of a largish still-life arrangement. You need to get the outline shape right first. Because it is a large object, you will find it easier to do this if you stand back and view it from a distance where you can take in the whole shape in one glance. Of particular interest is the difference in texture between the softness of the cushions and the tightly woven basketwork of the chair itself. Notice too the legs jutting out backwards, and the bare wooden floor with its clearly defined boards.

At first glance you may consider this chandelier and lamp a bit too simple. Both are relatively easy to draw. The interesting – and important – aspect of these two objects is the cast shadow, which in both cases is part of the artist's means of placing an object in situ.

This object is a bit bigger than the chair and much more complicated: a bicycle. Although it presents difficulties, there is not much in the way of solid forms to draw, thanks to its linear construction.

The lack of depth in the parts making up the shape means that your initial drawing will probably look very rudimentary. Don't worry about this; concentrate on trying to work out the proportion of, say, the ellipses of the wheels in relation to the structure of the frame.

You may require several attempts before you can produce a convincing bicycle shape. Do keep at it, because this whole exercise provides excellent training for the eye and hand. This object is a bit like drawing a skeleton for a human figure. The structural shape is everything, because this is what makes it work.

TEXTILES

The best way to understand the qualities of different textures is to look at a range of them. We'll begin by examining different kinds of textiles: viscose, silk, wool and cotton. Key with each example is the way the folds of cloth drape and wrinkle. You will also need to look carefully at the way the light and shade fall across the folds of the material, because these will tell you about the more subtle qualities of the surface texture.

This scarf or pashmina made of the synthetic material viscose is folded over upon itself in a casual but fairly neat package. The material is soft and smooth to the touch, but not silky or shiny; the folds drape gently without any harsh edges, such as you might find in starched cotton or linen. The tonal quality is fairly muted, with not much contrast between the very dark and very light areas; the greatest area of tone is a medium tone, in which there exists only slight variation.

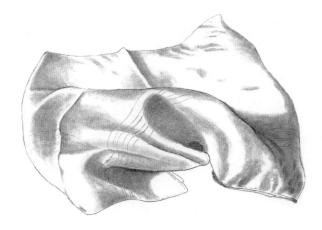

A silk handkerchief which, apart from a couple of ironed creases in it, shows several smooth folds and small undulations. The tonal qualities are more contrasting than in the first example – the bright areas ripple with small patches of tone to indicate the smaller undulations. We get a sense of the material's flimsiness from the hem and the pattern of stitched lines.

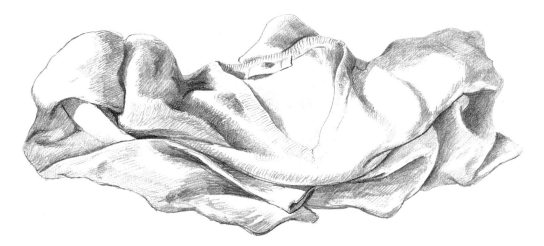

The folds in this woolly jumper are soft and large. There are no sharp creases to speak of. Where the two previous examples were smooth and light, here the texture is coarser and heavier. The neckline with its ribbed pattern helps to convince the eye of the kind of texture we are looking at.

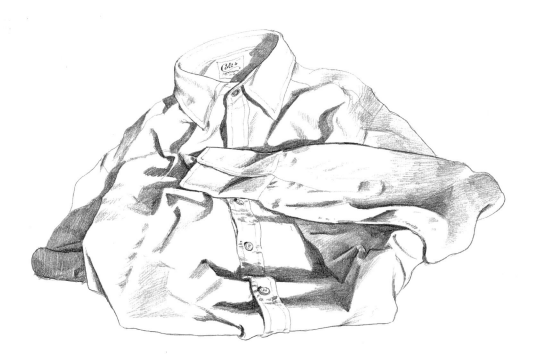

This well-tailored cotton shirt is cut to create a certain shape. The construction of the fabric produces a series of overlapping folds. The collar and the buttoned fly-front give some structure to the softly folded material.

EXERCISES WITH PAPER

Now we have a look at something completely different. In the days when still-life painting was taught in art schools the tutor would screw up a sheet of paper, throw it onto a table lit by a single source of light, and say, 'Draw that.' Confused by the challenge, many students were inclined to reject it. In fact, it is not as difficult as it looks. Part of the solution to the problem posed by this exercise is to think about what you are looking at. Soon you will realize that although you have to try to follow all the creases and facets, it really doesn't matter if you do not draw the shape precisely or miss out one or two creases. The point is to make your drawing look like crumpled paper, not necessarily achieve an exact copy.

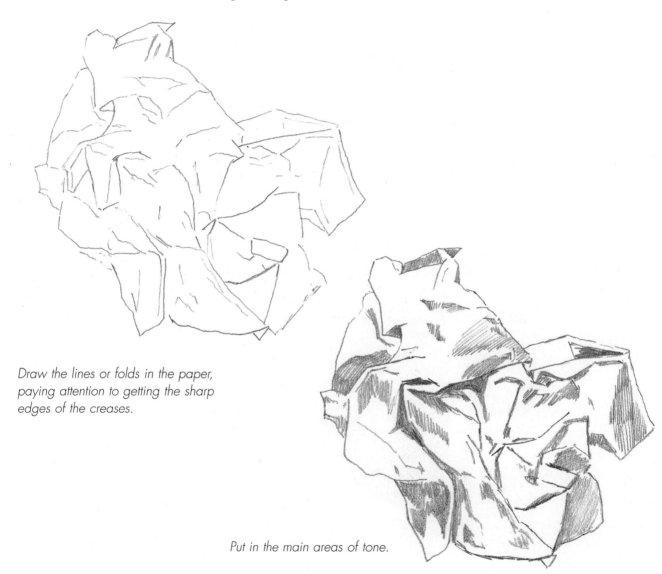

Draw the lines or folds in the paper, paying attention to getting the sharp edges of the creases.

Put in the main areas of tone.

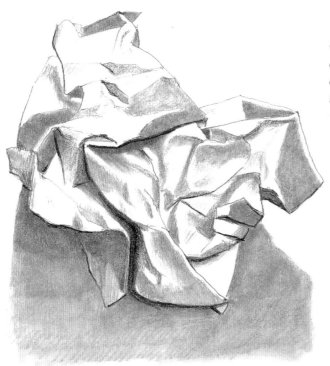

Once you have covered each tonal area, put in any deeper shadows, capturing the contrasts between these areas.

When you have completed the last exercise, try a variation on it. Crumple a piece of paper and then open it out again. Look at it and you will see that the effect is rather like a desert landscape. Before you try to draw it, position the paper so that you have light coming from one side; this will define the facets and creases quite clearly and help you.

Follow the three steps of the previous exercise, putting in the darkest shadows last.

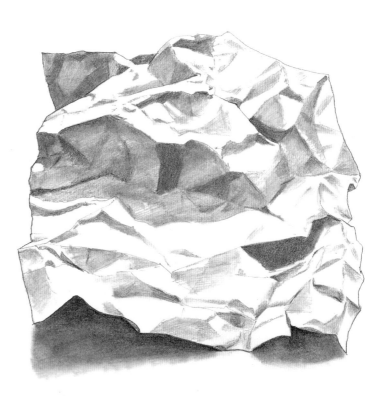

MAKING GROUPS

Once you reach this stage in your learning process, the actual drawing of individual objects becomes secondary to the business of arranging their multifarious shapes into interesting groups. Many approaches can be used, but if you are doing this for the first time it is advisable to start with the most simple and obvious.

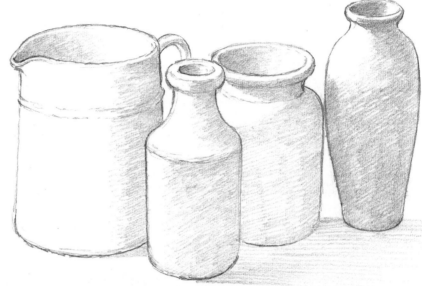

Put together three or four objects of the same type and roughly similar size. Place them close together. The effect, especially if you place them against a neutral background, is a harmonic arrangement of closely related shapes.

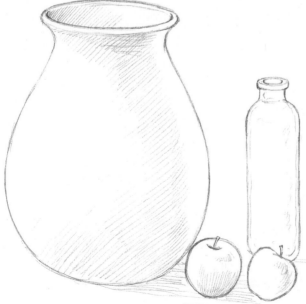

Now try the opposite. Find several objects that contrast radically in size and shape: something large and bulky, something small and neat, and something tall and slim. Contrast is the point of this combination, so when considering the background go for a contrast in tone.

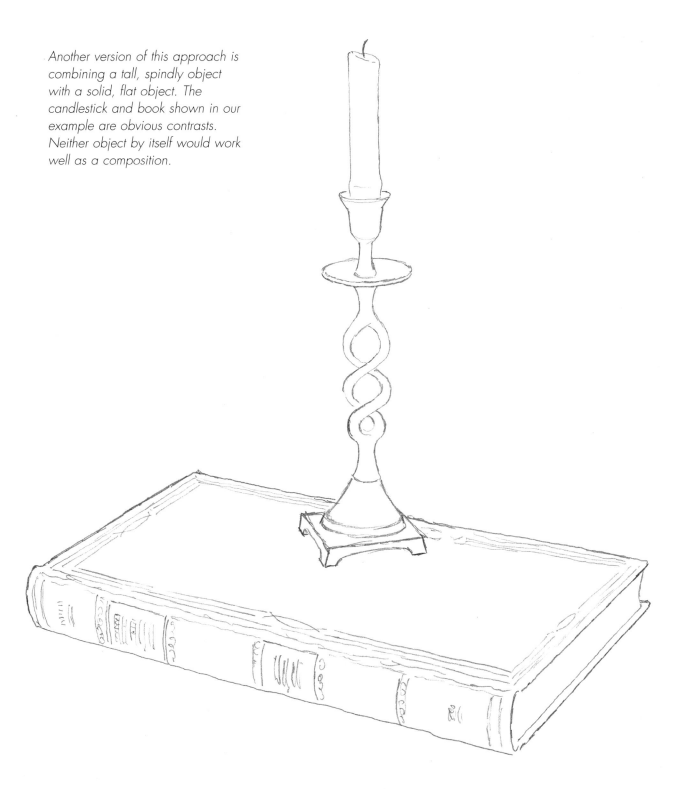

Another version of this approach is combining a tall, spindly object with a solid, flat object. The candlestick and book shown in our example are obvious contrasts. Neither object by itself would work well as a composition.

ENCOMPASSED GROUPS

Sometimes the area of the objects you are drawing can be enclosed by the outside edge of a larger object. Two classic examples are shown here: a large bowl of fruit and a vase of flowers.

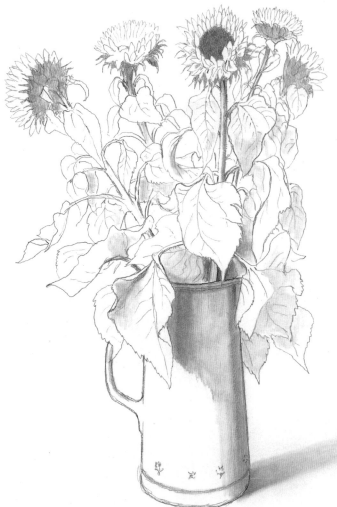

A large vase filled with flowers can be a very satisfying subject to draw. These sunflowers in a large jug make quite a lively picture: the rich heavy heads of the blooms contrast with the raggedy-edged leaves dangling down the stalks, and the simplicity of the jug provides a solid base.

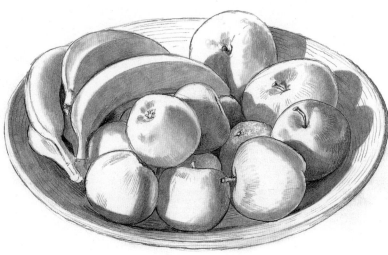

With this type of still life you get a variety of shapes held within the main frame provided by the bowl.

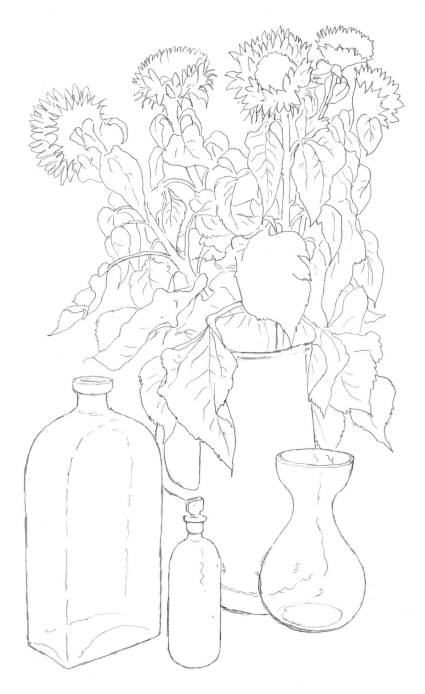

If you were to take the same jug of flowers seen in the previous arrangement and place it among other objects of not too complicated shape, you would get an altogether different composition and yet one that is just as lively. Particularly noteworthy is the relationship between the smooth rounded shapes in the lower half of the picture and the exuberant shapes of the flowers and leaves in the upper part of the composition.

MEASURING UP

One of your first concerns when you are combining objects for composition will be to note the width, height and depth of your arrangement, since these will define the format and therefore the character of the picture that you draw. The outlines shown below – all of which are after works by masters of still-life – provide typical examples of arrangements where different decisions have been made.

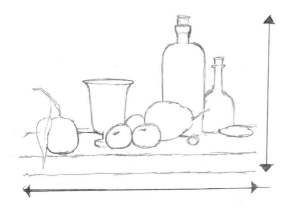

In our first example (after Chardin) the width is greater than the height and there is not much depth.

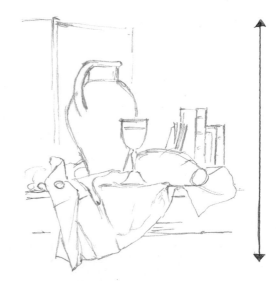

The height is the dominant factor in our second example (also after Chardin). The lack of depth gives the design a pronounced vertical thrust.

In his original, Francisco Zurburan put the emphasis solely on width. The objects, which divide neatly into three sub-groups, align themselves across our view horizontally, allowing us to take in one sub-group at a time or all three simultaneously.

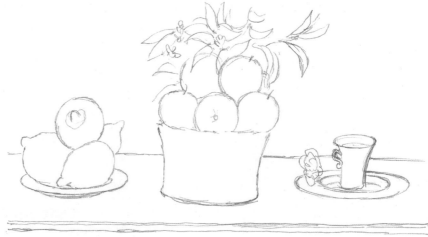

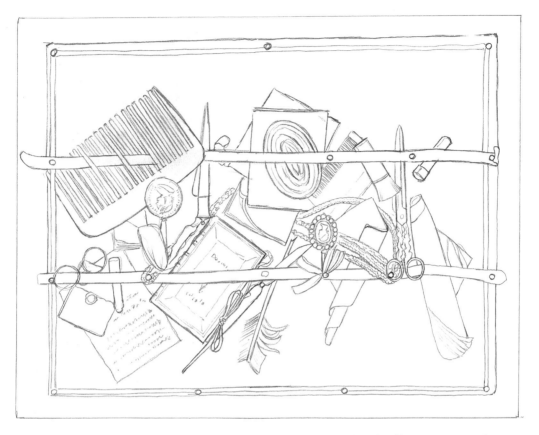

Now for a type of still life that was a great favourite in the 17th and 18th centuries. In this example after Samuel van Hoogstraten, almost all the depth in the picture has been sacrificed to achieve what is known as a 'trompe l'oeil' effect, meaning 'deception of the eye'. The idea was to fix quite flat objects to a pinboard, draw them as precisely as possible and hope to fool people into believing them to be real.

Depth is required to make this kind of arrangement work (after Osias Beert). Our eye is taken into the picture by the effect of the receding table top, the setting of one plate behind another and the way some of the objects gleam out of the background.

FRAMING

Every arrangement includes an area around the central group of objects. How much of this you include depends on the effect you are trying to achieve. Think back to the example by Juan Sánchez Cotán (see page 106), where a dark background frame was used for dramatic effect. Here, we consider three different 'framings', where varying amounts of space are allowed around the objects.

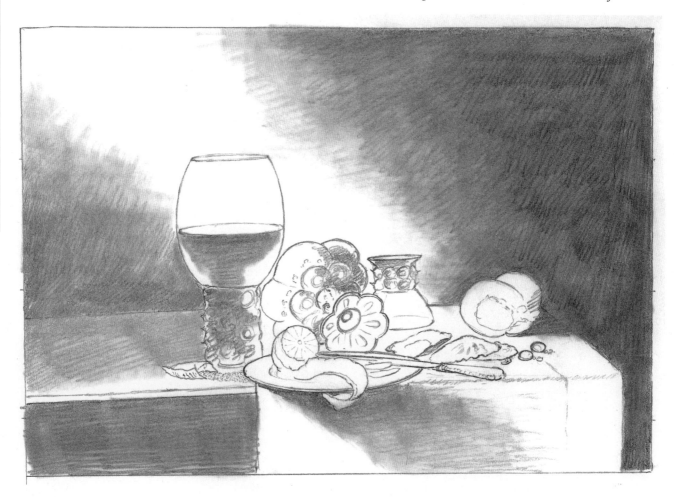

A large area of space above the main area, with some to the side and also below the level of the table. This treatment seems to put distance between the viewer and the subject matter.

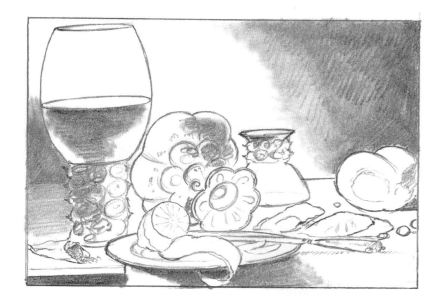

The composition is made to look crowded by cropping into the edges of the arrangement.

This is the framing actually chosen by the artist, Willem Claesz. The space allowed above and to the sides of the arrangement is just enough to give an uncluttered view and yet not so much that it gives a sense of the objects being left alienated in the middle of an empty space.

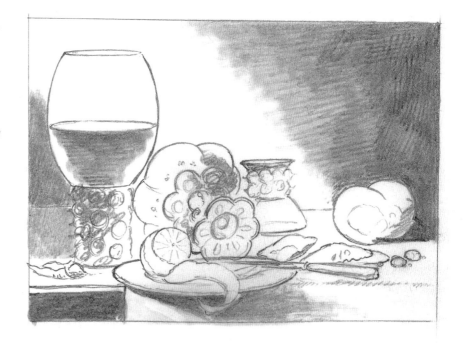

THE EFFECTS OF LIGHT

Many an art student has been put out by the discovery that the natural light falling on his still-life arrangement has changed while he has been drawing and that what he has ended up with is a mish-mash of effects. You need to be able to control the direction and intensity of the light source you are using until your drawing is finished. If this can't be done with a natural light source, use an artificial lighting set up.

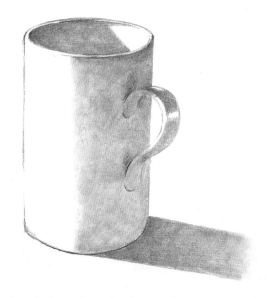

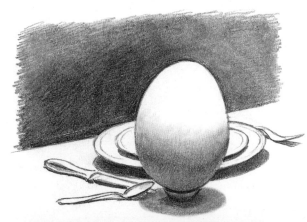

Lit directly from the side; this produces a particular combination of tonal areas, including a clear-cut cast shadow.

Lit from above; the result is cooler and more dramatic than in the first example.

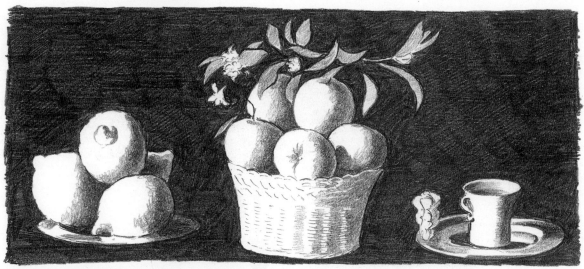

Lit strongly from the side; the strength of the light and the fact that the arrangement is set against such a dark background produces the effect of spotlighting, attracting our attention to the picture and giving a rather theatrical effect.

A small table lamp lighting a lidded glass jar from directly above. The upper surfaces are very bright. The cast shadows are simple and encircle the bases of both object and lamp. The glass jar catches the light from all around, as we can see from the small reflections in it. The darkest areas are behind the light, around the lamp and especially the lampshade.

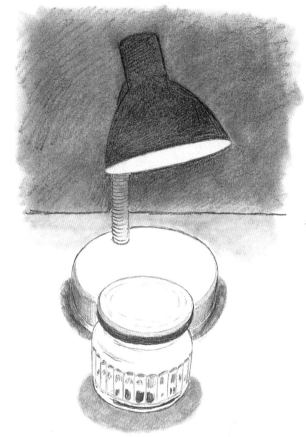

Directing light from below and to one side is traditionally the way to make objects look a bit odd, unearthly or sinister. Mainly this interpretation is down to our perception; because we are not used to viewing objects lit from below, we find it disturbing when we do. Seen in an ordinary light this cherub's expression looks animated, but lit from below, as here, it appears to have a malign tinge.

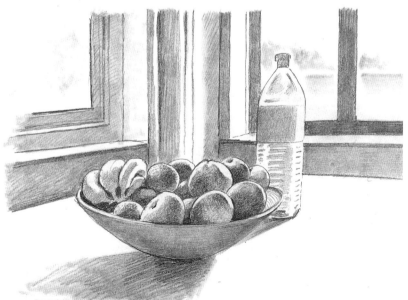

Now a more traditional form of lighting, although still unusual. The bowl of fruit and the bottle of water are backlit from the large windows with the sun relatively low in the sky; I made this sketch in the evening, but you can get a very similar light in early morning. The effect is to make the objects look solid and close to us, but also rather beautiful, because of the bright edges.

143

MIXING MATERIALS

Now we have looked at different shapes, textures, tonal shading, composition and framing, we finish by combining a range of different materials in a still life. The arrangement shown below is one of the tests that has traditionally been set for student artists to help them develop their skill at portraying different kinds of materials in one drawing. Such exercises are an excellent means of honing ability.

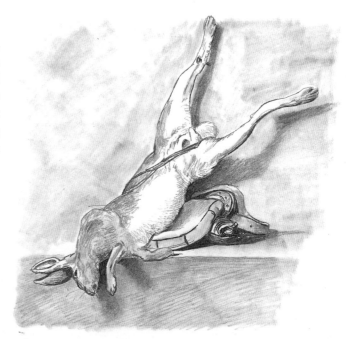

The still life (right) after Chardin is of a dead rabbit lying across a game bag on a shelf. The furry rabbit, the soft smooth bag and the hard-edged background make a good test.

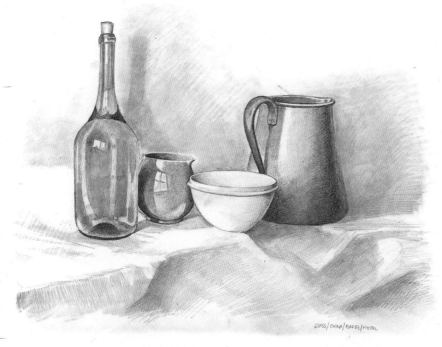

GLASS/CHINA/PLASTIC/METAL

In this still life group we have a mixture of glass, china, plastic and metal. Note that the glass bottle is filled with water and that the metal jug has an enamelled handle. All the objects are placed on blocks hidden under a soft hessian cloth draped across the background and over the foreground.

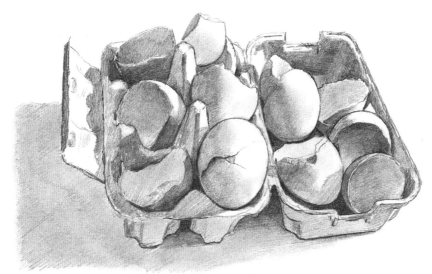

This exercise was quite fortuitous. I came across this egg box full of broken egg shells after one of my wife's cooking sessions. She had replaced the broken shells in the box prior to throwing them away. The light on the fragile shells with their cracks and shadowed hollows made a nice contrast against the papier-maché egg box.

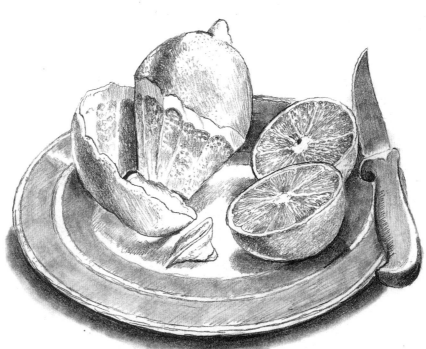

This is an interesting exercise, though it is a fairly difficult one. Here is an orange sliced in half and a partially peeled lemon, the knife resting on the plate beside them. The picture's charm comes from the fact that it is of work in progress, a standard preparation for a meal or drinks. The real difficulty of this grouping is to get the pulp of the fruit to look texturally different from the peel. The careful drawing of contrasting marks helps to give an effect of the juice-laden flesh of the orange and lemon.

STUDYING THE NATURAL WORLD

Drawing the natural world around us is one of the most rewarding aspects of draughtsmanship and producing landscapes, in any medium, is an excellent pursuit. Apart from getting you out into the world and helping you to appreciate its beauties and structure, it calms the mind and soothes the emotions. As you observe and draw, draw and observe, a certain detached acceptance of what is there in front of you takes over. It is also fascinating to discover ways of translating impressions of an outside scene into a two-dimensional set of marks on the paper. Whether or not you share some of your experience with others, it is a truly beneficial activity.

In this section, we look at the elements that make up the natural world: plants and trees, rocks and earth, rivers and waterfalls, the sea and the sky. Each of these require specific approaches, although many of the same techniques and devices can be used to tackle them. By building up a basic visual vocabulary of the natural world and becoming familiar with drawing it, you can then progress to more complex compositions, including landscapes.

PLANTS AND FLOWERS

The essential structure of a plant is not difficult to see if you study it for a time. Take a group of leaved plants: you soon notice how one type will have leaves springing up in clusters, whereas in another the leaves will hang down around a central point. Some plants have stalks coming off the branches evenly at the same point, others have the stalks staggered alternately down the length of the stem. Once you are familiar with a plant's characteristic shape and appearance, you will begin to notice it or similar properties in other plants. Observation will lend verisimilitude to even your most casual sketches. Look at the examples of plants on this spread, noting their similarities and differences.

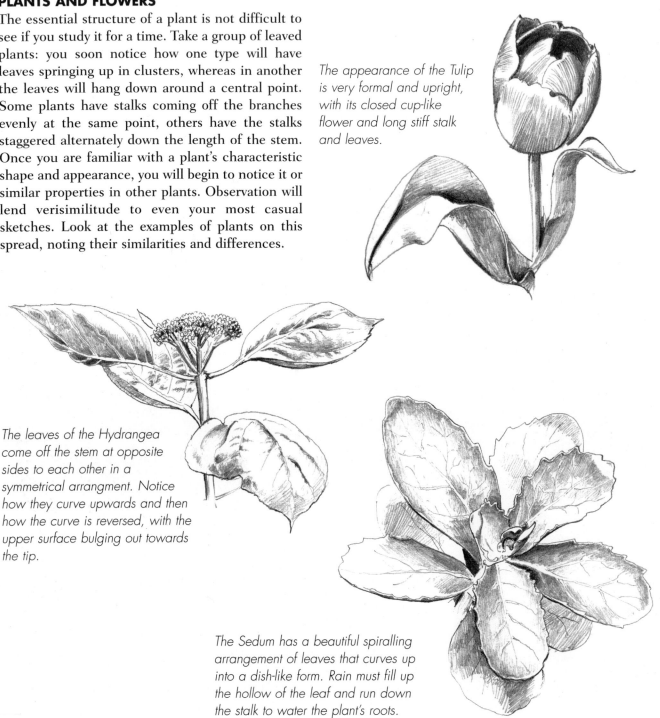

The appearance of the Tulip is very formal and upright, with its closed cup-like flower and long stiff stalk and leaves.

The leaves of the Hydrangea come off the stem at opposite sides to each other in a symmetrical arrangement. Notice how they curve upwards and then how the curve is reversed, with the upper surface bulging out towards the tip.

The Sedum has a beautiful spiralling arrangement of leaves that curves up into a dish-like form. Rain must fill up the hollow of the leaf and run down the stalk to water the plant's roots.

The easiest way to study plants is by sketching them as often as you can. Before you begin to draw, look at the plant closely: at the bloom (if there is one), and note how the leaves grow off the stalk. Look at it from above, to see the leaves radiating out from the centre; and from the side to see the different appearance of the leaf shapes. Note the texture of the leaves, and how it compares with other plants.

When your subject is a flower-head, draw it from an angle, where you can see the pattern of the petals around the centre of the blossom or a profile view of them. Notice the texture of the petals and how the centre of the flower contrasts with the main part of the bloom.

The more you draw plants, the more details you will notice and the broader your vocabulary will become. After you have been drawing plants for a while, try drawing one from memory. This type of exercise helps to sustain the image that your senses have recorded. You will find drawing from memory gives a simpler result than drawing from life, because you tend to leave out unnecessary details.

The delicate blossom of the Camellia looks so fragile. It contrasts beautifully with the solid, perfect shape of the leaves.

Here we have two blooms from the same plant (a Clematis) at different stages of its growth. The difference is quite dramatic.

The Clematis captured as it is just opening, with its smooth looking petals hanging down.

The fully open bloom, centre showing to the sun. By this stage the edges of the petals are quite crinkly.

PLANTS: GROWTH PATTERNS

Nature offers so much variety, as you will discover once you start studying it in earnest. In the examples shown on this spread you will find three very different effects in as many examples.

Compare them, and note the differences you observe. You will find these patterns of growth fascinating as you investigate them more fully and extend your experience.

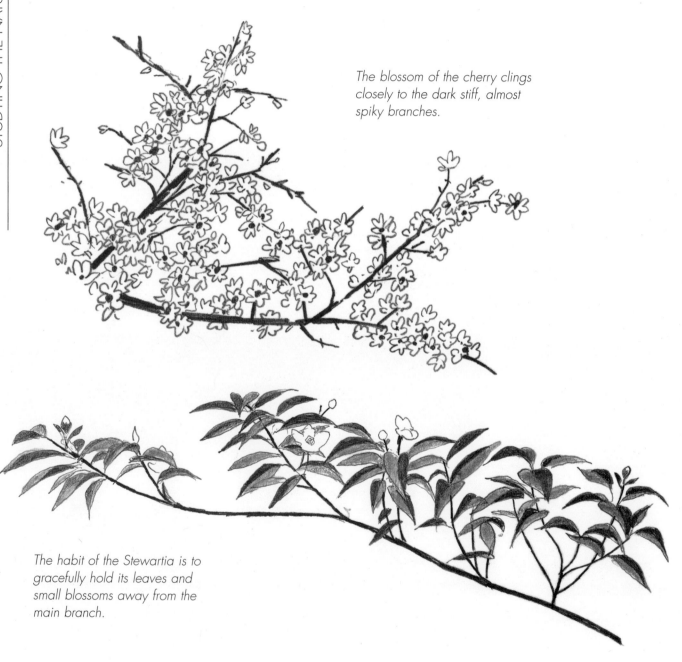

The blossom of the cherry clings closely to the dark stiff, almost spiky branches.

The habit of the Stewartia is to gracefully hold its leaves and small blossoms away from the main branch.

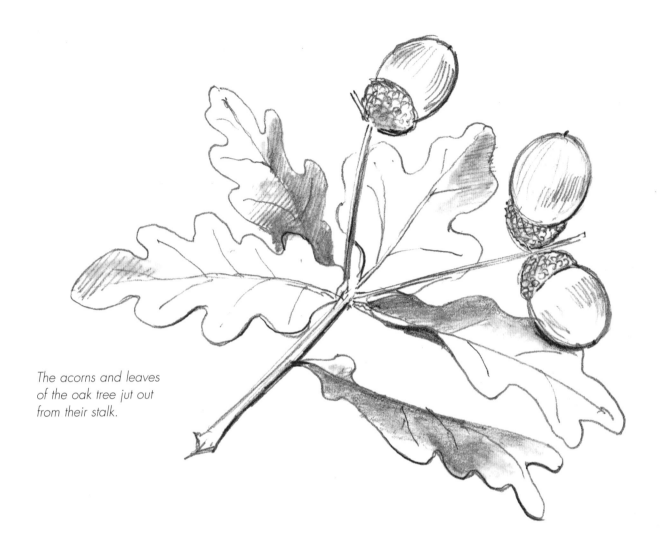

The acorns and leaves
of the oak tree jut out
from their stalk.

Exercising eye and hand

It cannot be over-emphasized that, in order to become a proficient artist, you
need to get into the habit of drawing every day. If you do, very soon you will
become adept at handling almost any shape. Keep trying different objects,
and be adventurous, trying more difficult subjects once you've got
somewhere with easier ones.

TREES: GROWTH PATTERNS

Drawing trees has always been a favourite pastime of artists even when a commission is not involved. Trees are such splendid plants and often very beautiful but they are not that easy to draw well.

Before you begin, have a look at the sketches on this page.

Have a look at the bigger trees in your local park or, if you're lucky enough to live out of town, in your local woods and hedgerows. Notice the strength of the root structure when it is evident above ground, like great gnarled hands clutching at the earth. Next, look closely at the bark on the main trunk and branches, then at its texture. Make sketches of what you see.

Oak

SHAPES

Getting a feel for the whole shape of the tree you want to draw is important. Often the best way to approach this is to draw in a vague outline of the main shape first. Then you need to divide this up into the various clumps of leaves and give some indication of how the main branches come off the trunk and stretch out to the final limit of the shape.

Of course, if your subject is a deciduous tree in winter the network of branches will provide the real challenge. The branches are a maze of shapes and success can only be achieved if you manage to analyze the main thrust of their growth and observe how the smaller branches and twigs hive off from the main structure. Luckily trees don't move about too much, and so are excellent 'sitters'.

Beech

Outline of Oak with branch pattern.

These three types of deciduous tree present very different shapes and textures. Discover for yourself how different they are by finding an example of each, observing each one closely and then spending time drawing the various shapes. Note the overall shapes and the branch patterns – see accompanying drawings.

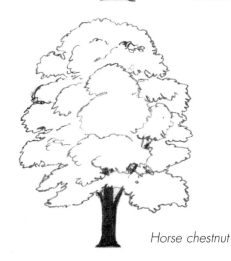

Horse chestnut

Outline of Beech with branch pattern.

Outline of Horse Chestnut with branch pattern.

153

TREES: PATTERNS

Drawing branches can prove problematical for even experienced artists. The exercise below is designed to get you used to drawing them. Don't worry about rendering the foliage precisely, just suggest it.

I drew this large tree in spring when its leaves were not completely out. It was an ideal subject for demonstrating the intricate tracery of branches because its foliage was largely restricted to the tops of the branches.

When you first look at a tree like this it is not at all easy to see how to pick out each branch. One useful approach is to draw the main stems without initially worrying whether they cross in front of or behind another branch. Only when you draw a branch that crosses the first one need you note whether it crosses behind or in front.

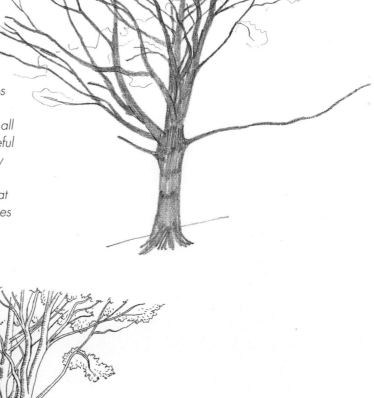

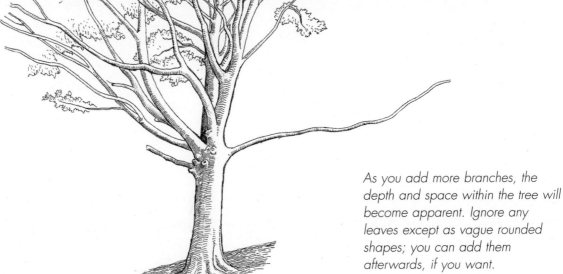

As you add more branches, the depth and space within the tree will become apparent. Ignore any leaves except as vague rounded shapes; you can add them afterwards, if you want.

When seen in silhouette every tree produces a distinctive web pattern. The point of this next exercise is to try to put in as much detail as you can, including leaves (if there are any) and twigs. To achieve this you have to draw the silhouette at a reasonable size; ie, as large as possible on an A4 sheet of paper.

One of the best varieties to choose for this exercise is a hawthorn, or May, tree. Its twisting, prickly branches and twigs make a really dense mesh, which can be very dramatic. Try drawing it in ink, which will force you to take chances on perceiving the shapes immediately; you are committing yourself by not being able to rub out. It won't matter too much if you are slightly inaccurate in detail as long as the main pattern is clear to you.

Winter is the best time to do this exercise, although the worst time to be drawing outdoors.

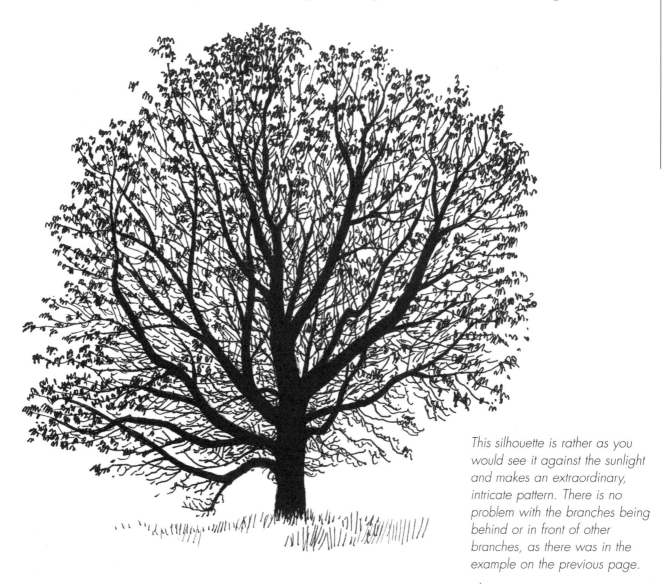

This silhouette is rather as you would see it against the sunlight and makes an extraordinary, intricate pattern. There is no problem with the branches being behind or in front of other branches, as there was in the example on the previous page.

MOUNTAINS, HILLS AND ROCKS

Next we look at that fundamental element of the natural world – the earth itself. Handling the structure of a mountain, hill or rock depends on the nature of the feature you are drawing. Your subject might be presented as a bare, hard mass against a clear, cloudless sky or perhaps be softened by vegetation and/or cloud formations. The shape, texture and materiality of natural features in the landscape vary greatly and require individual approaches. Below are two extremes for you to consider before we tackle drawing them.

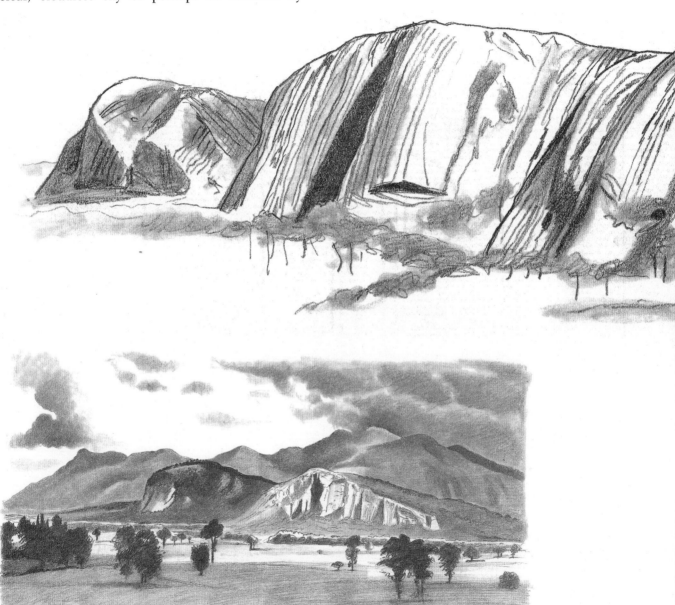

This depiction of Ayer's Rock (after Michael Andrews) accentuates the striations and folded layers of what is one of the world's most curious hill features. Little attempt has been made to create texture. The shadows are put in very darkly and sharply to give an effect of strong sunlight falling on the amazing shapes. The rock's strange regularity of form, devoid of vegetation, almost makes it look like a manufactured object. As a contrast the trees at ground level are drawn loosely and in faint, scribbly lines.

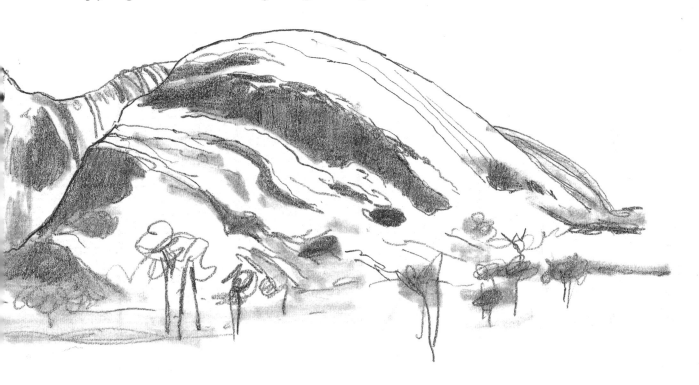

In contrast to the previous drawing, Moat Mountain (after Albert Bierstadt) includes several elements that combine to soften its aspect. The vegetation growing over the folds of the rocky slopes brings additional tonal values to the picture. The fairly well worn appearance of the rocks, visible signs of glaciation in the remote past, has a softening effect. The dark clouds sweeping across the mountain tops and the silhouetted trees looming up from the plain in the foreground also help to unify the harmony of tone all over the picture.

When drawing the solid rocks that make up the surface of the world, it can be instructive to think small and build up. Pick up a handful or soil or gravel and take it home with you for close scrutiny, then try to draw it in some detail. You will find that those tiny pieces of irregular material are essentially rocks in miniature. You can get a very clear idea of how to draw the earth in all its guises by recognizing the essential similarities between earth materials and being prepared to take a jump from almost zero to infinity.

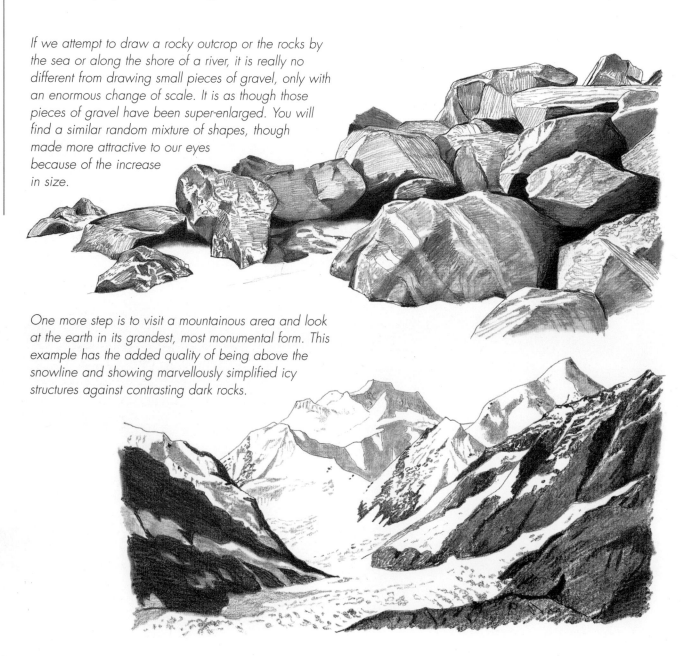

If we attempt to draw a rocky outcrop or the rocks by the sea or along the shore of a river, it is really no different from drawing small pieces of gravel, only with an enormous change of scale. It is as though those pieces of gravel have been super-enlarged. You will find a similar random mixture of shapes, though made more attractive to our eyes because of the increase in size.

One more step is to visit a mountainous area and look at the earth in its grandest, most monumental form. This example has the added quality of being above the snowline and showing marvellously simplified icy structures against contrasting dark rocks.

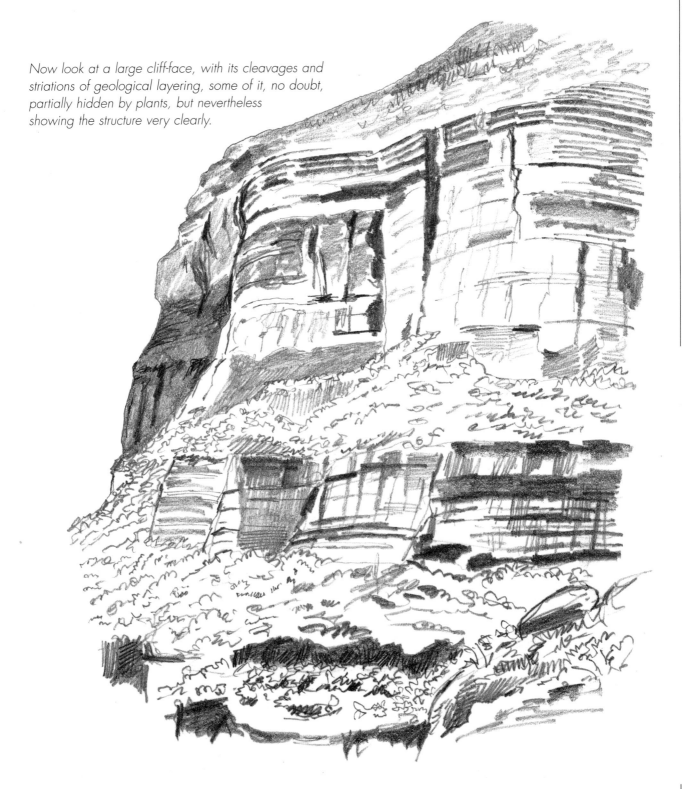

Now look at a large cliff-face, with its cleavages and striations of geological layering, some of it, no doubt, partially hidden by plants, but nevertheless showing the structure very clearly.

ROCKS: ANALYSIS

The visual nature of a mountain range will change depending on your viewpoint. Looked at from a considerable distance the details recede and your main concern is with the mountain's overall structure and shape. The nearer you get the softer

the focus of the overall shape and the greater the definition of the actual rocks.

Below we analyze two examples of views of rocks from different distances.

In our first example, from a mountain range in Colorado, the peaks and rift valleys are very simply shown, giving a strong, solid look to the landscape. The main shape of the formation and the shadow cast by the light defines each chunk of rock as sharply as if they were bricks. This is partially relieved by the soft misty patches in some of the lower parts. The misty areas between the high peaks help to emphasize the hardness of the rock. Let's look at it in more detail.

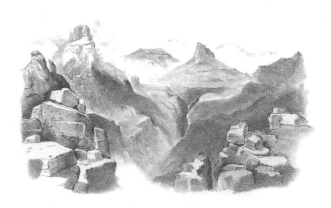

1.

2.

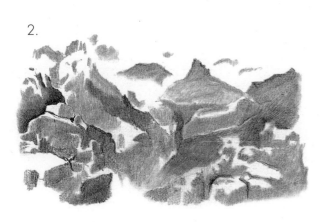

1. Sketch in with a fairly precise line the main areas of the mountain shapes, keeping those in the background very simple. For the foreground shapes, clearly show the outlines of individual boulders and draw in details such as cracks and fissures.

2. The real effect comes with the shading in soft pencil of all the rock surfaces facing away from the light. In our example the direction of the light seems to be coming from the upper left, but lit from the back. Most of the surfaces facing us are in some shade, which is especially deep where the verticals dip down behind other chunks of rock. The effect is to accentuate the shapes in front of the deeper shade, giving a feeling of volume. In some areas large shapes can be covered with a tone to help them recede from the foreground. All the peaks further back should be shaded lightly. Leave untouched areas where the mist is wanted. The result is a patchwork of tones of varying density with the line drawing emphasizing the edges of the nearest rocks to give a realistic hardness.

You will find this next example, drawn exclusively in line, including the shadows, useful practice for when you tackle the foreground of a mountainous landscape or a view across a valley from a mountainside.

The cracks in the surfaces and the lines of rock formation help to give an effect of the texture of the rock and its hardness. The final effect is of a very hard textured surface where there is no softness.

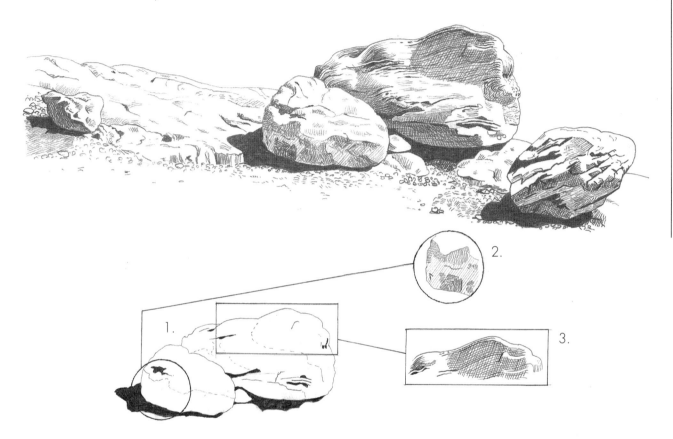

1. Draw in the outline as in the previous example, then put in areas of dark shadow as a solid black tone. Indicate the edges of the shaded areas by a broken or dotted line. Now carefully use cross-hatching and lines to capture the textured quality of the rock.

2. These particular rocks have the striations associated with geological stratas and, as these are very clearly shown, you can draw them in the same way. Ensure that the lines follow the bending shape of the stone surface. Some of the fissures that shatter these boulders cut directly across this sequence of lines. Once again they should be put in clearly.

3. Now we come to the areas of shadow which give extra dimension to our shapes. These shadows should be put in very deliberately in oblique straight lines, close enough together to form a tonal whole. They should cover the whole area already delineated with the dotted lines. Where the tone is darker, put another layer of straight lines, close together, across the first set of lines, in a clearly different direction.

WATER

The character and mood of water changes depending on how it is affected by movement and light. Over the next few pages we look at water in various forms, which present very different problems for artists and very different effects on viewers. To understand how you can capture the effect of each of the forms shown here requires close first-hand study, supported by photographic evidence of what is happening, followed by persistent efforts to draw what you think you know.

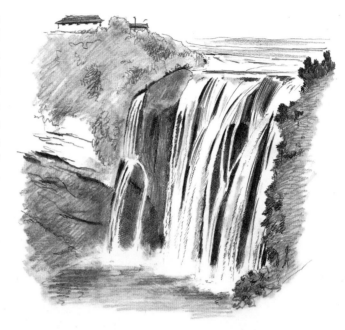

A waterfall is an immensely powerful form of water. Most of us don't see such grand works of nature as this magnificent example. Of course, you would need to study one as large as this from a distance to make some sense of it. Take a look at pages 168–9 for more on drawing falling water.

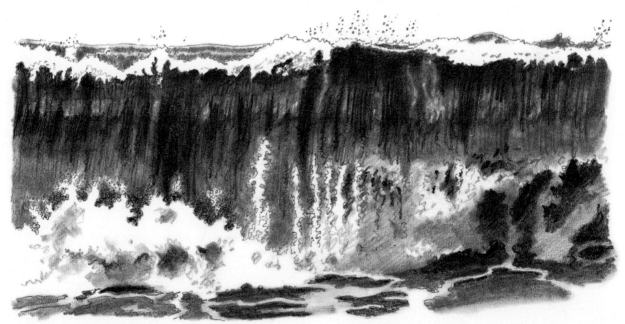

Unless you were looking at a photograph, it would be almost impossible to draw with any detail the effect of an enormous wave breaking towards you as you stood on a shore. Leonardo made some very good attempts at describing the movement of waves in drawings, but they were more diagrammatic in form.

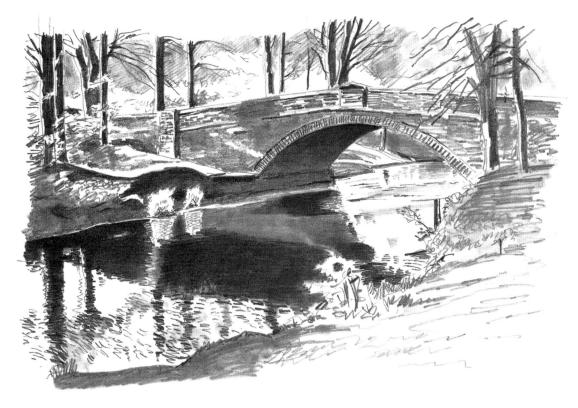

This is water as those who live in an urban environment see it, still and reflective. Although the surface of a stretch of water may look smooth, usually there is a breeze causing small shallow ripples. When you draw such a scene you need to gently blur the edges of each large reflected tone to simulate the ripples.

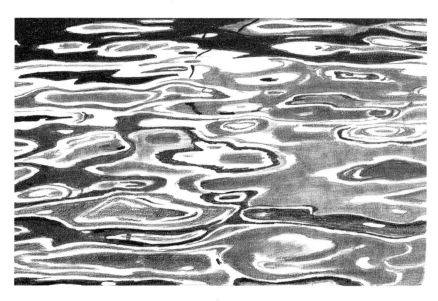

In this very detailed drawing of a stretch of water rippling gently, there appear to be three different tones for the smooth elliptical shapes breaking the surface. This is not an easy exercise but it will teach you something about what you actually see when looking at the surface of water.

WATER FEATURES NEAR AND FAR

Water tends to give the landscape an added dimension of space, rather as the sky does. The fact that water is reflective always adds extra depth to a scene. The drawing of reflections is not difficult where you have a vast expanse of water flanked by major features with simple outlines, as in our first example. Use the technique shown, which is a simple reversal, and you will find it even easier.

Here the water reflects the mountains in the distance and therefore gives an effect of expanse and depth as our eyes glide across it to the hills. The reflection is so clear because of the stillness of the lake (Wastwater in the Lake District), and the hills being lit from one side. Only the ripples tell us this is water.

The mountains were drawn first and the water merely indicated. The drawing of the reflection was done afterwards, by tracing off the mountains and *redrawing them reversed in the area of the water (see inset on the facing page). This simple trick ensures that your reflection matches the shape of the landscape being reflected, but is only really easy if the landscape is fairly simple in feature. The ripple effect was indicated along the edges of each dark reflection, leaving a few white spaces where the distant water was obviously choppier and catching the sun.*

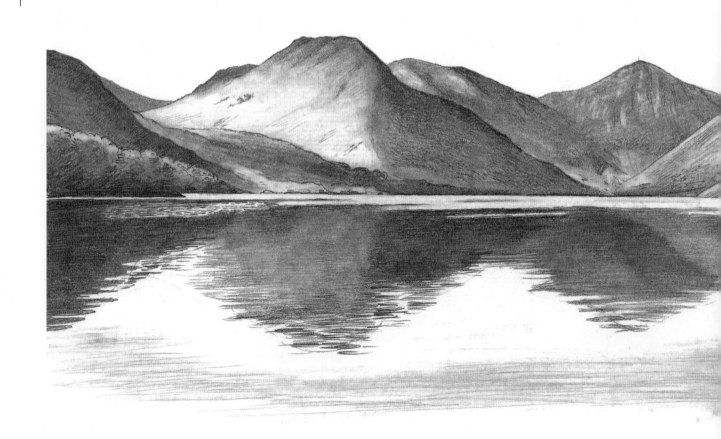

This view of Monet's pond at Giverny is seen fairly close up, looking across the water to trees and shrubs in the background. The light and dark tones of these reflect in the still water. Clumps of lily pads, appearing like small elliptical rafts floating on the surface of the pond, break up the reflections of the trees. The juxtaposition of these reflections with the lily pads adds another dimension, making us aware of the surface of the water as it recedes from us. The perspective of the groups of lily pads also helps to give depth to the picture.

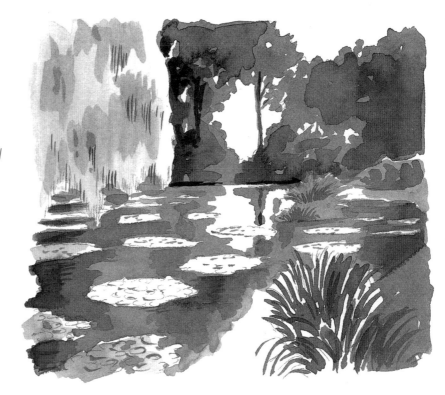

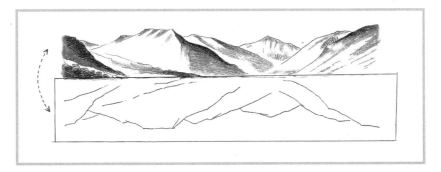

How to draw in a reflection – see main caption, left.

WATER: CONTRASTING MOODS

The contrast in moods between the choppy sea depicted in the first drawing and the glassy looking water in the second couldn't be more extreme. Pay particular attention to the absence of any reflecting light in the first example, and the fact that the second drawing comes across as all-reflection.

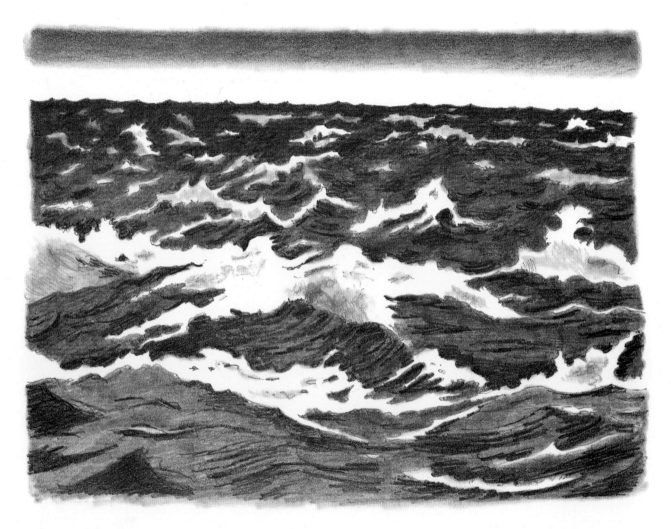

In this view of a choppy inky sea, with breaking crests of foam, the skyline is dark and there is no bright reflection from the sky. The shapes of the foaming crests of the wind-blown waves are very important. They must also be placed carefully so that you get an effect of distance, with large shapes in the foreground graduated to smaller and smaller layers as you work your way up the page towards the horizon.

Observe how foam breaks; take photographs and then invent your own shapes, once you've seen the typical shapes they make. If you are depicting a stormy sea, it is important to make the water between the crests dark, otherwise the effect might be of a bright, breezy day.

This whole drawing is made up of the sky and its reflection in the river below. The lone boat in the lower foreground helps to give a sense of scale. Although the trees are obviously quite tall in this view, everything is subordinated to the space of the sky, defined by the clouds, and the reflected space in the water. The boat and a few ripples are there to tell the viewer that it is water and not just air. The effect of this vast space and mirror is to generate awe in the viewer.

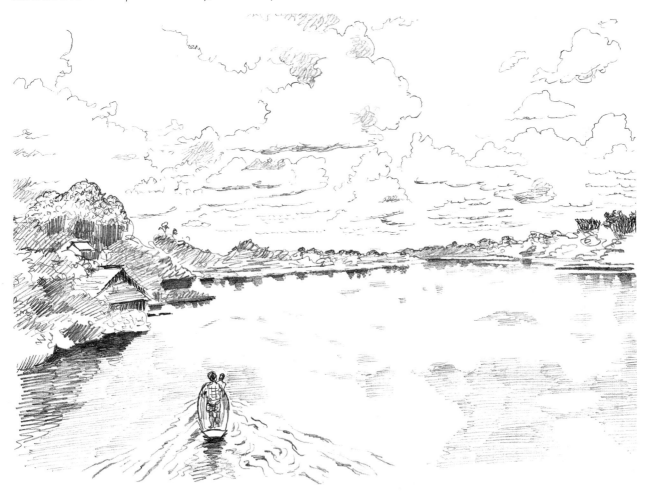

Practice with water

Water is one of the most interesting of subjects for an artist to study and certainly adds a lot to any composition. As you will have noticed, the different shapes it can make and the myriad effects of its reflective and translucent qualities are quite amazing. In this section we look at still water and reflections, drawing ripples, choppy water, falling water and capturing the essence of the sea itself. The subject is limitless, and you will always manage to find some aspect of it that is a little bit different. Go out and find as many examples as you can to draw.

FALLING WATER

One of the problems with drawing waterfalls is the immense amount of foam and spray that the activity of the water kicks up. This can only be shown by its absence, which means you have to have large areas of empty paper right at the centre of your drawing. Inexperienced artists never quite like this idea and usually put in too many lines and marks. As you become more proficient, however, it can be quite a relief to leave things out, especially when by doing so you get the right effect. The spaces provide the effect.

The rapids at Ballysadare produce the most amazing expanse of white water. Most of the drawing has gone into what lies along the banks of the river, throwing into sharp relief the white area of frothing water. These features were put in fairly clearly and in darkish tones, *especially the bank closest to the viewer. The four sets of small waterfalls are marked in with small pencil strokes, following the direction of the river's flow. The far bank is kept simple and the most distant part very soft and pale in tone.*

The Daddy of all falls – Niagara

The view at the bottom of page 168 is after F. E. Church and shows the Horseshoe from above. The drawing shown above is after Albert Bierstadt and looks at the Falls from below. In both examples the falling water is mostly left as white paper with just a few streaks marked to indicate it. The contrast between the almost blank water, the edges of the bank and the tone of the plunge pool, gives a good impression of the foam-filled area as the water leaps down into the gorge it has cut in the rock. Drawing such a scene is not difficult as long as the tonal detail is limited.

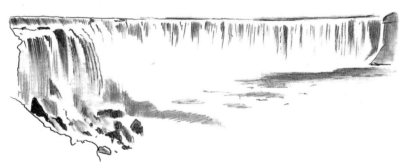

How to draw Niagara

For this exercise I have chosen to ignore the details on the lower river to concentrate on the area of the falls themselves. Mark in the top line of the falls carefully, leaving a strip of white paper between the distant grey line of the banks and the series of vertical marks that denote the tumbling water. These verticals must not be carried too far down or they will destroy the effect of the cloud of spray rising from the bottom of the fall. You will notice that at either end of the falls, where the spray is not so dense, the lines continue from top to bottom. In the central area there is almost nothing to draw. The gaping hole gets across the idea of water dissolving into mist.

THE SEA: LITTLE AND LARGE

When you want to produce a landscape with the sea, you have to decide how much you want to show. The viewpoint you choose may mean you have to draw very little sea, a lot of sea, or all sea. In the next series of drawings we examine ways of using the sea in proportion to the land.

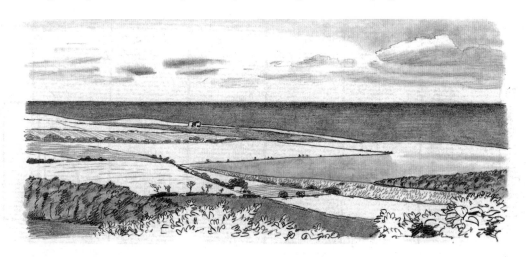

In our view of the Norfolk coast, the sea takes up about one-eighth of the whole picture. Because the landscape is fairly flat and the sky is not particularly dramatic, the wide strip of sea serves as the horizon line. The result is an effective use of sea to show depth. The calm water provides a harmonious feel to the landscape.

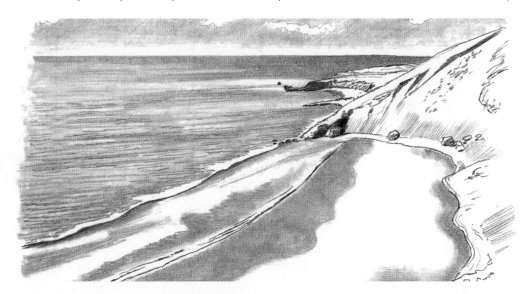

In the next scene, the sea takes up two-thirds of the drawing, with sky and land relegated in importance. The effect is one of stillness and calm, with none of the high drama often associated with the sea. The high viewpoint also helps to create a sense of detachment from everyday concerns.

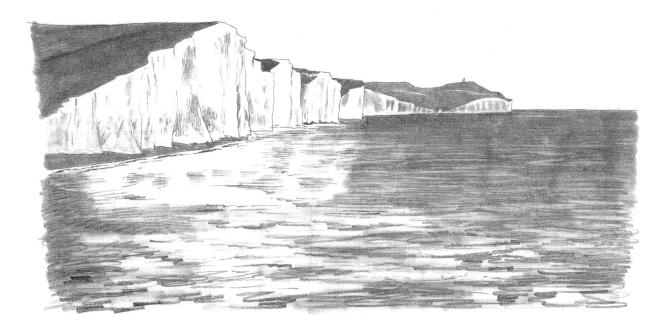

Such a large expanse of sea could be boring unless it was turbulent. What makes the scene interesting is the strip of solid earth jutting into the picture and dividing the sea from the sky. This transforms the sea into a foil for the rugged cliffs.

When the sea forms the whole landscape, the result is called a seascape. The boat with the three fishermen is just a device to give us some idea of the breadth and depth of the sea. If the sea is to be the whole scope of your picture, a feature like this is necessary to give it scale and interest.

SEA IN THE LANDSCAPE: PRACTICE

The sea takes up half of this picture, which shows a wide bay with rocky cliffs enclosing a flat beach on Lanzarote. The sweep of the sea from the horizon to the surf on the beach creates a very pleasant and restful depth to the drawing. The close-up of rocky boulders adds a touch of connection to the onlooker, as does the viewpoint, which suggests we are viewing the scene from high up on the cliff. As with the previous drawing, it is the area of calm sea that sets the mood.

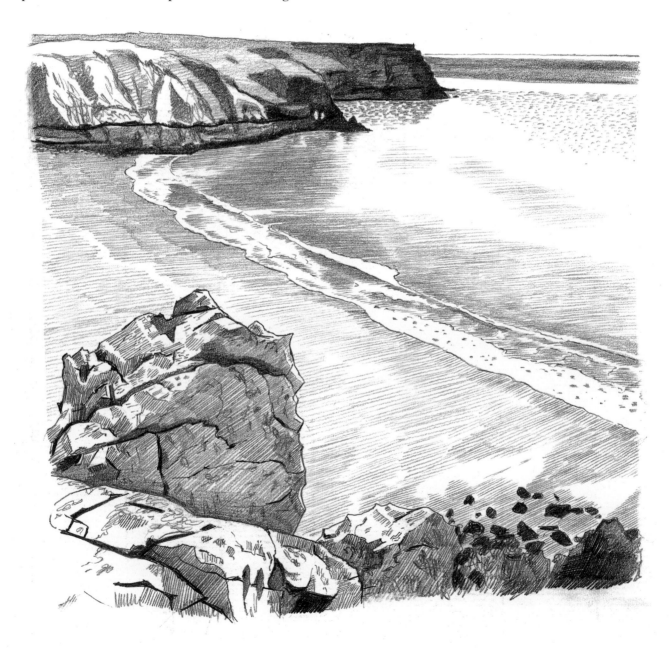

1. Outline the main areas, starting with the horizon and the cliffs in the background, then the edge of the water across the bay, and finally the close-up of the nearest rocks on the clifftop.

When the outline is in place, put in the very darkest areas of the background. This will establish the values for all the other tones you will be using. Keep it simple at first, just blocking in the main areas. Then add the lighter tones to the background, including the furthest layers of tone to designate the sea near the horizon.

2. Add tones to the beach in two stages. First, mark in very gently and carefully the tone along the line of the surf. Keep this fairly light and very even and follow the slope of the beach with your pencil marks. Next, draw the slightly darker areas of the sea where it is closest to the surf line. The contrast between this tone and the white paper left as surf is important to get a convincing effect. Lastly, put in the larger areas of tone in the sea. Use dotted or continuous lines, but don't overdo them. Leave plenty of white space to denote reflections of light. Tonal lines similar to those already put in can be carefully stroked in all over the beach area. Don't vary

1.

2.

your mark-making too much or you may end up with the effect of deep furrows, which would not look natural on a flat beach.

3.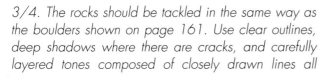

4.

3/4. The rocks should be tackled in the same way as the boulders shown on page 161. Use clear outlines, deep shadows where there are cracks, and carefully layered tones composed of closely drawn lines all in the same direction. Some of these should be in small patches, others in larger areas. Leave all well-lit surfaces as white paper, with only marks to show texture.

173

THE SKY: ITS IMPORTANCE

The next series of pictures brings into the equation the basic background of most landscapes, which is, of course, the sky. As with the sea in the landscape, the sky can take up all or much of a scene or very little. We consider some typical examples and the effect they create. Remember, you control the viewpoint. The choice is always yours as to whether you want more or less sky, a more enclosed or a more open view.

Our first example (after Albert Cuyp) is of a dramatic sky with a chiaroscuro of tones. Very low down on the horizon we can see the tops of houses, ships and some land. The land accounts for about one-fifth of the total area, and the sky about four-fifths. The sky is the really important feature for the artist. The land tucked away at the bottom of the picture just gives us an excuse for admiring the spaciousness of the heavens.

This country scene (after Pissarro) is a very different proposition. The downs behind the village, which is screened by the small trees of an orchard, allows us a glimpse of only a small area of sky beyond the scene. The fifth of sky helps to suggest space in a fairly cluttered foreground, and the latticework quality of the trees helps us to see through the space into the distance. It is important when drawing wiry trees of this type to capture their supple quality, with vigorous mark-making for the trunks and branches.

John Constable's view of East Bergholt church through trees shows what happens when almost no sky is available in the landscape. The overall feeling is one of enclosure, even in this copy. Constable obviously wanted this effect. By moving his position slightly and taking up a different viewpoint he could have included much more sky and banished the impression of a secret place tucked away.

THE SKY: USING SPACE

The spaces between clouds as well as the shapes of clouds themselves can alter the overall sense we get of the subject matter in a drawing. The element of air gives us so many possibilities, we can find many different ways of suggesting space and open views. Compare these examples.

This open flat landscape with pleasant soft-looking clouds, gives some indication of how space in a landscape can be inferred. The fluffy cumulus clouds, floating gently across the sky, gather together before receding into the vast horizon of the open prairie. The sharp perspective of the long, straight road and the car in the middle distance tell us how to read the space. This is the great outdoors.

Another vision of air and space is illustrated here: a sky of ragged grey and white clouds, and the sun catching distant buildings on the horizon of the flat, suburban heathland below. Note particularly the low horizon, clouds with dark, heavy bottoms and lighter areas higher in the sky.

Despite the presence of dark, dramatic clouds in this scene at sunset, the atmosphere is not overtly gloomy or brooding. The bright sun, half-hidden by the long flat cloud, radiates its light across the edges of the clouds, which tell us that they are lying between us and the sun. The deep space between the dark layers of cloud gives a slightly melancholic edge to the peacefulness.

CLOUDS

The importance of clouds to suggest atmosphere and time in a landscape has been well understood by the great masters of art since at least the Renaissance period. When landscapes became popular, artists began to experiment with their handling of many associated features, including different types of skies. The great landscape artists filled their sketchbooks with studies of skies in different moods. Clouded skies became a significant part of landscape composition with great care going into their creation, as the following range of examples shows.

After a follower of Claude Lorrain
This study is one of many such examples which show the care that artists lavished on this potentially most evocative of landscape features.

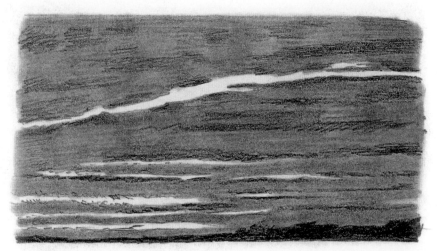

After Caspar David Friedrich
One of the leading German Romantic artists, Friedrich gave great importance to the handling of weather, clouds and light in his works. The original of this example was specifically drawn to show how the light at evening appears in a cloudy sky.

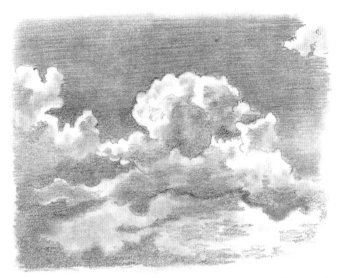

After Willem van de Velde II
Some studies were of interest to scientists as well as artists and formed part of the drive to classify and accurately describe many natural phenomena.

After Alexander Cozens
The cloud effects are the principal interest here. The three evident layers of cloud produce an effect of depth, and the main cumulus on the horizon creates an effect of almost solid mass.

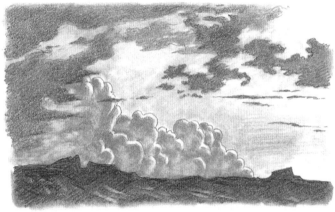

After J. M. W. Turner
Together with many other English and American painters, Turner was a master of using cloud studies to build up brilliantly elemental landscape scenes. Note the marvellous swirling movement of the vapours, which Turner used time and again in his great land and seascapes.

A DRAMATIC SKY: PRACTICE

Here is a large dramatic sky, after Constable, depicting a rainstorm over a coastal area, with ships in the distance. The sweeping linear marks denoting the rainfall give the scene its energy. The effect of stormy clouds and torrential rain sweeping across the sea is fairly easily achieved, as long as you don't mind experimenting a bit. Your first attempt might not be successful, but with a little persistence you will soon start to produce interesting effects, even if they are not exactly accurate. This type of drawing is great fun. Keep going until you get the effect you want.

Using a fine pen and black ink, scribble in vertical and windblown lines to suggest heavy rainfall. The sea can be marked in, using both fine horizontal strokes and more jagged, wave-like marks. To suggest agitated sea and rain, dip a hog hair brush into dark watercolour paint and splatter this across areas of the picture.

Then, using a large and small (size 12 and smaller) hog hair brush, put in pale washes of watercolour across the sweep of the rain and horizontally across the sea. Repeat this with a darker tone until you get the effect you require in the sky and sea.

AN EXPRESSIVE SKY: PRACTICE

The sky plays a very dramatic role in these two examples of landscapes: copies of Van Gogh's picture of a cornfield with cypress trees, and of Van Ruisdael's 'Extensive Landscape'. Although different in technique, both types of landscape are easier to do than they look.

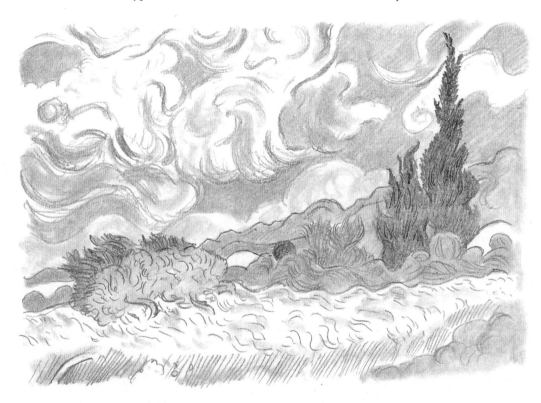

The Van Gogh copy is characterized by strange, swirling mark-making for the sky, trees and fields. The feeling of movement in the air is potently expressed by the cloud shapes which, like the plants, are reminiscent of tongues of fire. Somehow the shared swirling characteristic seems to harmonize the elements.

Draw in the main parts of the trees and clouds and the main line of the grass and bushes. Once you have established the basic areas, it is just a case of filling in the gaps with either swirling lines of dark or medium tones or brushing in lighter tones with a stump. Build up slowly until you get the variety of tones required.

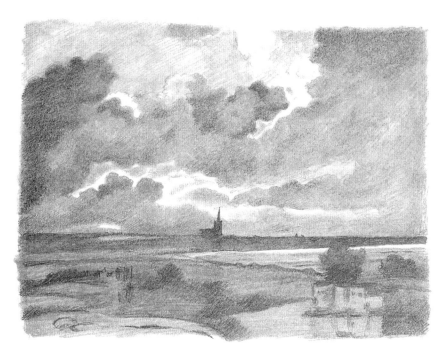

Ironically the land referred to in the title 'Extensive Landscape' only takes up a third of the space. The clouds, drawn in contrasting dark areas with a few light patches, create an enormous energetic sky area in which most of our interest is engaged. The land by comparison is rather muted and uneventful.

First, mark in with light outlines the main areas of cloud, showing where the dark cloud ends and the lighter sky begins. Draw in the main areas of the landscape, again marking the lines of greatest contrast only.

Next, take a thick soft pencil (2B–4B) and shade in all the darker and medium tones until the sky is more or less covered and the landscape appears in some definition. Finish off with a stump to smooth out some of the darker marks and soften the edges of clouds. The more you smear the pencil work, the more subtle will be the tonal gradations between dark and light. Afterwards you may have to put in the very darkest bits again to increase their intensity.

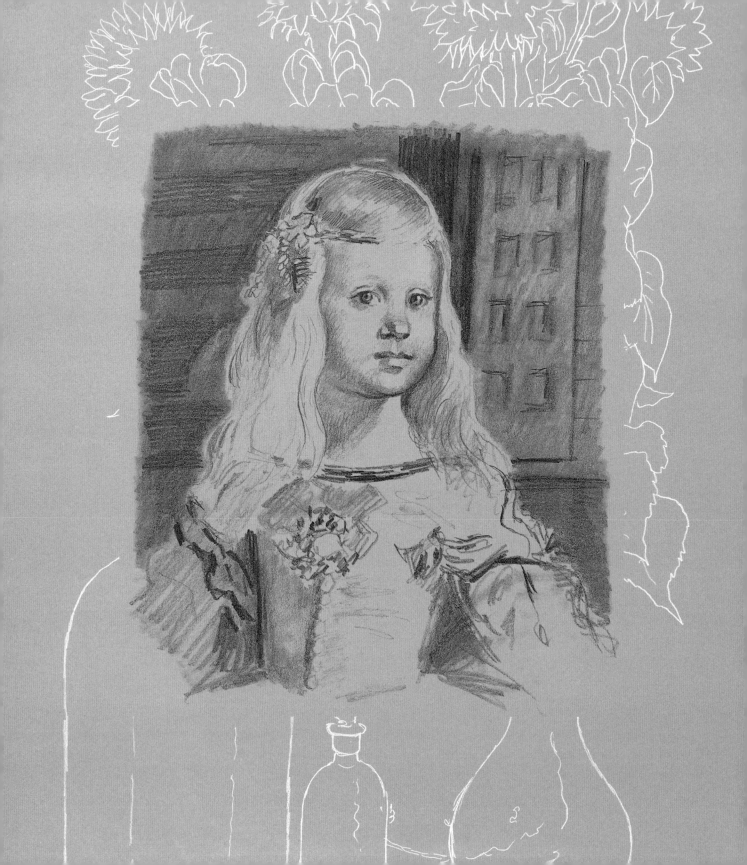

PORTRAIT DRAWING

In this section we look at one of the most challenging subjects of drawing: portraits. Capturing a likeness can seem a daunting task, but the key is not to get distracted by facial details. The main shape of the head is vital because if you ignore this, the resulting drawing will never really catch the qualities of the sitter. Once you have learned to draw the basic structure of the head, you are already well on your way to making a portrait.

The particular arrangement of features is also very important. If you are keen to do so, you can measure everything, and this can help greatly in producing a good likeness. However, measurement by itself will only give the proportion, and you should aim to use your drawing practice as your guide to how the features relate and fit together.

There is no substitute for careful observation. If you practise looking at people's faces it will enormously enhance your ability to recognize and draw the shapes in front of you. In the following pages, there are numerous examples of how the human face ages over time, and how the great masters of art have tackled portraiture with success.

LOOKING AT THE HEAD

When a person is presented as a subject, the obvious approach is to sit them down in a good light, look at them straight on and begin to draw what you see. However, the obvious does not always produce the best or most accurate result. If you concentrate solely on getting a likeness of a subject, you miss out on the most important and most interesting aspects of portrait drawing.

The aim of this next exercise is to encourage you to look at the head as a whole. There's much more to the head than mere features, as you will discover if you look at it from many different angles, excluding the obvious one. Take a look at the two drawings shown below.

The head leaning back. This angle gives a clear view of underneath the chin and the nose. Seen from this angle the person is no longer instantly recognizable, because the forehead has disappeared and the hair is mostly behind the head.

Notice the large area of neck and chin and how the nose sticks up out of the main shape of the head. When seen at this angle the ears seem to be in a very odd position, and their placement can be quite tricky. Notice that the eyes no longer dominate the head.

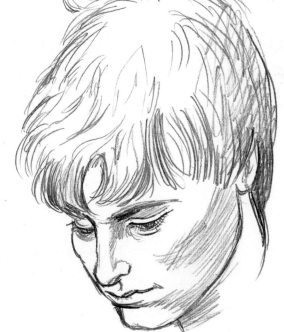

The head looking downwards. This allows a good view of the top of the head, which tends to dominate the area in view. Notice how the eyes disappear partly under the brow; how the eyelashes stick out more noticeably; how the nose tends to hide the mouth and the chin almost disappears.

Once you have looked at various heads of different people you will begin to classify them as whole shapes or structures and not just as faces. This approach teaches that although there are many different faces, many heads share a similar structure. The individual differences won't seem half so important once you realize that there are only a few types of heads and each of us has a type that conforms to one of these.

The structure and proportions of the head are explored in detail over the following pages.

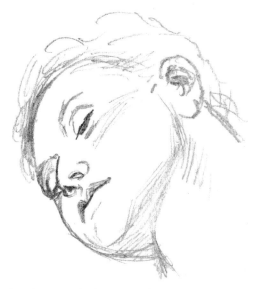

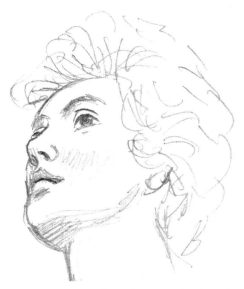

Mostly when we look at people our attention is too easily captured by the facial expression conveyed by their eyes and mouth. When drawing the head, try to *focus your attention on these features: forehead, jaw, cheekbones and nose. They give the face its structure and thereby its character.*

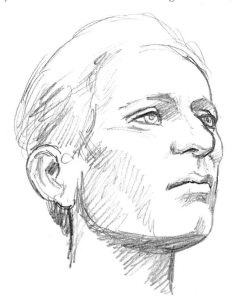

DRAWING THE HEAD: BASIC METHOD

The basic shapes and areas of the head have to be taken into account when you start to draw your portrait. There are five basic steps. These will give you a strong shape which you can then work over to get the subtle individual shapes and marks that will make your drawing a realistic representation of the person you are drawing.

First ascertain the overall shape of the head or skull and the way it sits on the neck. It may be very rounded, long and thin or square and solid. Whatever its shape you need to define it clearly and accurately at the outset, as this will make everything else easier later on.

Decide how the hair covers the head and how much there is in relation to the whole head. Draw the basic shape and don't draw in details at this stage.

Now ascertain the basic shape and position of the features, starting with the eyes. Get the level and size correct and their general shape, including the eyebrows.

The nose is next, its shape (whether upturned, straight, aquiline, broad or narrow), its tilt and the amount it projects from the main surface of the face. Now look at the mouth, gauging its width and thickness, and ensuring that you place it correctly in relation to the chin.

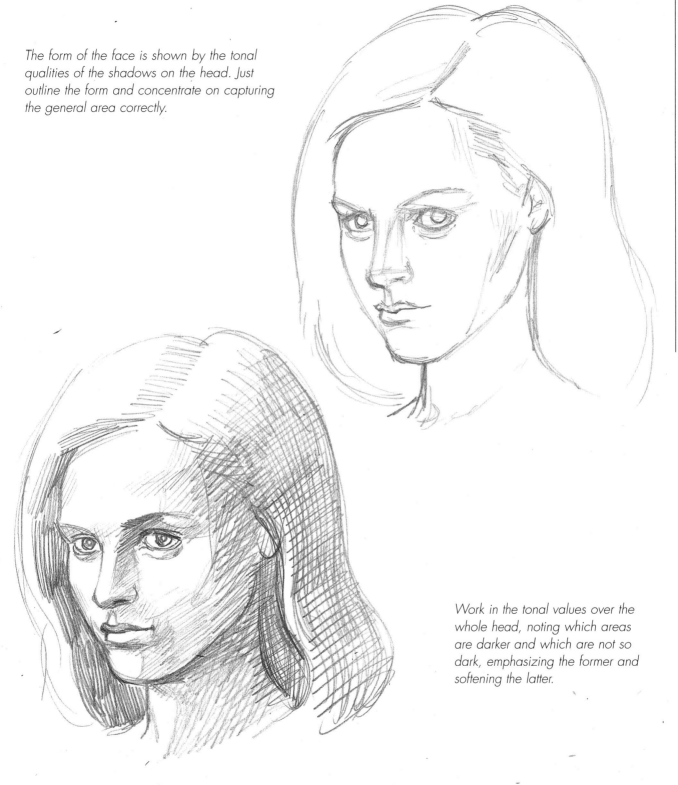

The form of the face is shown by the tonal qualities of the shadows on the head. Just outline the form and concentrate on capturing the general area correctly.

Work in the tonal values over the whole head, noting which areas are darker and which are not so dark, emphasizing the former and softening the latter.

DRAWING THE HEAD: ALTERNATIVE METHOD

An alternative method for beginning a portrait is to work from the centre of the features and move outwards toward the edges. This approach is very helpful if you are not too sure about judging proportions and measuring distances.

For this exercise we will assume that we are drawing a three-quarter view. Start by drawing a vertical line on a sheet of paper and then make a mark at the top and bottom of it. Now follow the steps shown in the following series of illustrations.

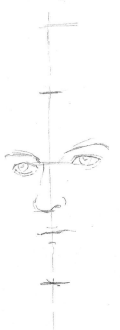

Phase One: Marking out the Features

• *Mark a horizontal line for the position of the eyes, halfway between the top and bottom marks. Roughly draw in the relative position and shapes of the eyes.*
• *Make a mark halfway between the top mark and the level of the eye for the position of the hairline.*
• *A mark halfway between the level of the eye and the bottom mark will give you the position of the end of the nose. Indicate by sketching in a very simple shape.*
• *The bottom line marks the point of the chin, which will be on the vertical line.*
• *The position of the mouth has to be calculated next. Remember, the mouth is nearer to the nose than it is to the chin, so don't put it halfway between them.*

Phase Two: Defining the Features

• *Draw in the shapes of the eyes and eyebrows, ensuring they are correctly placed. Notice how the eye nearest to you is seen more full on than the far eye.*
• *The nose now needs to be carefully drawn in: its outside shape, and also – in lightly drawn lines – how the form creates shadows on the unlit side.*
• *Positionally the ear fits between the levels of the eye and the nose, but is off to the side. Gauge how the distance between the eye and the ear relates to the length of the nose and put in the outline shape of the ear.*
• *Next, shape the mouth. The far half of the mouth will not look as long as the near half. Draw in the pointed part of the chin.*

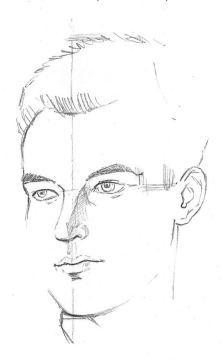

Phase Three: Outlining Shadows

• *Trace out the shape of the shadows running down the side of the head facing you. Don't make the lines too heavy; just outline the edge of the shadow faintly from the forehead down round the cheekbone and onto the chin. Indicate the neck and its shadow outline.*

• *Put in the shadow around the eyes, nose and, where needed, the mouth. Softly shade in the whole area including the hair area and the neck. Define the edges of the back of the head and neck and on the opposite side where the brow stands out against the background. Complete the shape of the top of the head.*

• *Outline the whole of the far edge of the face; be careful not to make the chin jut out too far. Check the accuracy by looking at the distance between the line of the nose and the outline of the cheekbone. Make any corrections. At this stage your drawing should look like a simplified version of your sitter.*

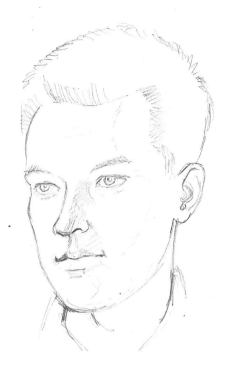

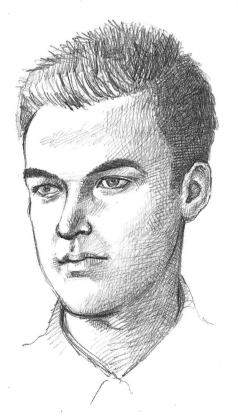

Phase Four: Applying Tonal Values

• *Begin by darkening the areas that stand out most clearly. Carefully model the tone around the form so that where there is a strong contrast you increase the darkness of the tone and where there is less contrast you soften it, even rubbing it out if necessary.*

• *The greatest definition in the features should be the shape of the eyes, sometimes the eyebrows, and the corner between the nose and eye and around the nostrils. The most definite part of the mouth is where it opens, and sometimes the area just below the lower lip.*

• *Mark the highlights in the hair; and the outer and inner shapes of the ear. Look at the set of the head on the shoulders, noting how the shoulders slope away from the neck on both sides of the head.*

• *You may find that the background behind the lighter side of the head looks dark and the background behind the darker side of the head looks lighter. A darker background can help to project the face forward. Finish off by applying delicate touches – either with the pencil or a good rubber – to soften the edges of the tones.*

THE MALE HEAD:
WORKING OUT PROPORTIONS

For beginners especially it can be very helpful to use a grid as a guide on which to map out the head, to ensure that the proportions are correct. Despite the amazing variety of faces found in the world, the proportions shown here are broadly true of all adult humans from any race or culture. The only proviso is that the head must be straight and upright, either full face or fully in profile. If the head is at an angle the proportions will be distorted.

The number of units varies depending on whether you are drawing the head full on or in profile. Study each example with its accompanying notes before trying to use the system as a basis for your portraits.

Horizontal Reading: Full Face

For the full-face examples a proportion of 5 units across and 7 units down has been used. Before you begin to study the individual units, note the line drawn vertically down the centre of the face. This passes between the eyes, and centrally through the nose, mouth and chin.

- *The width of the eye is one-fifth of the width of the whole head and is equal to 1 unit.*
- *The space between the eyes is 1 unit.*
- *The edge of the head to the outside corner of the eye is 1 unit.*
- *The outside corner of the eye to the inside corner of the eye is 1 unit.*
- *The inside corner of the left eye to the inside corner of the right eye is 1 unit.*
- *The inside corner of the right eye to its outside corner is 1 unit.*
- *The outside corner of the right eye to the edge of the head is 1 unit.*
- *The central unit contains the nose and is also the width of the square base of the chin or jaw.*

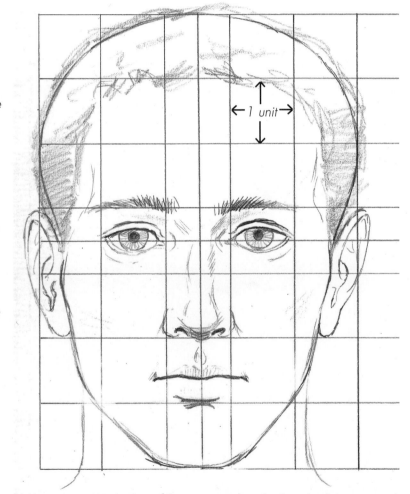

← 1 unit →

Vertical Reading: Full Face

- *Eyes: halfway down the length of the head.*
- *Hairline: 1 unit from the top of the head.*

- *Nose: one and a half units from the level of the eyes downwards.*
- *Bottom of the lower lip: 1 unit up from the edge of the jawbone.*

- *Ears: the length of the nose, plus the distance from the eye line to the eyebrows is 2 units.*

Horizontal Reading: Profile

• *The head in profile is 7 units wide and 7 units long, including the nose.*

• *The front edge of the eye is 1 unit back from the point of the nose.*

• *The ear is 1 unit in width. Its front edge is 4 units from the point of the nose and 2 units from the back edge of the head.*

• *The nose projects half of 1 unit from the front of the main skull shape, which is about six and a half units wide in profile.*

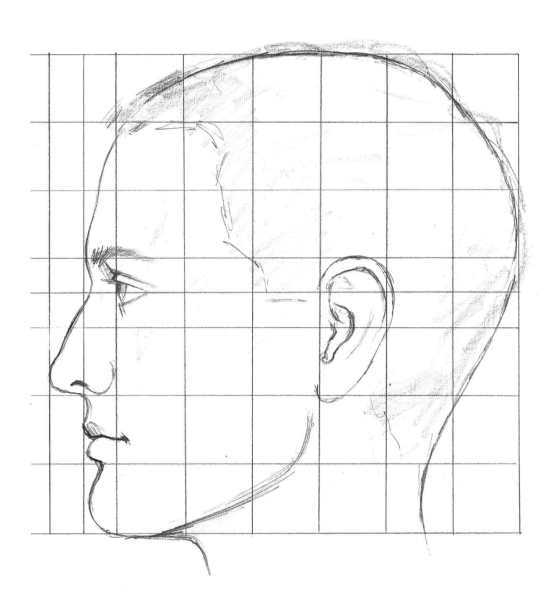

THE FEMALE HEAD:
WORKING OUT PROPORTIONS

These examples have been drawn to exactly the same size as those on the preceding spread. Generally the female head is smaller than the male but the proportions are exactly the same. (Also see pages 222–3 for information on the head proportions of children, which at certain ages are significantly different from those of adults.)

Horizontal Reading: Full Face

For the full-face examples a proportion of 5 units across and 7 units down has been used. Before you study the individual units, note the line drawn vertically down the centre of the face. This passes between the eyes, and centrally through the nose, mouth and chin.
- *The width of the eye is one-fifth of the width of the whole head and is equal to 1 unit.*
- *The space between the eyes is 1 unit.*
- *The edge of the head to the outside corner of the eye is 1 unit.*
- *The outside corner of the eye to the inside corner of the eye is 1 unit.*
- *The inside corner of the left eye to the inside corner of the right eye is 1 unit.*
- *The inside corner of the right eye to its outside corner is 1 unit.*
- *The outside corner of the right eye to the edge of the head is 1 unit.*
- *The central unit contains the nose and is also the width of the square base of the chin or jaw.*

Vertical Reading: Full Face
- *Eyes: halfway down the length of the head.*

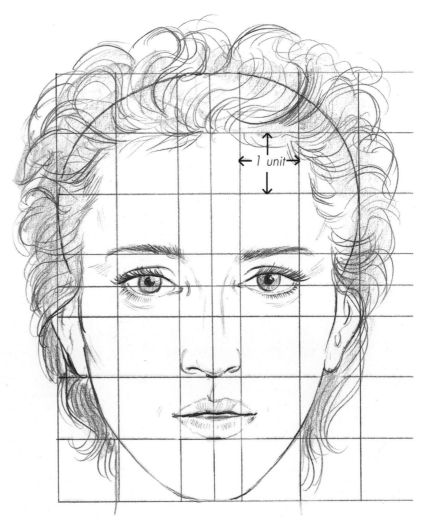

← 1 unit →

- *Hairline: 1 unit from the top of the head.*
- *Nose: one and a half units from the level of the eyes downwards.*
- *Bottom of the lower lip: 1 unit up*

from the edge of the jawbone.
- *Ears: the length of the nose, plus the distance from the eye line to the eyebrows is 2 units.*

Horizontal Reading: Profile

• *The head in profile is 7 units wide and 7 units long, including the nose.*

• *The front edge of the eye is 1 unit back from the point of the nose.*

• *The ear is 1 unit in width. Its front edge is 4 units from the point of the nose and 2 units from the back edge of the head.*

• *The nose projects half of 1 unit from the front of the main skull shape, which is about six and a half units wide in profile.*

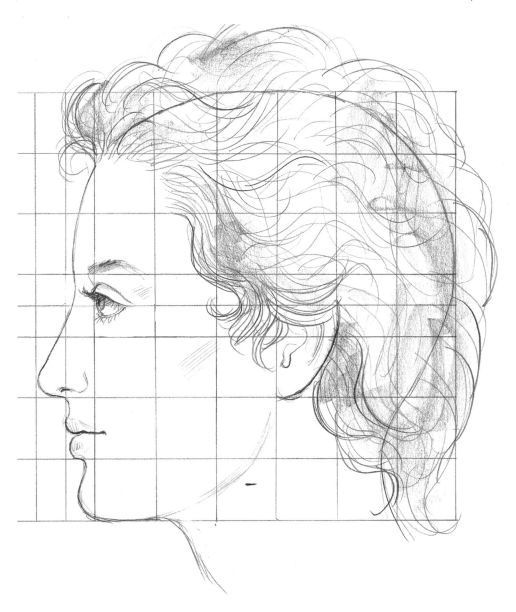

MEASURING THE HEAD

The surest way of increasing your understanding of the head, and becoming adept at portraying its features accurately, is to practise drawing it life-size, from life. It is very difficult to draw the head in miniature without any experience of drawing it at full size, but this is what beginning artists tend to do, in the mistaken belief that somehow it will be easier. Getting to know the head involves mapping it out, and this means taking measurements between clearly defined points. For the next exercise you will need a live model, a measuring device, such as a ruler or callipers, a pencil and a large sheet of paper.

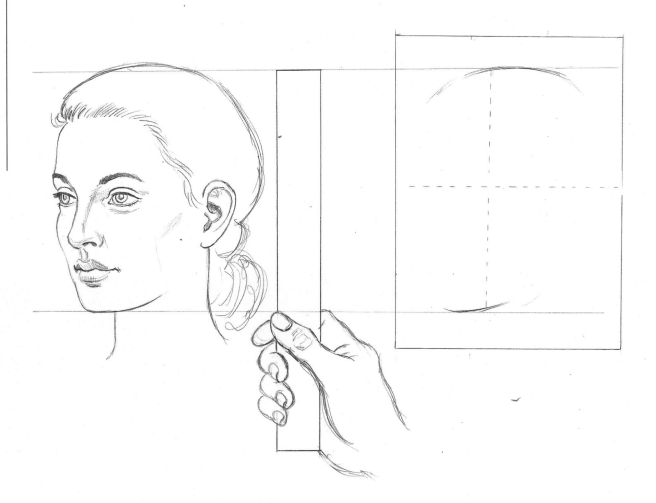

Measure the length of the head from the highest point to the tip of the chin. Mark your measurement on the paper. Measure the width of the head at the widest point; this is usually across the area just above the ears, certainly if viewed full on from the front. Mark this measurement on the paper. The whole head should fit inside the vertical and horizontal measurements you have transferred to your drawing paper.

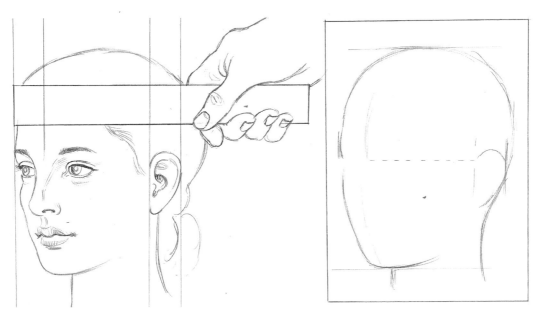

Measure the eye level. This should be about halfway down the full length of the vertical, unless the head is tilted. Decide the angle you are going to look at the

head. Assuming it is a three-quarter view, the next measurement is critical: it is the distance from the centre between the eyes to the front edge of the ear.

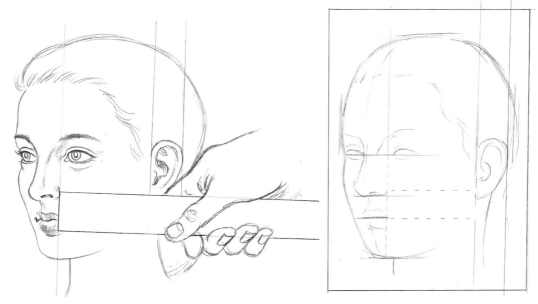

Measure the distance from the outside edge of the nostril to the front edge of the ear. Mark it and then place the shape of the ear and the position of both eyes. Check the actual length of the nose from the inside corner of the eye down to the base of the nostril.

Next measure the line of the centre of the mouth's opening; you can calculate this either from the base of the nose or from the point of the chin. Mark it in. Now measure from the corner of the mouth facing you to a line projecting down the jawbone under the ear. Mark it.

FACIAL FEATURES

The features are worth sketching many times from more than one angle until you begin to understand exactly what happens with every part. You can do this quite easily by just moving your point of view while the model remains still. However, sometimes the head needs to be tilted, the eyes moved and the lips flexed to get a better idea of the way these features change. Time spent working on these exercises now means that your drawing will take on a new conviction in future and you will begin to notice subtleties that were perhaps less obvious to you before.

EYES

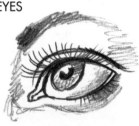 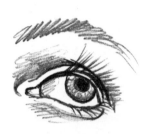

The eye seen from below looking up, and seen from above looking up, add extra permutations to the variety of shapes.

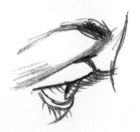 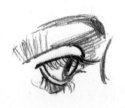

When the eyes look down, the upper eyelid takes on the shape of the eyeball it is covering and the open part of the eye forms a sort of crescent shape. The upper lid stretches and the lower one creases.

You will quickly notice that the eye looking up and the eye looking down are vastly different in expression.

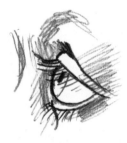 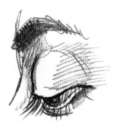

See how the eye seen from the side gives a much clearer view of the ball shape and how the lens seems to sit on the surface of the eyeball, the pupil appearing to recede into the shape of the lens.

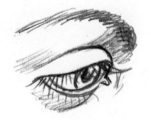 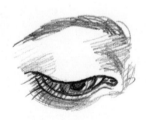

EARS

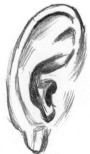 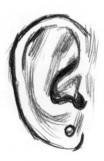 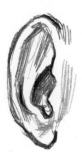

Not many people can move their ears, so they are less of a problem than any other feature. Their convolutions are unfamiliar because rarely do we look at them. Seen from the front or back most ears are inconspicuous. The shapes of ears do vary, but have certain shapes in common. Look at these examples.

NOSE

The nose doesn't have a great deal of expression although it can be wrinkled and the nostrils flared. However, its shape often presents great difficulty to beginning students. Drawing the nose from in front gives the artist a lot of work to describe the contours without making it look monstrous.

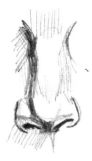

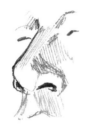

A clear dark shadow on one side helps a lot when drawing the nose from the front.

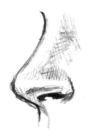

However, from the side it is clear how it is shaped. The nostrils are a well defined part of the nose and from the front, are the best part to concentrate on to infer the shape of the rest of the features.

If you want to reduce the projection of the nose, a full facing light will tend to flatten it in terms of visible contours.

MOUTH

The mobility of the mouth ensures that, next to the eyes, it is the most expressive part of the face. Although there are many shapes of mouth, these can be reduced to a few types once you begin to investigate them.

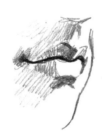

First of all, draw from the front, followed by three-quarter views from left and right, and then from the side.

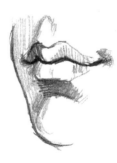

Next draw from slightly above and slightly below; this gives you the basic shape of the mouth. Note the edge of the lips; some parts project and give a definite edge to the lip. On other parts, the colour of the lip is in the same plane as the surface of the face.

When you have a fairly clear idea of the basic form of the mouth, see what happens when it opens. First, try drawing it slightly open from at least two views (front and side) and then wider, and then wide open. Notice what happens to the lips when the mouth is open, how they stretch, and how creases appear in the cheeks either side and below. Next, look at the mouth smiling; first with the lips shut, and then more open.

HAIR

Here we look at two examples of hair and the technical problems involved when trying to draw them. Hair comes in thin strands that can either curl, tangle or smoothly lie against each other, and these characteristics call for very different qualities to be shown in a drawing. You will find all of these challenging but fascinating to attempt.

The shine on the top of the head shows up strongly, despite the darkness of the hair. There is also another slightly more subdued shine lower down, across the back of the head. The pleating over, and the plait itself, pick up the shine and accentuate the strands of hair held together, none out of place, effectively producing an almost smooth surface to each fold of plait.

A lot of effort has gone into this hairstyle, with every seemingly wayward strand beautifully arranged. Contrived it may be, but it does show to good effect how hair can wave and corkscrew in ringlets.

Notice the many highlights on the bends of the curls and the darker richer tones underneath. It's not easy to make this style look natural in a drawing, but this is a good attempt.

Good features can enhance the dramatic effect of elaborate dressing of the hair. However, where the gods have been more sparing in their distribution of looks, artists have to employ more subtle means of portraying their sitters. An elegant hairstyle, assisted by good lighting, can flatter the plainest individual.

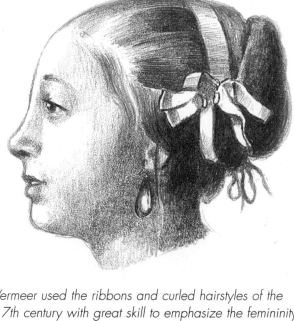

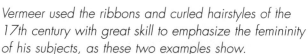

Vermeer used the ribbons and curled hairstyles of the 17th century with great skill to emphasize the femininity of his subjects, as these two examples show.

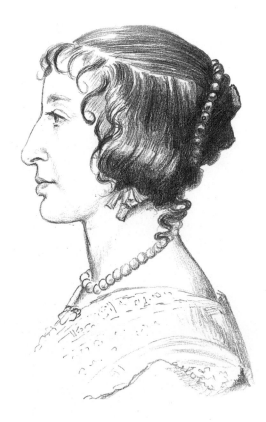

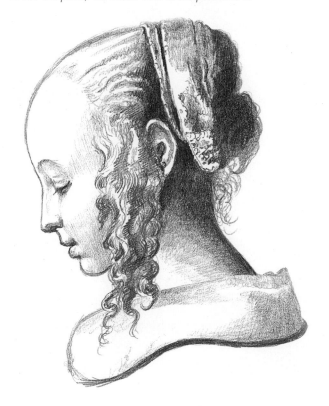

The ribbons and jewellery at this period enabled hair to become an architectural element in portraiture, which artists had to capture by paying attention to the intricacies of the design.

Notice how Van Dyck produces a similar effect to Vermeer with his portrait of Queen Henrietta Maria. Many people, when they saw the queen close-to, were rather disappointed with her looks, so it is a tribute to Van Dyck's skill that in this profile she appears gracious and elegant.

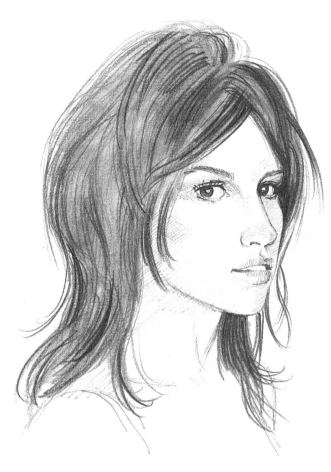

By contrast modern hairstyles are less fussy and less structured than styles from earlier periods. Usually you need only to observe the direction of the combing or, in a more dishevelled look, just allow your pencil, brush or pen to move freely. The direction of the hair is important, but as there is usually less in the way of braiding or curling, the problem is simpler.

This example of a modern hairstyle, taken from a fashion magazine promoting hairdressing, gives a seemingly natural look, although this is sometimes attained at some effort and after a great deal of careful work.

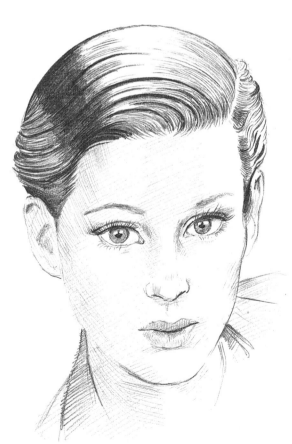

Short hair has been very popular with women since the 1920s, and like most modern hairstyles, is not difficult to draw.

PORTRAYING DIFFERENT AGES

As a portrait artist, you have to assess correctly the age of the face in front of you, so that it can be shown without causing the sitter to feel that you have made them look older or younger. Making people look younger is not normally a problem because most of us have an image of ourselves as younger than we really are.

The hardest individuals to draw, oddly enough, are the very young. First and foremost, they can't pose for you. Secondly, baby faces have very little in the way of distinctive features and therefore are very difficult to make interesting. As I hope you will see from the following series of drawings, the older we become the richer are the opportunities for the artist.

(Unless stated otherwise, a B grade pencil was used for all the pencil drawings in this series.)

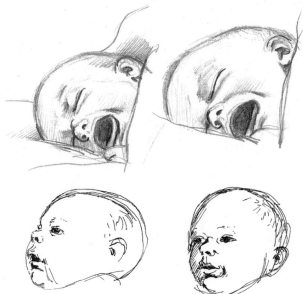

4 weeks: *Drawing a young baby is a very salutary exercise, because the features at this age are not distinctive enough to allow a satisfactory result. Indeed the baby's mother is very likely the only person to whom the features are significantly different from those of any other baby of the same age. The most sensible way of tackling a portrait of this sort is to wait until the baby is fast asleep and then concentrate on placing the eyes, nose, mouth and ears in relation to the whole head. Apart from making sure that the head is also drawn accurately, this really is the best you can do in the circumstances.*

6 months: *At this age the face is becoming a bit more distinctive, because of a widening repertoire of expressions and the addition of hair. Pen and ink is not ideal for drawing a child this young, but as this was a spontaneous portrait, I used what was to hand.*

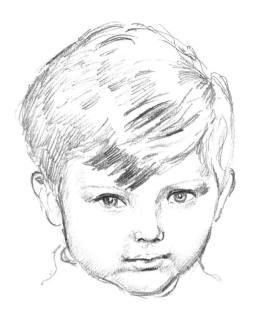

3 years: *It is not easy to get young children to sit still for long, which is why drawings of them are often small. Luckily this chap managed not to wriggle for about five minutes at a time, giving me just long enough to capture his clear, bright, lively expression. His eyes and mouth moved a lot, so I also took a photograph to help me in the finished pencil drawing. The technique is careful and as exact as possible. The expression is easy enough if you get the proportions of eyes, nose and mouth correct within the shape of the head. Note the large area of the top of the head; the proportion at this age is unlike that of the adult head, the chin being much smaller in proportion to the rest of the skull.*

4 years: *Two tones of conté pencil used carefully with as light a touch as possible. The hair is smooth and relatively easy to draw. The main interest is in the eyes and the soft blurred look of the snub nose and the mouth. The absence of sharp edges meant that the pencil had to be gently stroked onto the paper.*

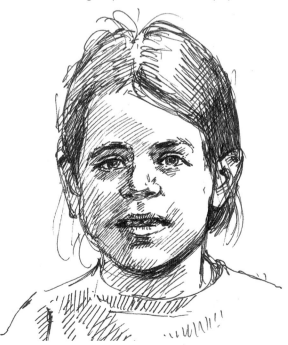

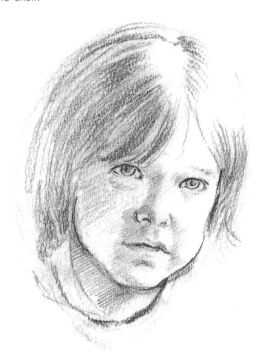

5 years: *Ink is a difficult medium for a face as unformed as this and so the style had to be fairly loose and fluid. I used sweeping lines to prevent them looking too dry and technical. Ink does not allow a lot of subtle variations but its very simplicity can give a drawing great strength.*

6 years: *In this small sketch with a ballpoint pen I was interested in capturing the shape of the head and the dimensional effect of the large area of shadow and the bright areas catching the light. The features are drawn simply in line to show through the overall texture of shadow. At this age the features are becoming better defined, allowing the use of a stronger line.*

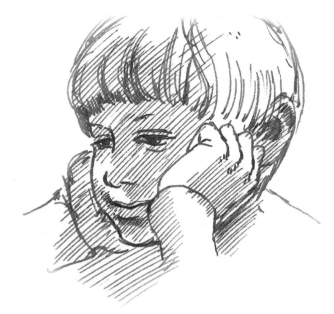

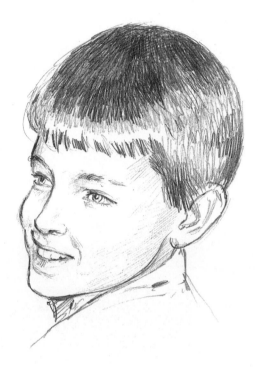

10 years: *Although the face is still very young, the lines can be drawn more crisply and definitely. The shiny, short hair produces a nice contrast with the face. The features are clearly drawn but with little tone, to capture the fresh, clear look which is typical of children of this age.*

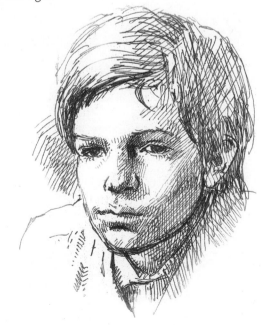

13 years: *In this example in ink, the toned paper gives a slightly heavy look to the face which, although still soft and relatively unmarked by experience, has a slightly stronger bone structure and a dour uncertain look expressive, of the mood swings that beset youngsters around this age.*

15 years: *The face has the clarity and charm of youth but in the expression there is a hint of deeper knowledge. Drawing a portrait of this age group is not easy for the artist and is largely a question of what you leave out rather than what you put in. Often you can end up making your subject look older than young adults who are several years their senior. The beauty of the form demands clarity in the drawing. Further than this, you have to try to express in some way the expectant feelings that girls of this age experience.*

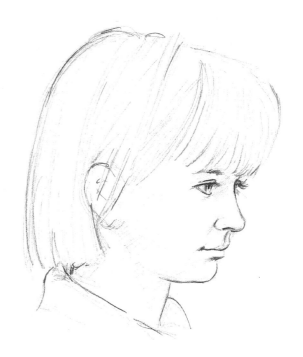

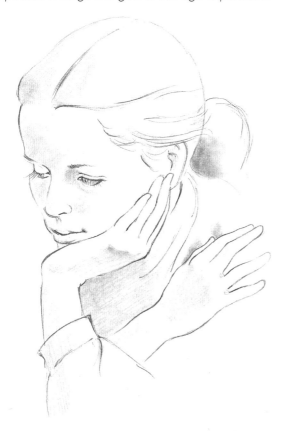

16 years: *At this age the features are complete in form and full of life, strongly marked but still fresh and untouched by real anxieties. A light touch is required. Here the features are clearly drawn and there was an opportunity for making much of the hairstyle.*

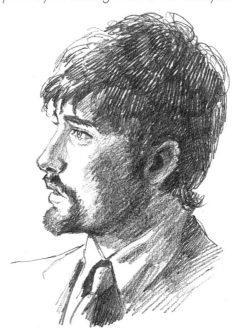

20 years: *There is plenty of form to draw at this age and the greater maturity in style and carriage provides opportunities for interest. The beard growth and sculpted bones showing through, help to define the age nicely. A 2B grade pencil was used in addition to a B grade.*

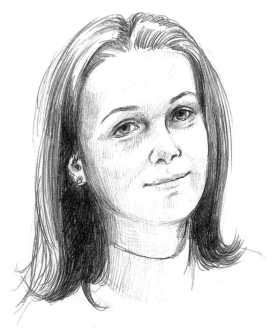

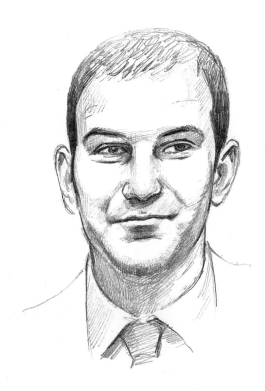

25 years: *The personality is now distinct and tends to come through in any drawing in any style. As before, the features and head shape should be kept clear and definite, but you will have to pay careful attention to detail, to convey distinctive nuances of expression and attitude.*

33 years: *In the thirties, experience of the world begins to tell on the face. The artist needs to identify the main characteristic of the subject and then bring into it all the subtle psychological variations that are shown in expression, habitual lines on the face and ambiguity in the projection of personality.*

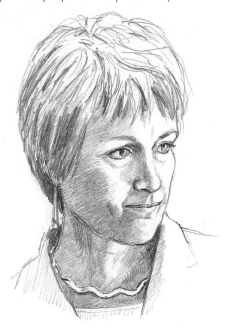

50 years: *At the half century mark, the artist is presented with a range of experience to emphasize or play down. You can opt for craggy weathered surfaces, volatile expressions of emotion, the more benign influences registered on the face or a more generalized form that reduces the wear and tear to a texture of soft marks. Whatever you decide, it will not be difficult to see how to put down the structure. At this age there is plenty to draw. The media used were B and 2B grade pencils.*

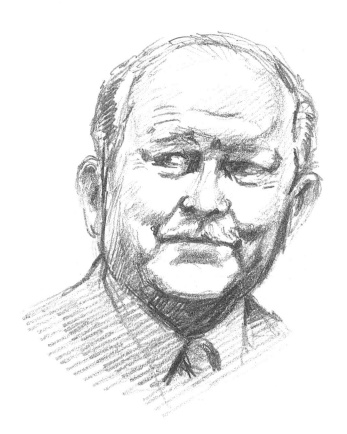

70 years: *The features show very definite marks by this age. Lines are firmly engraved on the face and deterioration of the surface textures and hair is quite evident. However, if the person's experience has been mainly of a pleasant nature the face will show wisdom, benignity and, often, good humour. All is revealed and is not difficult to draw.*

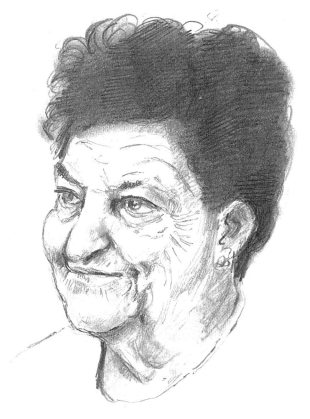

80 years: *This particular subject is very well preserved and sprightly, but with all the lines and wrinkles associated with old age. Her expression shows what she is like; it is almost as impossible to dissimulate at this age as it is at the very youngest. The artist is presented with a map of a whole career, which can be fascinating to draw. Careful drawing is required to get across the texture of the features and the expression. The media used were B and 2B grade pencils and a stub.*

MASTER STROKES

In the following pages we look at examples of the changing ages of humanity as seen through the eyes of some of the great artists. In earlier periods it may have been true that people aged more quickly because life was physically much harder, and so someone depicted in their middle years will look far older than would their equivalent in age now. However, if you study these remarkable portraits purely from the standpoint of the way the subtle signs of youth or age are shown on the human face,

you will find them immensely instructive. Some look almost elementary in their simplicity. Closer examination will reveal the tremendous skill it takes to reduce complex subtle effects to such a degree.

Every mark you make on a drawing gives some information, even if it is just that you are unsure of what you've seen. In every portrait you attempt, your observation is paramount. Never forget this: the best results always derive from observation and attention to detail, as the following examples prove.

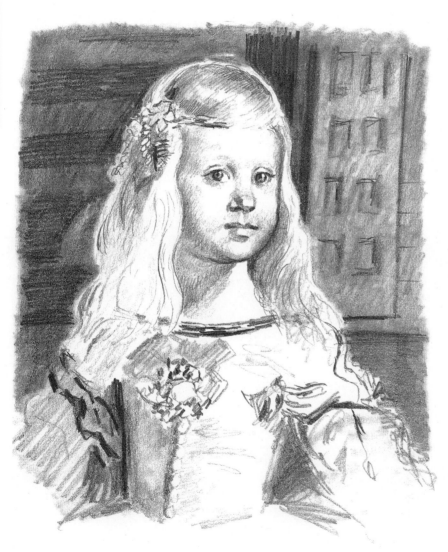

Velázquez's portrait of the five-year-old Infanta of Spain captures the innocence of early childhood. The sweetness of her expression contrasts with the dark background and her stiff formal dress, accentuating her innocence. Soft black pencil (B) and graphite stick (2B) were used for this copy. With the exception of the edges of the eyes and the dress, the lines were kept sparse and light. The broad edge of the graphite produced the dusky background tones.

The original of this portrait of a dreamy ten-year-old boy, by Antonella da Messina, was done in silverpoint.

A B pencil was used throughout, producing closely grouped lines with a little cross-hatching on the face and very sharp, clear lines around the eyes, mouth and for the main strands of hair.

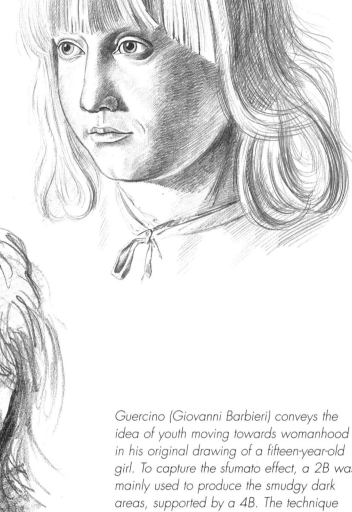

Guercino (Giovanni Barbieri) conveys the idea of youth moving towards womanhood in his original drawing of a fifteen-year-old girl. To capture the sfumato effect, a 2B was mainly used to produce the smudgy dark areas, supported by a 4B. The technique was fairly even strokes in the same direction, except for the hair.

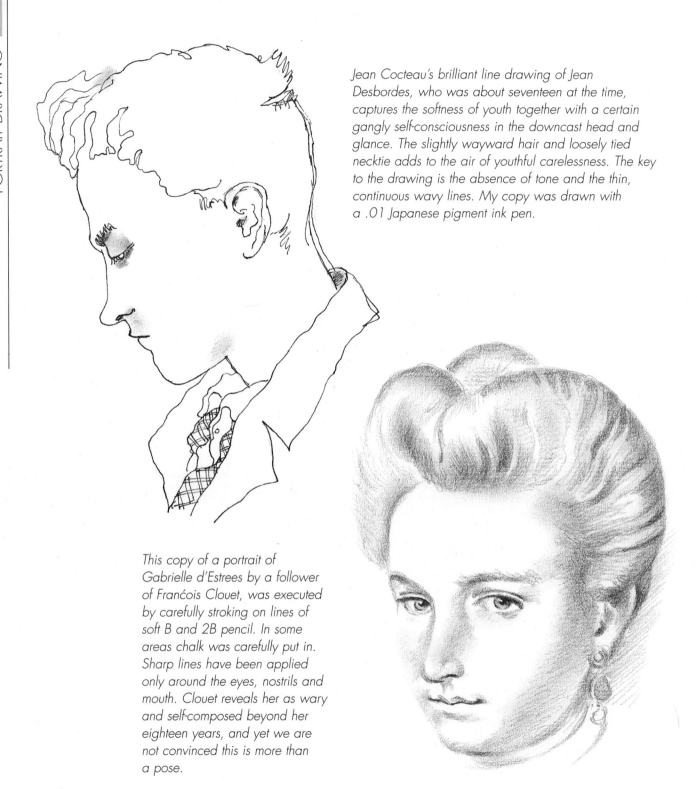

Jean Cocteau's brilliant line drawing of Jean Desbordes, who was about seventeen at the time, captures the softness of youth together with a certain gangly self-consciousness in the downcast head and glance. The slightly wayward hair and loosely tied necktie adds to the air of youthful carelessness. The key to the drawing is the absence of tone and the thin, continuous wavy lines. My copy was drawn with a .01 Japanese pigment ink pen.

This copy of a portrait of Gabrielle d'Estrees by a follower of François Clouet, was executed by carefully stroking on lines of soft B and 2B pencil. In some areas chalk was carefully put in. Sharp lines have been applied only around the eyes, nostrils and mouth. Clouet reveals her as wary and self-composed beyond her eighteen years, and yet we are not convinced this is more than a pose.

Lucian Freud's drawing of a young man in his early twenties emphasizes large hands and long features, giving an angular awkwardness to an otherwise composed and calm portrait.
In this copy, the pencil lines are incisive with minimal shading. The herringbone pattern on the jacket was done with a blunter point to achieve softer lines.

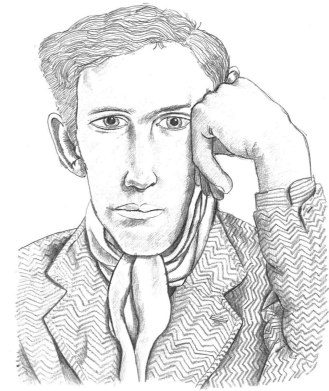

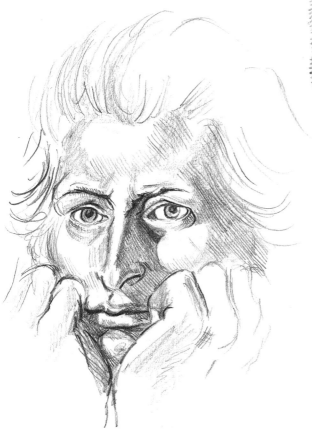

Henry Fuseli drew this self-portrait when he was in his thirties. It shows the anxieties and self-doubt of someone mature enough to be aware of his own shortcomings. B and 2B soft pencils were used for this copy, to capture the dark and light shadows as well as the sharply defined lines depicting the eyes, nose and mouth.

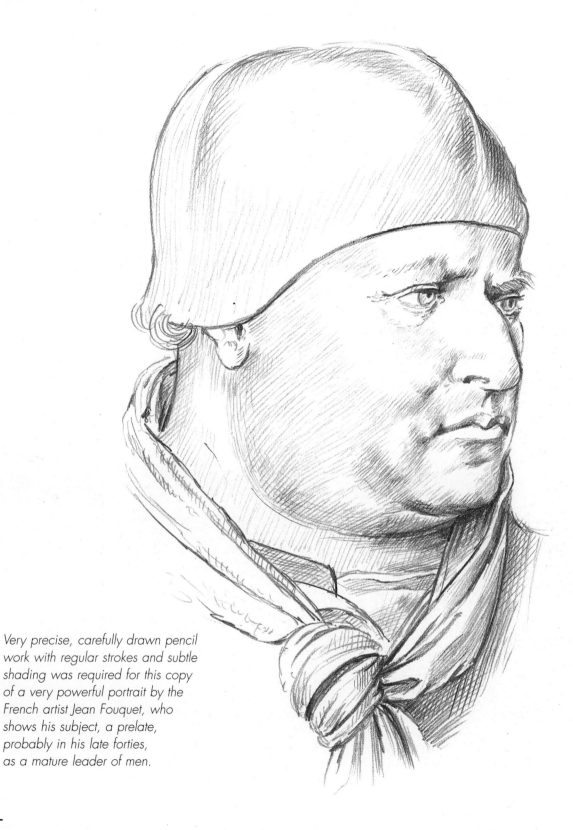

Very precise, carefully drawn pencil
work with regular strokes and subtle
shading was required for this copy
of a very powerful portrait by the
French artist Jean Fouquet, who
shows his subject, a prelate,
probably in his late forties,
as a mature leader of men.

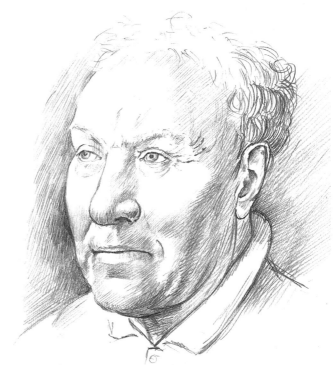

We happen to know that the sitter of this portrait by Jan Van Eyck, the Cardinal of Sante Croce, Florence, is fifty-six years old. The lines of the eyes, ears, nose, mouth and outline of the face are precise and give clear signs of the ageing process. The technique is generally smooth and light with some cross-hatching in the tonal areas. Although Van Eyck portrays his subject as still powerful, there is also a sense of resignation.

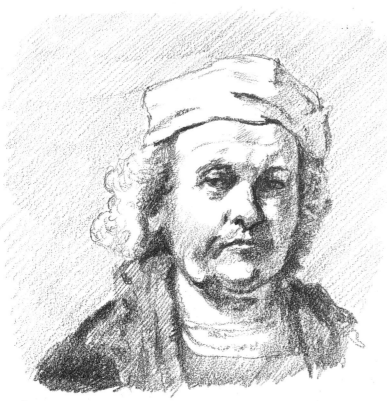

Rembrandt drew himself throughout his life, from early adulthood until just before his death, and has left us an amazing record of his ageing countenance. In this copy of a self-portrait done when he was about sixty years old, a smudgy technique with a soft 2B pencil was used in imitation of the chalk in the original.

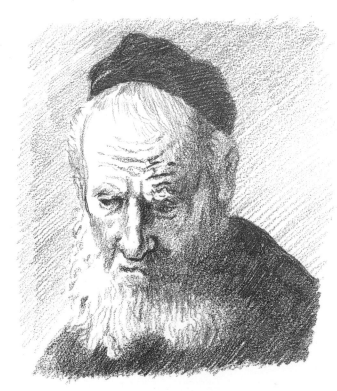

The definition in this copy of Rembrandt's portrait of his father, who was in his early seventies, derives from the use of tonal areas instead of lines. The technique with the pencil is very smudgy and creates an effect that is very similar to one you would get with chalk.

Drawn in pen and ink, after Guercino, these two examples are graphic depictions of the ravages of age, although there is no record of how old the men were. I tried to emulate Guercino's methods, using bold strokes in some places (hair and hood) with tentative broken lines.

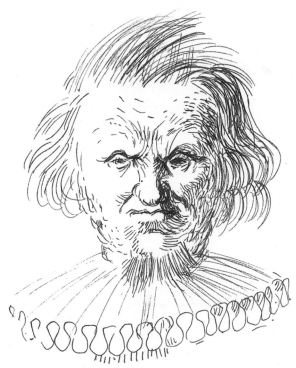

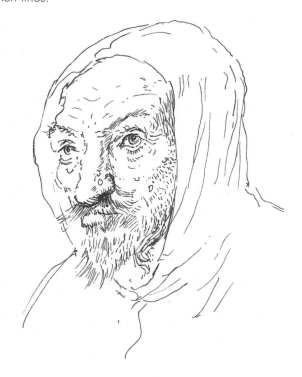

A copy in chalk of a portrait of Jean Edouard Vuillard's mother, done when she was in her eighties, describes age in a most economic way. Echoing the original, I was sparing with the tone and detail, and allowed the wavering lines to follow the gentle disintegration of the flesh on the face.

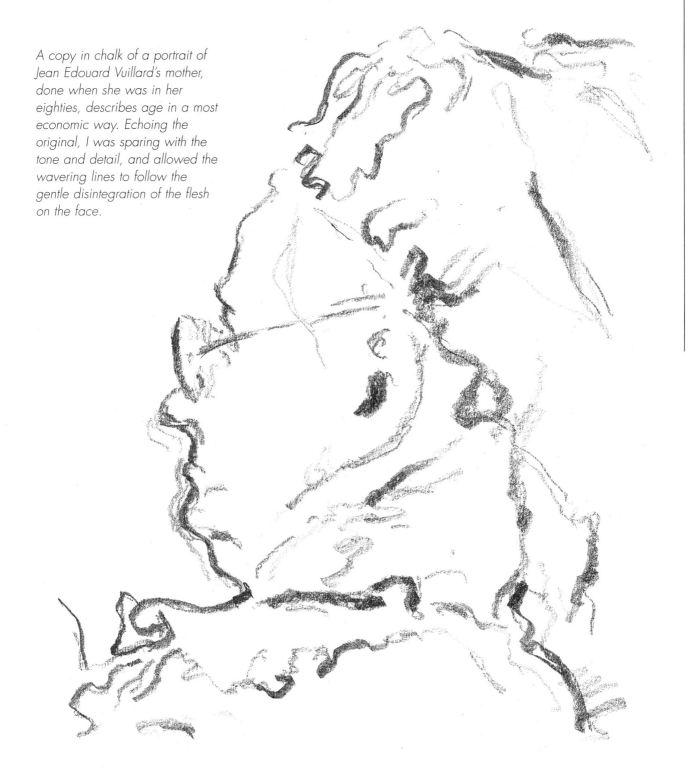

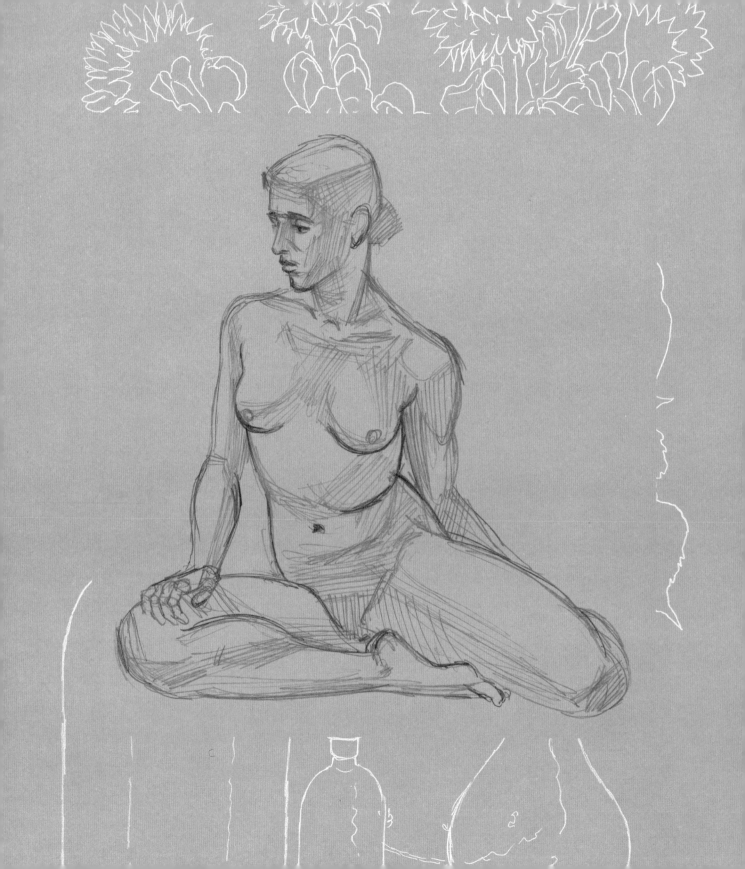

FIGURE DRAWING

In this section we explore that fundamental subject of drawing – the human figure. Drawing the human body is probably the hardest task of draughtsmanship that you will ever have to accomplish – because of course you will be able to accomplish it, so long as you take the time to improve your drawing techniques as you do so.

We begin by looking at the proportions, the structure and the obvious variations between male and female, child and adult, and then progress to the different parts of the body: the torso, arms and legs. Don't be tempted to skip these basics to get on quickly to drawing the whole figure. Putting in the groundwork at this stage will make your figures look more solid and more real, and capture the human quality you wish to portray.

When we come to tackling the whole figure, I outline the stages that make it easier to approach, as well as the tricky question of the figure in perspective, with the foreshortening of parts or all of the body. We also look at capturing the figure in movement, both slow and controlled, and leaping and falling. In drawing from life, although we may attend life classes, we will often find that our models are clothed. Understanding how clothing hangs on the body is vital to making a successful figure drawing, whether it be a quick sketch or a detailed study.

PROPORTIONS OF THE HUMAN FIGURE

Here I have a front view and a back view of the male and female body. The two sexes are drawn to the same scale because I wanted to show how their proportions are very similar in relation to the head measurement. Generally, the female body is slightly smaller and finer in structure than that of a male, but of course sizes differ widely.

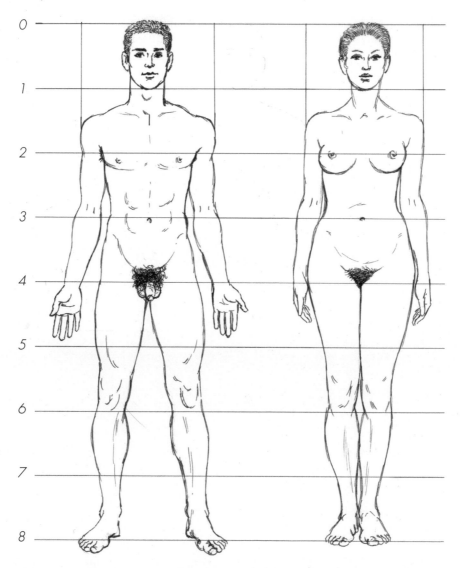

These drawings assume the male and female are both exactly the same height, with both sexes having a height of eight times the length of their head. As you can see, this means that the centre of the total height comes at the base of the pubis, so that the torso and head are the upper half of this measure, and the legs alone account for the lower half. This is a very useful scale to help you get started.

These two examples are of the back view of the two people opposite, with healthy, athletic builds. The man's shoulders are wider than the woman's and the woman's hips are wider than the man's. This is, however, a classic proportion, and in real life people are often less perfectly formed.

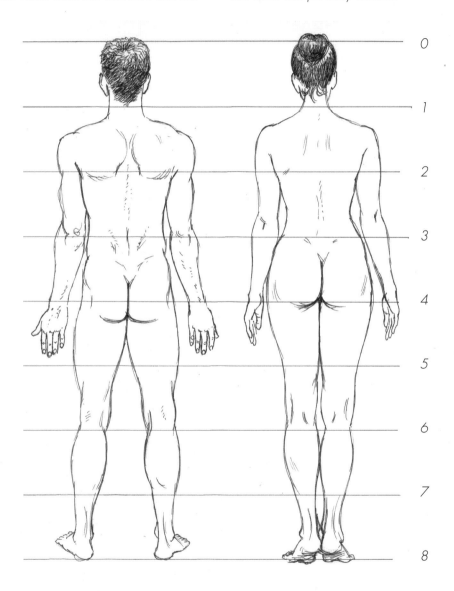

0

1

2

3

4

5

6

7

8

The man's neck is thicker in relation to his head while the female neck is more slender. Notice also that the female waist is narrower than the man's and the general effect of the female figure is smoother and softer than the man's harder-looking frame. This is due to the extra layer of subcutaneous fat that exists in the female body. These differences, including wider hips, are closely connected with the capacity for childbearing.

PROPORTIONS OF CHILDREN

The proportions of children's bodies change quite rapidly and because children grow at very different speeds what is true of one child at a certain age may not always be so true of another. Consequently, the drawings here can only give a fairly average guide to children's changes in proportion as they get older. The first thing of course is that the child's head is much smaller than an adult's and only achieves adult size at around 16 years old.

The thickness of children's limbs varies enormously but often the most obvious difference between a child, an adolescent and an adult is that the limbs and body become more slender as part of the growing process. In some types of figure there is a tendency towards puppy fat, which makes a youngster look softer and rounder. The differences between shoulder, hip and wrist width that you see between male and female adults are not so obvious in a young child, and boys and girls often look similar until they reach puberty.

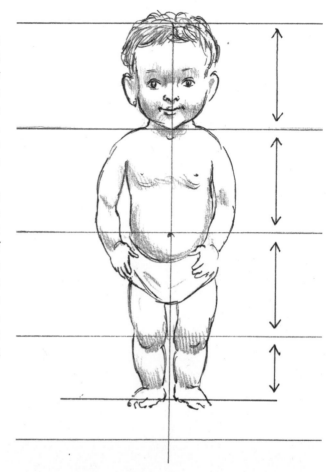

At the beginning of life the head is much larger in proportion to the rest of the body than it will be later on. Here I have drawn a child of about 18 months old, giving the sort of proportion you might find in a child of average growth. The height is only three and a half times the length of the head, which means that the proportions of the arms and legs are much smaller in comparison to those of an adult.

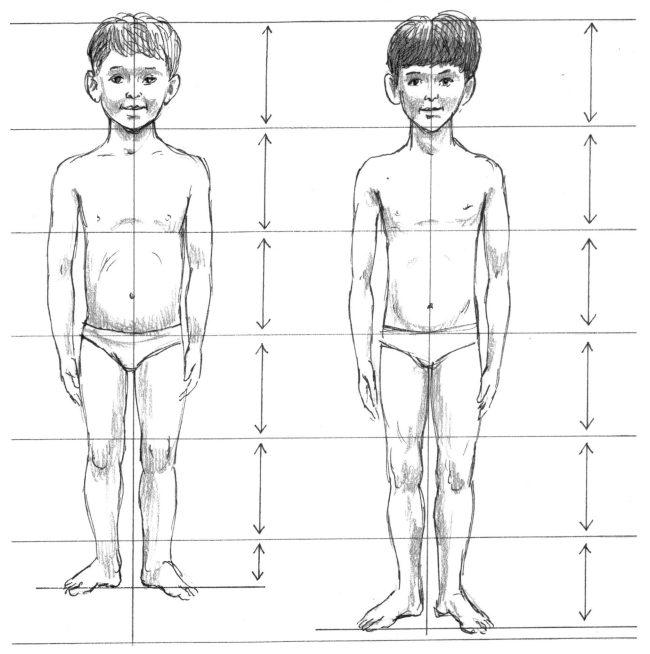

At the age of about six or seven, a child's height is a little over five times the length of the head, though again this is a bit variable. At around twelve years, the proportion is about six times the head size. Notice how for younger children the halfway point in the height of the body is much closer to the navel, but this gradually lowers until it reaches the adult proportion at the pubic bone where the legs divide. Also, the width of the body and limbs in relation to the height gradually becomes slimmer with age.

INDIVIDUAL PROPORTIONS

The greatest variation between adult bodies tends to be in the amount of flesh spread over the skeletal frame. While the proportion of head to height may be the same, body widths can be vastly different.

A broad appearance may be caused by muscle rather than surplus fat, but the distribution and appearance of the bulk will be very different.

A man who spends time working out at the gym

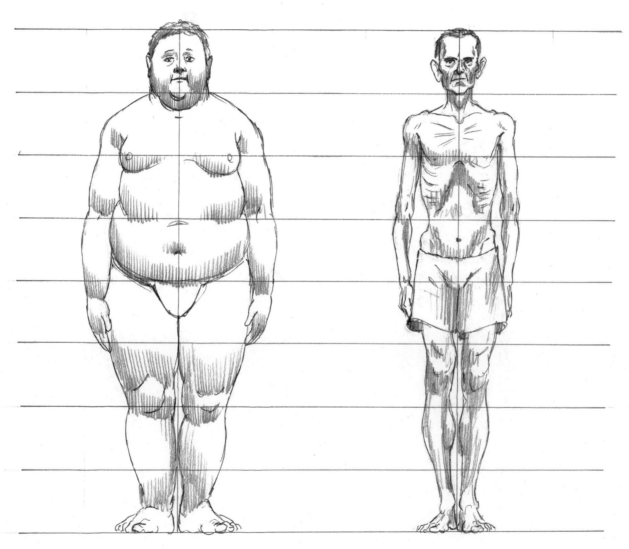

Most extra fat gathers around the central area of the body, and the first area to increase in width is usually the waist. The upper parts of the legs and arms are often thicker and there tends to be extra bulk around the neck and chest.

At the other extreme, when someone is below normal weight, the human frame is reduced to a very meagre stringy-looking shape. The width of the torso and limbs is dictated only by the bone structure.

may have thick legs and arms and wide shoulders and chest, but will not have the large waist of a couch potato. Sportsmen may have muscular development particular to their chosen field, such as the exaggerated shoulder muscles of a boxer. Although an individual's form may be extreme in one way or another, this book mainly deals with average shapes.

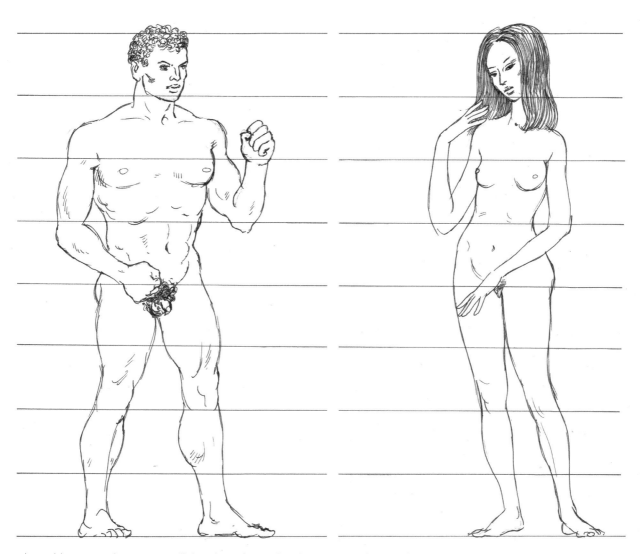

This athletic man has very well-developed muscles that enable him to be strong and powerful for his sport. Notice the large chest in relation to the narrow waist and the muscular upper arms and legs.

This female figure looks more like a gymnast or dancer, having a slender willowy look that is slim, lightweight and suggests extreme suppleness with strength.

THE TORSO

Male and female torsos present very different surfaces for the artist to draw. Because most men are more muscular than women, light will fall differently upon the angles and planes of the body and there will be more shadowed areas where the skin curves away from the light. The viewer will immediately understand these darker areas as showing muscular structure. In the case of the female torso, the shadowed areas are longer and smoother, as the planes of the body are not disrupted by such obvious muscle beneath the skin. Of course, many of the people you draw from life will not be so well toned as these models, which is where the infinite variety that makes figure drawing so rewarding starts to show.

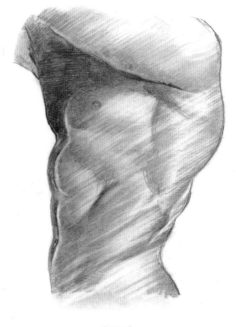

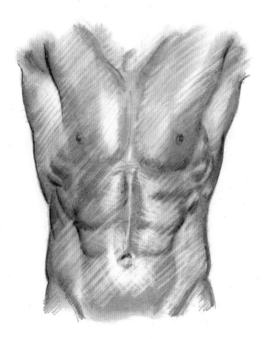

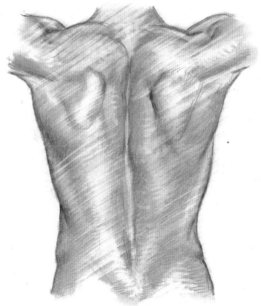

The masculine torso shown here from the front, back and side has a very distinctive set of muscles, which are easily visible on a reasonably fit man. I have chosen a very well developed athletic body to draw, which makes it very clear what lies beneath the skin.

Some of the edges of the large muscles are sharply marked, while other edges are quite soft and subtle. Showing this difference will prevent your drawing from looking like a cartoon strong-man character.

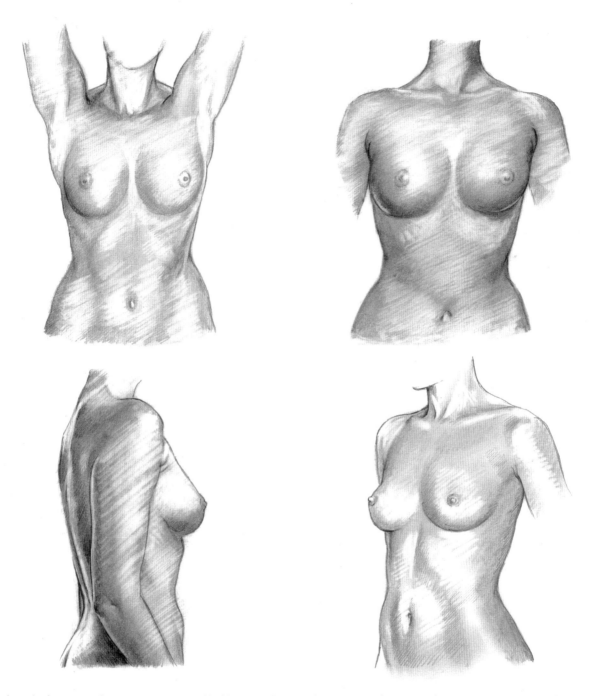

This female figure is also very young and athletic and many women will not have quite this balance of muscle and flesh. Generally speaking, the female figure shows less obvious muscle structure because of a layer of subcutaneous fat that softens all the contours of the muscles. This is why women always have a tendency to look rounder and softer than men do.

227

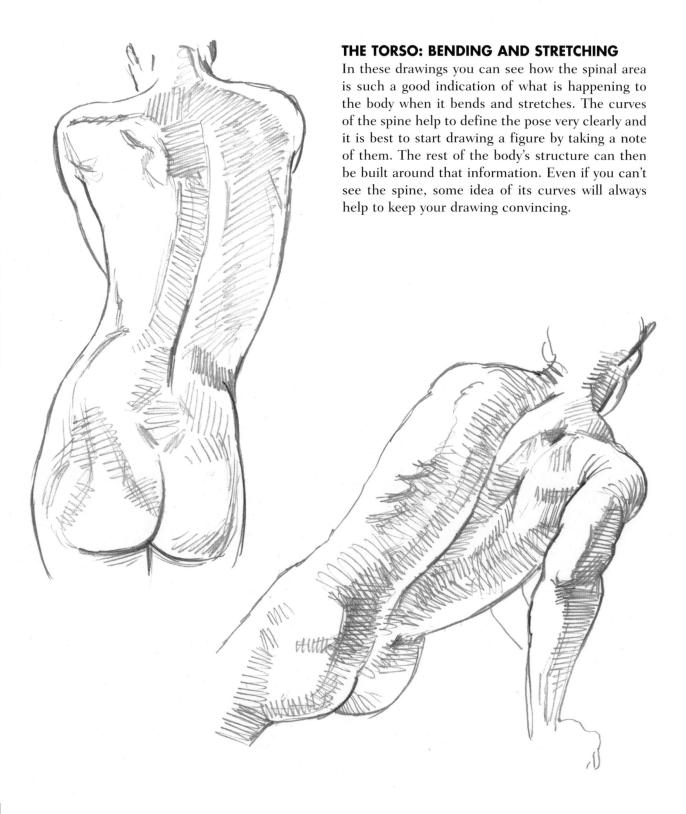

THE TORSO: BENDING AND STRETCHING

In these drawings you can see how the spinal area is such a good indication of what is happening to the body when it bends and stretches. The curves of the spine help to define the pose very clearly and it is best to start drawing a figure by taking a note of them. The rest of the body's structure can then be built around that information. Even if you can't see the spine, some idea of its curves will always help to keep your drawing convincing.

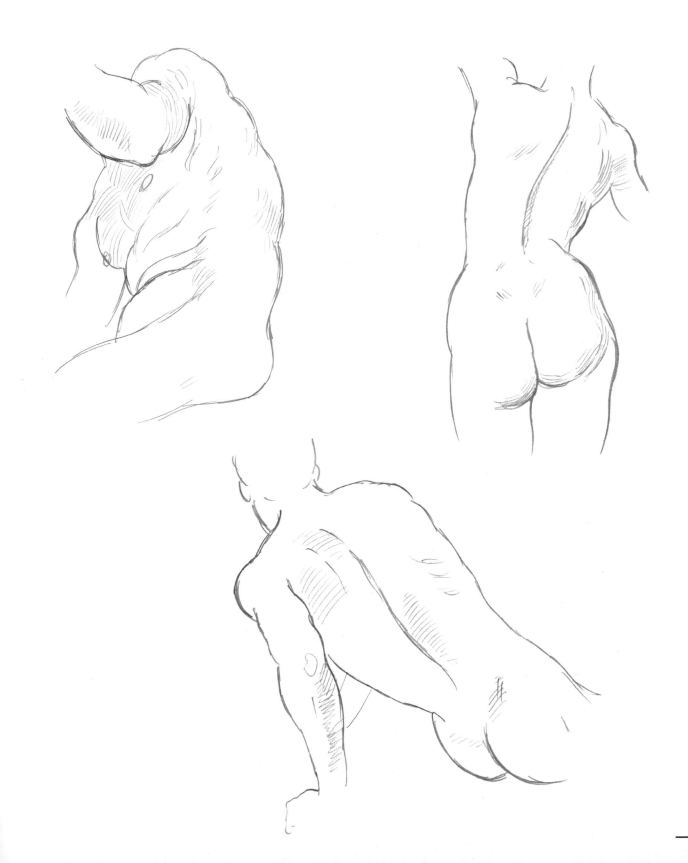

ARMS AND HANDS

The narrowness of the limb makes the musculature much more obvious than in the torso, and at the shoulder, elbow and wrist it is even possible to see points of the skeletal structure. This tendency of bone and muscle structure to diminish in size as it moves away from the centre of the body is something that should inform your drawings. Fingers and thumbs are narrower than wrists; wrists are narrower than elbows; elbows narrower than shoulders: a surprisingly large number of students draw them the opposite way round. As always, it is a matter of careful observation.

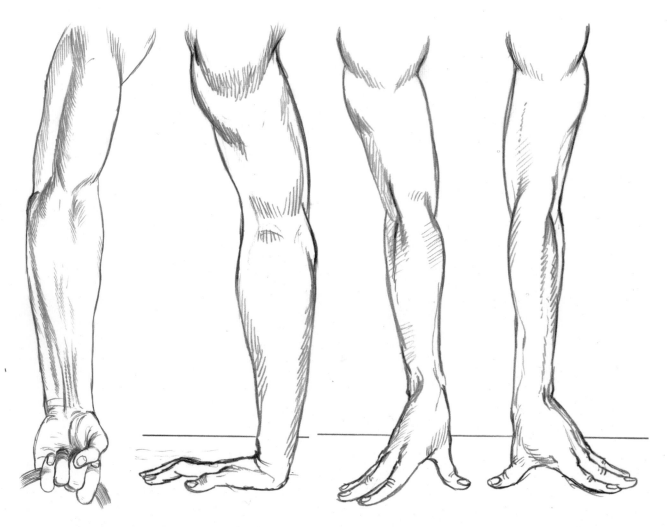

In these examples, notice how when the arm is under tension in the act of grasping an object or bearing weight, the muscles stand out and their tendons show clearly at the inner wrist. As can be seen on the page

opposite, when the arm is bent, the larger muscles in the upper arm show themselves more clearly and the shoulder muscles and shoulder blades are more defined.

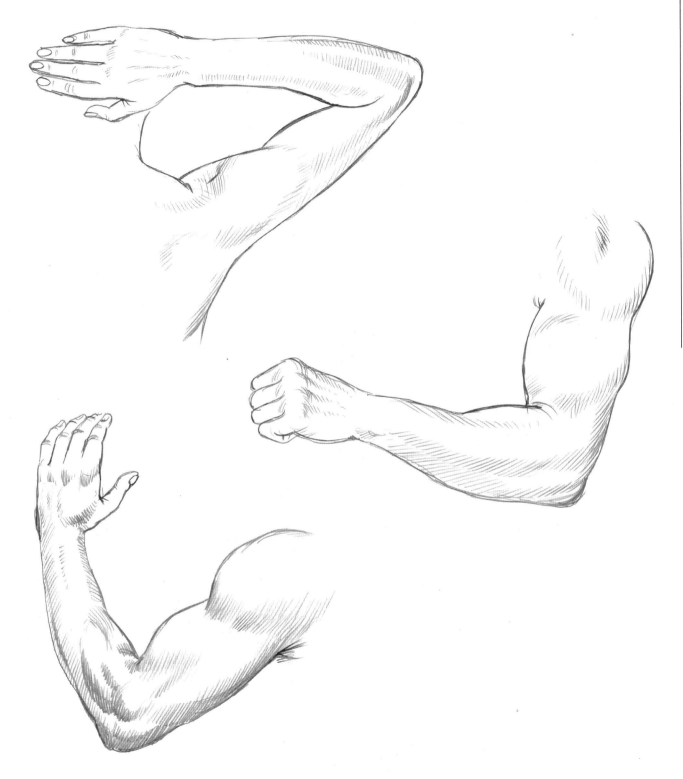

LEGS AND FEET

From the side, you will see that the muscles in the thigh and the calf of the leg show up most clearly, the thigh mostly towards the front of the leg and the calf towards the back. The large tendons show mostly at the back of the knees and around the ankle. Notice the way the patella (knee-cap) changes shape as the knee is bent or straightened. As with the arms, the bones and muscles in the leg are bigger towards the body and smaller towards the extremities.

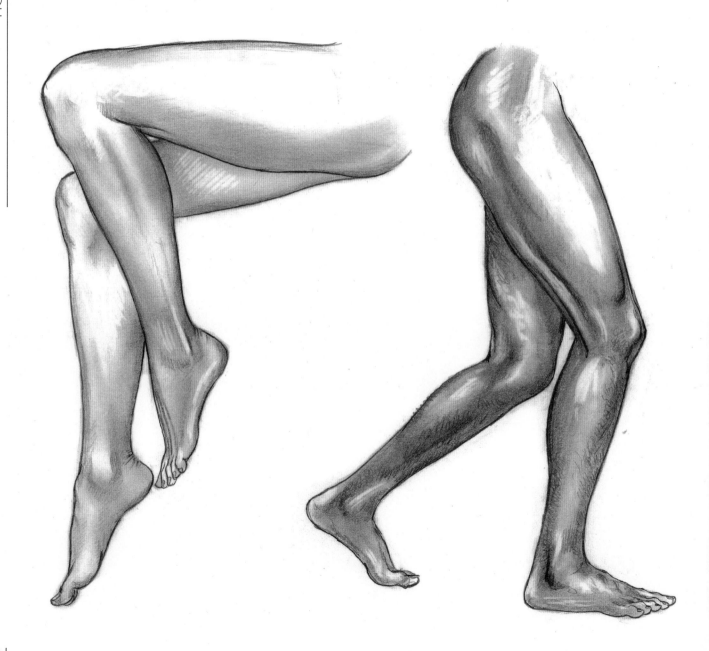

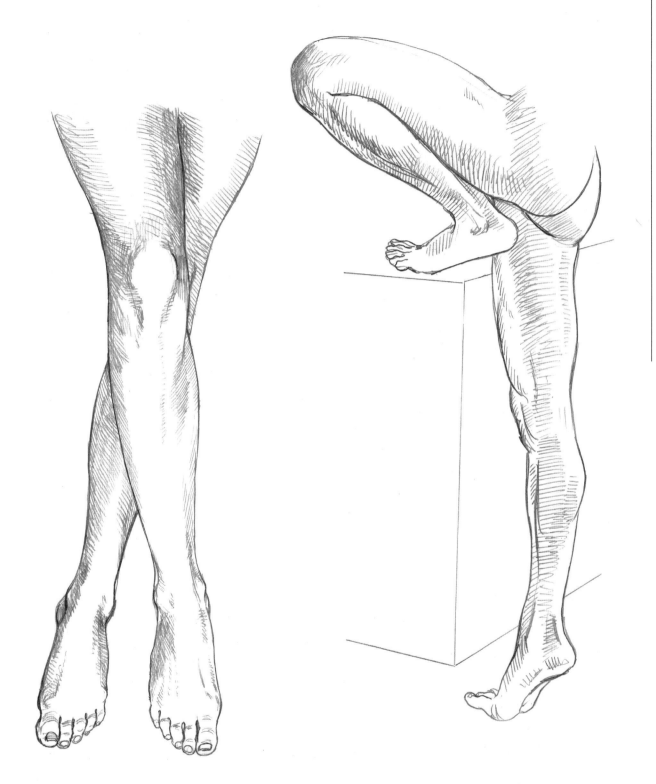

FOUR BASIC STAGES OF DRAWING A FIGURE

For a beginner first embarking on drawing the whole figure, the tendency is to become rather tense about the enormity of the task. The presence of a real live model, as opposed to a still-life object, can make you feel not only that your work may be judged and found wanting by your subject, but also by the life class you are in, and that you perhaps cannot work at your leisure.

To begin with, just think in terms of simple shapes rather than visualizing a finished drawing that you feel you are not capable of achieving. You can stop your drawing at any stage – there is no need to feel that you have to press on to a conclusion. Starting very simply, for example with a seated male figure, there are some easy ways to work your way into the task of drawing it.

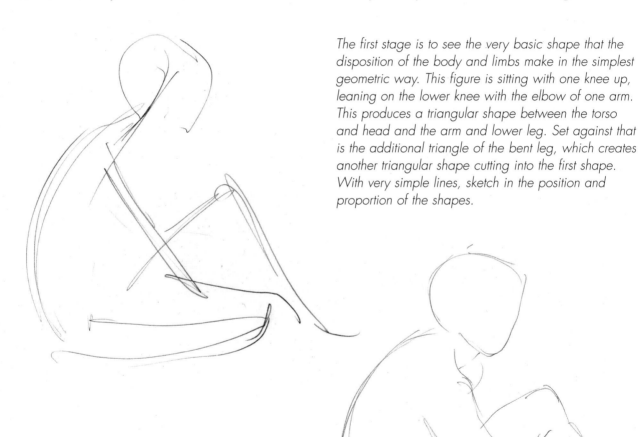

The first stage is to see the very basic shape that the disposition of the body and limbs make in the simplest geometric way. This figure is sitting with one knee up, leaning on the lower knee with the elbow of one arm. This produces a triangular shape between the torso and head and the arm and lower leg. Set against that is the additional triangle of the bent leg, which creates another triangular shape cutting into the first shape. With very simple lines, sketch in the position and proportion of the shapes.

The next stage is to indicate the actual volume of the figure by drawing curved outlines around each limb and the head and torso. I have left out the original lines of the above drawing so that you can see how much there is to draw in this stage. This drawing needs to be done quite carefully as it sets the whole shape for the finished piece of work.

The next step is to block in changes in the planes of the surface, as shown by light and shade on the body. This process needs only to be a series of outlines of areas of shadow and light. At the same time, begin to carefully define the shapes of the muscles and bone structure by refining your second outline shape, adding subtleties and details. Now you have a good working drawing that has every part in the right place and every area of light and shade indicated.

At this stage you will want to do quite a bit of correcting to make your shapes resemble your model. Take your time and work as as accurately as you can, until you see a strong similarity when you look from your drawing to the model.

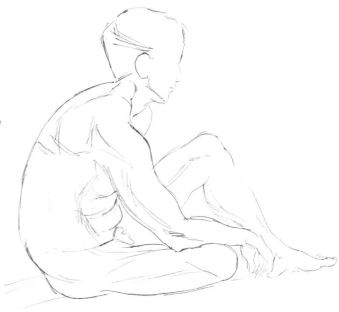

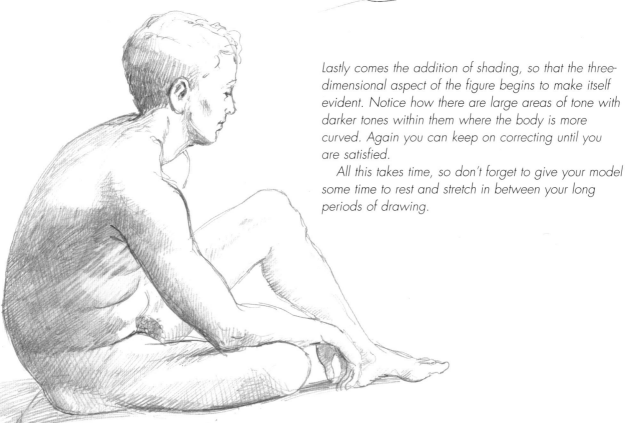

Lastly comes the addition of shading, so that the three-dimensional aspect of the figure begins to make itself evident. Notice how there are large areas of tone with darker tones within them where the body is more curved. Again you can keep on correcting until you are satisfied.

All this takes time, so don't forget to give your model some time to rest and stretch in between your long periods of drawing.

235

TACKLING A MORE DIFFICULT POSE

Once you have drawn a simple figure successfully, it is time to move on to something a little more challenging that will expand your skills further and build your confidence. This time, you will work through a similar set of stages with a female model

– but the pose is more difficult both for the model to hold and for you to draw. Go carefully, allowing yourself time for accuracy and the model adequate resting periods.

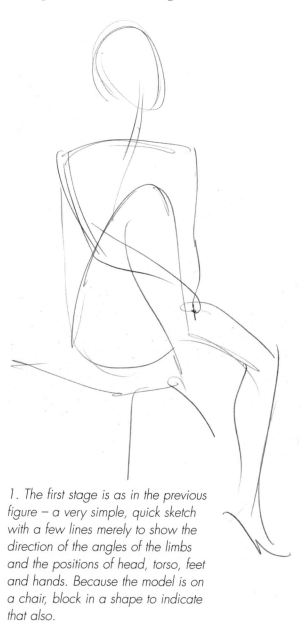

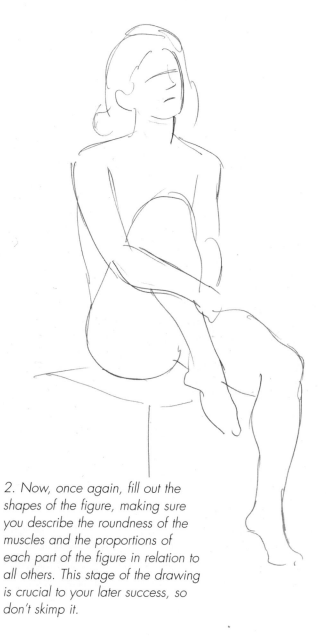

1. The first stage is as in the previous figure – a very simple, quick sketch with a few lines merely to show the direction of the angles of the limbs and the positions of head, torso, feet and hands. Because the model is on a chair, block in a shape to indicate that also.

2. Now, once again, fill out the shapes of the figure, making sure you describe the roundness of the muscles and the proportions of each part of the figure in relation to all others. This stage of the drawing is crucial to your later success, so don't skimp it.

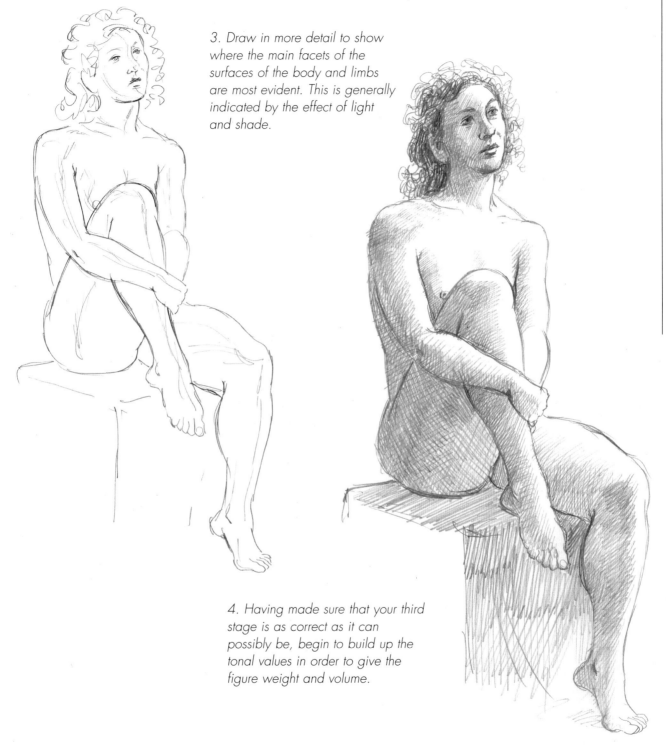

3. Draw in more detail to show where the main facets of the surfaces of the body and limbs are most evident. This is generally indicated by the effect of light and shade.

4. Having made sure that your third stage is as correct as it can possibly be, begin to build up the tonal values in order to give the figure weight and volume.

237

TRYING DIFFERENT APPROACHES

There are many techniques that you can adopt in order to improve your drawings – though there is no easy substitute for putting in hours of practice. Try the methods suggested here and familiarize yourself with them. In doing so you will begin to develop your own style and discover which method of working suits your personality best. You may find you revel in fine line drawing, or perhaps prefer to work in heavy blocks of tone.

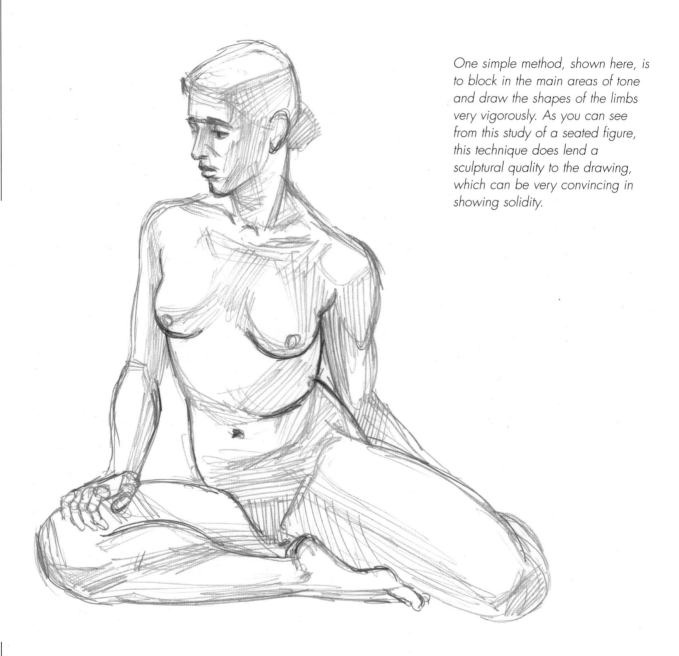

One simple method, shown here, is to block in the main areas of tone and draw the shapes of the limbs very vigorously. As you can see from this study of a seated figure, this technique does lend a sculptural quality to the drawing, which can be very convincing in showing solidity.

Another way is to draw your model's pose fairly simply from more than one angle. Therefore, if the model is sitting facing you, make a simple but effective outline sketch, then move round to the side or the back in order to draw the same pose from as many different angles as you think fit. What this does is to help you to see the pose more clearly. Although you may have to do these sketches quite fast, when you come to draw from one point of view in more detail, the knowledge you have gained about the model's pose and shape will inform your work, so that you will probably produce a much more accurate version of the pose.

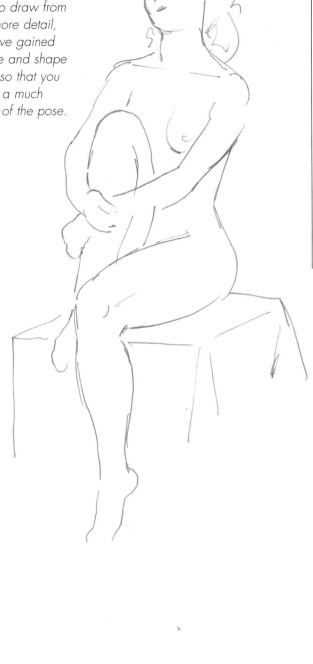

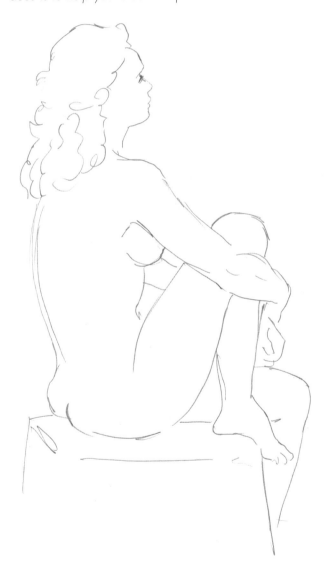

WORKING AT SPEED

Another practice, always useful for life drawing, is to draw extremely quickly with just a few fluid lines to see how fast the whole figure can be sketched in. This is encouraged by many life-class tutors as it teaches students to look for the essential lines of the pose. Practise a dozen or so drawings like these of the model, taking various one or two-minute poses and putting in the absolute minimum. You should be working so quickly you have no time to correct errors.

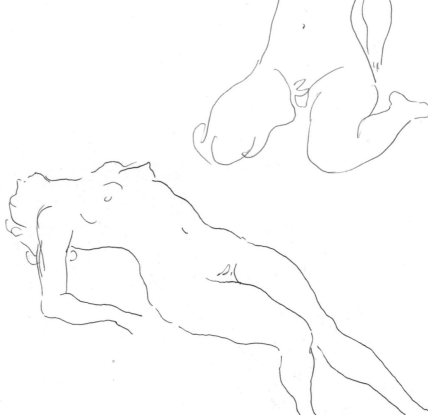

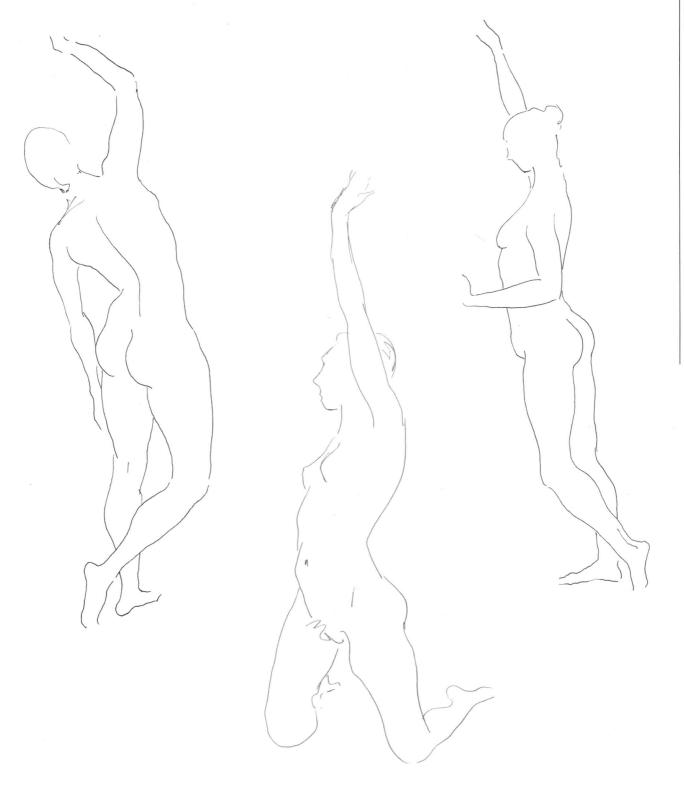

FIGURES IN PERSPECTIVE

Once you feel confident with the early stages of getting figures down on paper, you are ready to tackle the bigger challenge of seeing the figure in perspective, where the limbs and torso are foreshortened and do not look at all like the human body in conventional pose.

To examine this at its most exaggerated, the model should be lying down on the ground or a low platform or bed. Position yourself so that you are looking from one end of the body along its length and you will have a view of the human figure in which the usual proportions are all changed. Because of the laws of perspective, the parts nearest to you will look much larger than the parts farther away.

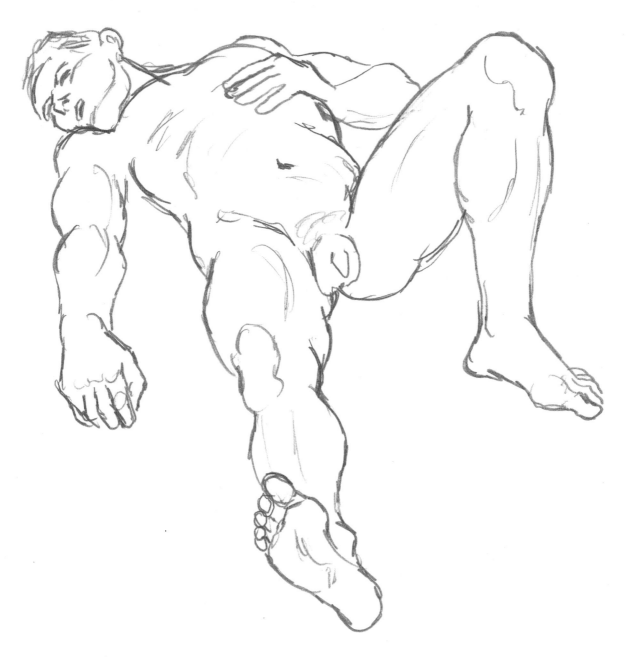

Looking at the figure from the feet end, the feet and legs look enormous and the chest and head almost disappear. The arms, with the hands towards you, look like a series of rounded bulges, with the large hands and fingers looking much wider than they are long.

Sometimes the shoulders can't be seen (see top drawing on the facing page) and the head is just a jutting jaw with the merest suggestion of a mouth, an upwardly pointing nose and the eyes, brows and hair reduced to almost nothing.

LIMBS IN PERSPECTIVE

If you are going to draw foreshortened limbs accurately, you have to discount what the mind is telling you and observe them directly, measuring if necessary to make sure that these rather odd proportions are adhered to. In this way, a limb seen from the end on (as in the illustration right) will carry real conviction with the viewer.

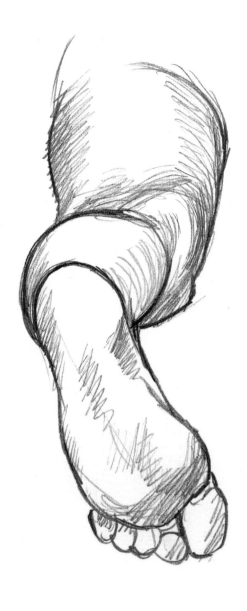

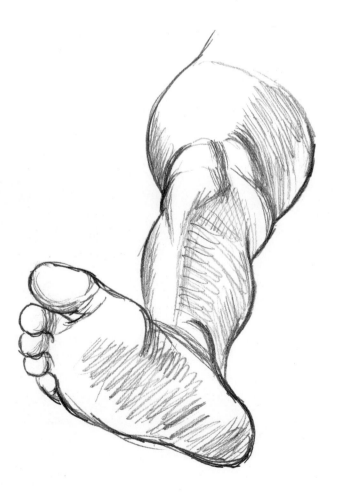

When the arm is seen from the end on, the size of the hand will often appear outrageously large, practically obscuring the rest of the arm. Seen in this perspective the bulge of any muscle or bone structure becomes the paramount shape.

It will help you make visual sense of a foreshortened hand if you view the limb as though it is one of a set of fingers attached to a hand.

Observe the shapes of the tips of the fingers and the knuckles particularly, because these too will be the dominant features of the fingers seen from end-on. The shape of the fingernail provides another good clue to seeing the finger in proper perspective. The main part of the hand loses its dominance in this position but still needs to be observed accurately.

THE FIGURE IN MOVEMENT

Drawing moving figures is not as difficult as it might seem at first, although it does need quite a lot of practice. You'll find it helpful if you can feel the movement you are portraying in your own body, because this will inform the movement you are trying to draw. The more you know about movement the better. It's a good idea to observe people on the move to check out how each part of the anatomy behaves in a range of poses and attitudes.

Photographs of bodies in action are very useful, but limited in the range they offer. It is noticeable that action shots tend to capture moments of impact or of greatest force. Rarely do you find an action shot of the movements in-between. With a bit of careful observation, watching and analyzing, you should be able to see how to fill in the positions between the extremes.

Here we see a man in the various stages of throwing a javelin. The point at which he is poised to throw and the moment when the javelin is launched are the two extremes of this process. However, you may find that drawing the man in a position between these extremes gives you a composition with more drama and tension.

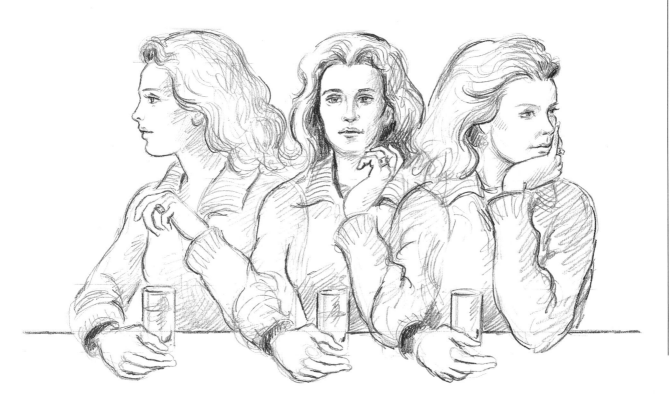

Similarly here, the point between the head completing its turn from one side to the other offers a different quality and perhaps a more revealing perspective on the subject.

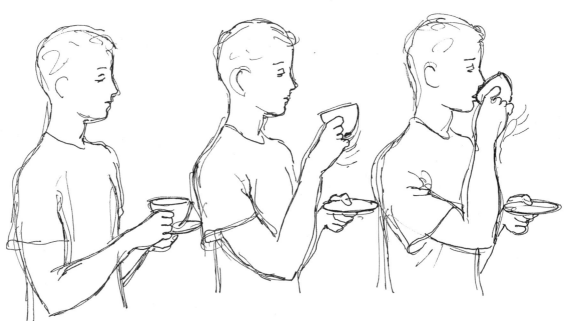

THE FIGURE IN MOVEMENT: CONTROLLED AND UNCONTROLLED

The most effective drawings of people falling accidentally capture the sheer unpredictability of the situation. In this example, the arms and legs are at all sorts of odd angles and the expression is a mixture of tension, fear and surprise. He is wondering where and how he's going to land. Deliberately, I made the line rather wobbly to echo the uncertainty of the situation.

In this example, the odd angle of the viewer's vision provides a contrast with the lines of the water and side of the pool, creating tension although it's obvious what is happening. The figure is seen from head-on, so his shoulders are much larger than his legs and feet. The slight strobe effect of the diving-board helps to give the impression that we are witnessing something first-hand, a moment frozen in time.

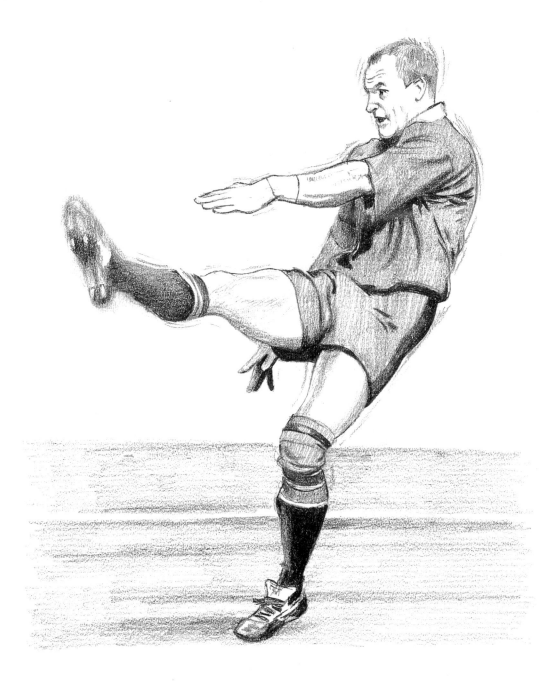

I used a clip from a newspaper as my model for this rugby player kicking a ball. My version is slightly amended from the original to accentuate the 'fuzz' of the out-of-focus kicking foot. The speed of this movement contrasts with the rest of the figure, which is much more clearly defined. The balance of the position is very important, to accentuate the force of the kick and the concentration of the kicker on those distant goalposts.

EVERYDAY CLOTHING

Your main source of models will probably be figures clad in casual modern garments such as skirts, trousers and loose coats, and here your task can be harder. These do not reveal the figure underneath, but nevertheless there are clues in the shapes of their clothing.

This drawing of a girl sitting on a window sill with her knees drawn up to her chest, shows the effect of a loose lightweight skirt rucked up in small folds and then hanging in open undulations down over the wall. The horizontal stripes of her sweater, by contrast, give a very clear idea of the shape of the torso underneath.

This full coat hugged around the figure of the girl with her hands deep in her pockets creates a tent-like shape, with the sharp, narrow folds giving some indication of the shoulders, the bend of the arms and a slight curve indicating the chest.

The stiff taffeta dress shows only the upper part of the body, but this is almost reduced to a tube shape. The skirt is so bouffant and stiff that it could disguise anything underneath and the only clue to the legs would be where the feet might be seen.

With the shirt and trousers, the lateral folds give a clear indication of the fairly bony arms under the shirtsleeves while the loose flopping folds of the lower part of the trousers define the knee. The thigh is shown because the leg is bent and the trouser is stretched across its muscles.

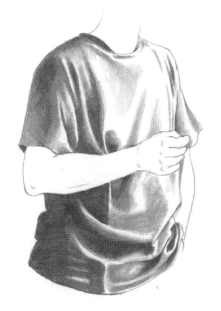

The more masculine garments here are two very typical pieces of materiality, part-disguising and part-revealing the shape underneath. The T-shirt is loose and floppy, and the solidity of the shoulders and chest is obvious. The way the folds hang down round the lower part of the torso leaves very little chance to discover the figure underneath. The only noticeable feature is the slight curve of the edge of the shirt around the hips.

CLOTHING AND MOVEMENT

Next we look at clothing and how the movement and actions of the wearer affect it. Of course, how an item of clothing behaves will depend on the type of material of which it is made, so you need to be aware of different properties and characteristics and how to render them realistically in various situations.

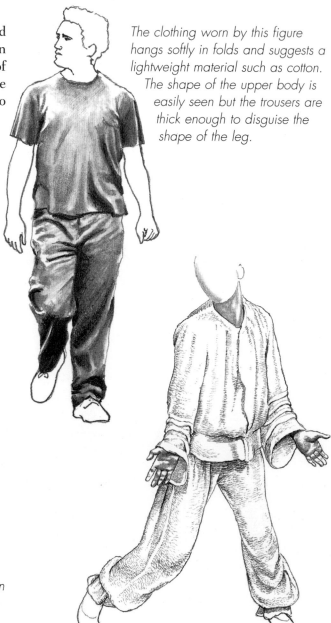

The clothing worn by this figure hangs softly in folds and suggests a lightweight material such as cotton. The shape of the upper body is easily seen but the trousers are thick enough to disguise the shape of the leg.

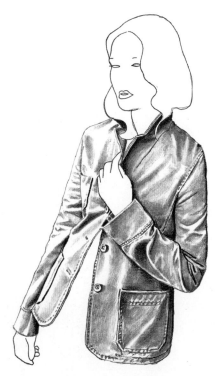

The simple movement of a girl pulling on her jacket produces all sorts of wrinkles and creases in a rather stiff material. The creases at the bend of the arm are relatively soft, however, which generally indicates an expensive material. As the American Realist painter Ben Shahn, remarked, 'There is a big difference between the wrinkles in a $200 suit and a $1,000 suit.' (This was said in the 1950s, so the prices are relative.) What he was remarking on was the fact that more expensive materials fold and crease less markedly and the creases often fall out afterwards, whereas a suit made of cheaper materials has papery looking creases that remain after the cloth has been straightened.

This drawing (above) was made from a picture of a dancer playing a part. The baggy cotton-like material has a slightly bobbly texture and its looseness in the sleeves and legs serves to exaggerate his movements.

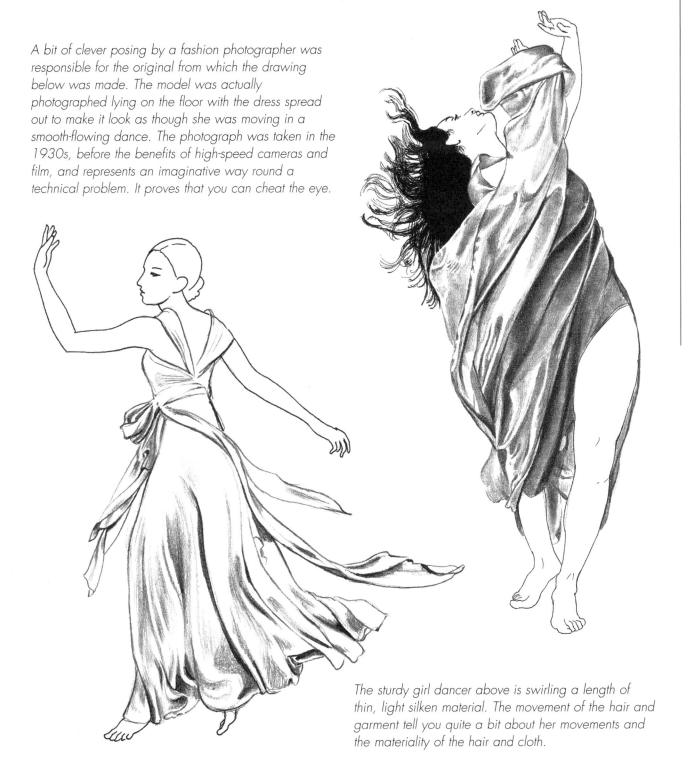

A bit of clever posing by a fashion photographer was responsible for the original from which the drawing below was made. The model was actually photographed lying on the floor with the dress spread out to make it look as though she was moving in a smooth-flowing dance. The photograph was taken in the 1930s, before the benefits of high-speed cameras and film, and represents an imaginative way round a technical problem. It proves that you can cheat the eye.

The sturdy girl dancer above is swirling a length of thin, light silken material. The movement of the hair and garment tell you quite a bit about her movements and the materiality of the hair and cloth.

Here are three drawings of different clothing that show different effects of folds and creases, mainly due to the type of material used in each case.

These jeans, made of tough hard-wearing cotton, crease easily and characteristically, and the creases remain even when the wearer is moving.

A couture garment made of heavy satin and tailored to keep the folds loose and mainly vertical. The movement is not extreme and so the weight and smoothness of the material ensure an elegant effect.

When you come to draw this type of material be sure to get a strong contrast between dark and light to capture the bright reflective quality of the garment.

The raincoat sleeve shown below is similar in character to our first example: a stiffish material but one made to repel water and so has a very smooth sheen. The folds are large, the sleeve being loose enough to allow ease of movement. Even in this drawing, they look as though they would totally disappear when the arm was straightened.

MAKING QUICK SKETCHES

One of the best ways to learn to draw figures without worrying about the results is to take your sketchbook to a busy event in the summer where people are enjoying their leisure time. You will see all sorts of characters, both stationary and in motion, and if they are engrossed in their doings you will not feel self-conscious about sketching them.

Draw in as few lines as you possibly can, leaving out all details. Use a thick, soft pencil to give least resistance between paper and drawing medium and don't bother about correcting errors. Keep drawing almost without stopping. The drawings will gradually improve and what they will lack in significant detail they will gain in fluidity and essential form. Only draw the shapes that grab the eye. Don't make choices; just see what your eye picks up quickly and what your hand can do to translate this vision into simple shapes. This sort of drawing is never a waste of time and sometimes the quick sketches have a very lively, attractive quality.

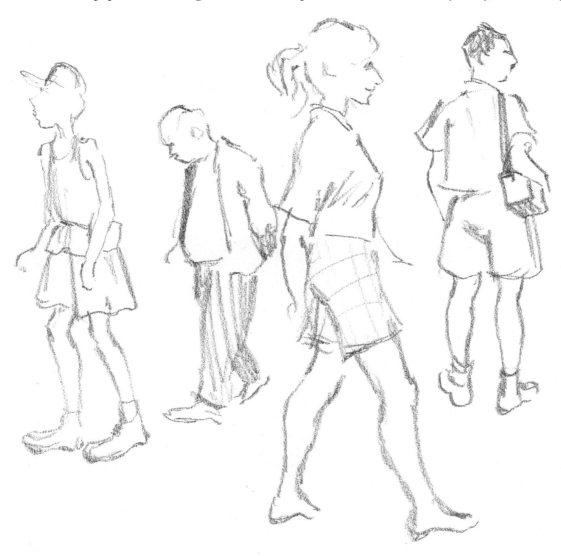

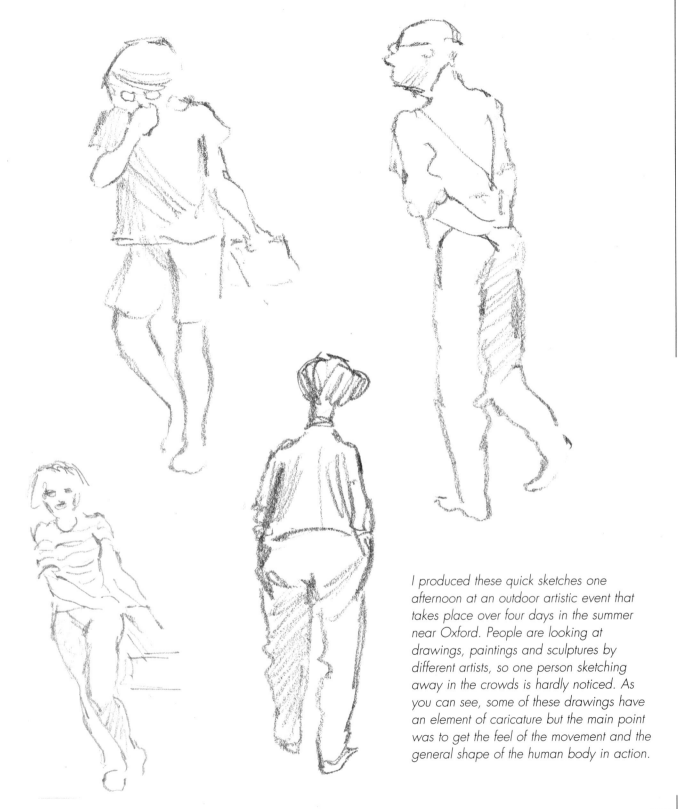

I produced these quick sketches one afternoon at an outdoor artistic event that takes place over four days in the summer near Oxford. People are looking at drawings, paintings and sculptures by different artists, so one person sketching away in the crowds is hardly noticed. As you can see, some of these drawings have an element of caricature but the main point was to get the feel of the movement and the general shape of the human body in action.

LIFE DRAWING CLASSES

Drawing from life is the foundation of all drawing and of course this is particularly so in the case of figure drawing. The human body is the most subtle and difficult thing to draw and you will learn more from a few lessons in front of a model than you ever could, drawing from photographs or the like.

In most urban areas, life drawing classes are not too difficult to come by and if there is an adult education college or an art school that offers part-time courses it would be the most excellent way in which to improve your drawing. Even professional artists will attend life drawing classes whenever possible, unless they can afford their own models. These classes are limited to people over the age of 16 because of the presence of a nude model.

One of the great advantages of life classes is that there is usually a highly qualified artist teaching the course. The dedication and helpfulness of most of these teachers of drawing will enable you to gradually improve your drawing step by step, and the additional advantage of having other students from beginners to quite skilful practitioners, will encourage your work by emulation and competition.

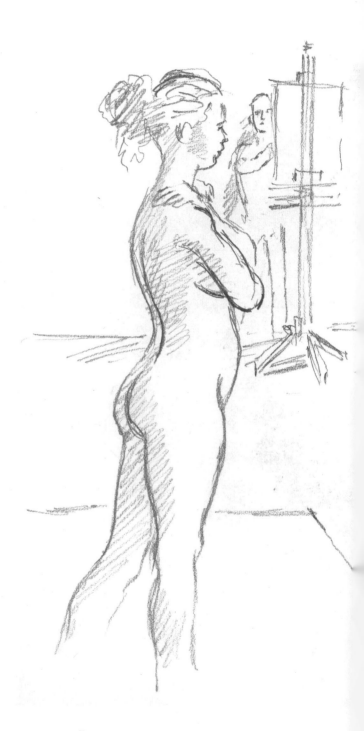

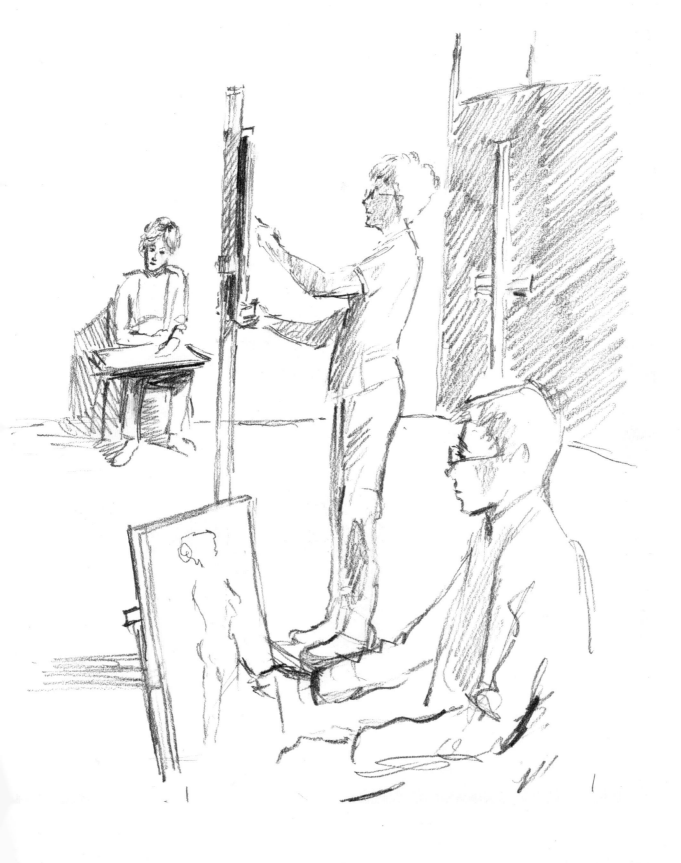

EXTREMES OF EXPRESSION

Artists in all ages have been interested in extremes of expression and experimenting with grotesque or humorous depictions of faces and bodies.

In the medieval period, they were found in sculpted stone gargoyles on chapels and cathedrals. Later, during the Renaissance, celebrated artists such as Leonardo drew grotesque faces and heads, in some instances taking them to fantastic extremes. The development of printing techniques enabled artists with a social or political message to take caricature beyond the realms of pure fun. William Hogarth campaigned vigorously against a number of social ills through his work. In our own time the production of cartoons on film has led to the extension of the art to television.

Inexperienced artists try so hard to be technically correct that often they turn out drawings that look wooden and lack expression. Caricature is a great antidote, helping to free us from an over-reliance on accuracy and to find a genuine means of expression in our work. Although the techniques we have learned for measuring proportion and portraying three dimensions on paper are invaluable, do not let yourself be limited by them – expression and humour in a drawing can be equally powerful.

GROTESQUES TO FANTASY

Leonardo da Vinci has left us many extraordinary examples of caricature which are undoubtedly not true to life but still recognizable. No one knows why the great man was so fascinated by this type of drawing but perhaps it is not surprising he wanted to see how far he could go with it.

In the second half of the 16th century the Milanese painter Giuseppe Arcimbaldo took caricature in a different direction, producing fantasy portrait heads in which the features were composed of clusters of fruit and vegetables. Some later commentators considered him to be an ancestor of the Surrealists.

Examples from both artists are seen here.

The features of this man (original by Leonardo) are greatly exaggerated and can in no way be taken as realistic – nose protuding, mouth pushed up at the centre and down at the sides. The great lump of a chin completes the ludicrous effect, which glazed eyes and rather lumpy ears don't diffuse.

This second copy of a Leonardo is more realistic apart from the protruding jaw which is taken to unnatural lengths. The first face looked rather stupid; this one looks more intelligent and even kindly.

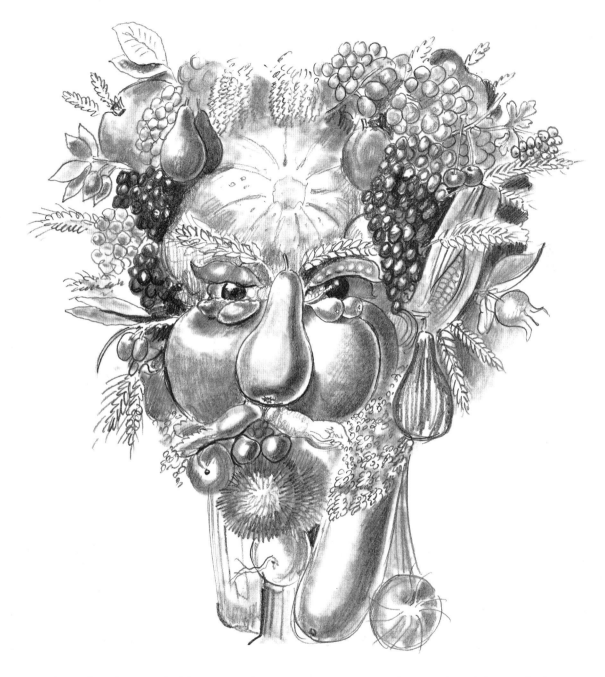

This extraordinary face by Arcimbaldo is reputed to be of the Hapsburg Emperor Rudolph II. Although made up of fruit and vegetables it is easily readable as a particular human face. The drawing is an amusing conceit but one doesn't know whether it was meant to make fun of its subject or was just a curious exercise in ingenuity.

CARICATURE AS SATIRE

The work of the great caricaturists was born out of social and political turmoil. Hogarth, Rowlandson and Gillray, three of Britain's greatest exponents of caricature, came to the fore at a time of unprecedented change. All three were valued more for their caricaturing skills than their serious gifts, an oversight that was particularly hard on Hogarth, who was undoubtedly a major artist.

In Spain, Francisco Goya was also railing against the injustices and follies he saw around him. He chronicled the horrors of the occupation by Napoleon's armies in both paint and ink. In his smaller studies we get snapshots of the human condition in extremes of expression that ring true.

Hogarth's view of the journalist and political agitator John Wilkes.

A money-lender as seen through the sharp eye of Rowlandson.

In his series of drawings known as 'Los Caprichos', Goya castigated a host of iniquities. Here he directs his venom against the Catholic Church, represented by two rather disreputable looking monks.

At the end of the 18th century Napoleon became a target for English caricaturists, who, like their countrymen, feared what might happen once he had overrun mainland Europe. Initially portrayed by them as a tiny monkey-like character with a big hat, he evolved into a portly villain with a scowl and a big chin.

No one was safe from the caricaturists' pen, even the Duke of Wellington, a great hero of the popular press thanks to his victories in the Napoleonic Wars. The treatment of him in these two contemporary examples (right), after he had swapped his uniform for a frock coat and entered Parliament, is fairly good natured.

Political leaders at home came in for just as much attack from the caricaturists as their foreign counterparts. In these two examples (right) it is a weaselly-looking William Pitt the Younger by Gillray. Fresh-faced in the first illustration (he was after all only 24 when he became British Prime Minister for the first time), he seems to have matured a little in the second, with clusters of freckles on the nose and cheek and the makings of a moustache and beard.

Pitt's great political rival, Charles James Fox, by Rowlandson.

CARICATURE AS ART

In 19th-century France, political comment was often mixed with an illustrative kind of art which combined to make a rather strange brew. The result was certainly caricature but of a type that was more finished and obviously polished. The Salon culture of the French art world would have been horrified by less. The influence of the Impressionists would soon be felt, however, even in caricature.

Honoré Daumier made many drawings which hovered at the edges of caricature. The first of the two examples of his work shown here is from a French treatise on suffrage. The second, taken from a journal, is of 19th-century France's leading literary figure, Victor Hugo, hence the immense brow.

Jean-Louis Forain was a regular contributor to journals as a caricaturist and graphic artist. This example of his work shows a departure in style from the satirical drawing usually seen in France up to this time. Very few lines have been used to depict the sleek, moustachioed bourgeois gentleman in evening dress.

An early caricature by Impressionist Claude Monet of his art teacher.

A contemporary of Forain, Arthur Rackham became popular for his book illustrations, especially of children's stories. Rackham's imaginative approach went down well not only with children, who were sometimes almost frightened by them, but by their parents who particularly admired his finely drawn grotesquerie.

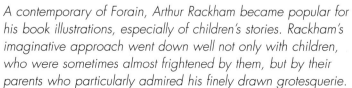

STEREOTYPING

All the well-known public figures of the last fifty years or so are mostly remembered by us because we are familiar with caricature images of them we have seen in newspapers and magazines and on films and television.

As well as emphasizing perceived personal weaknesses or humorous aspects of public figures, caricature can also be used creatively to suggest solid virtues, such as those of perhaps the two most famous national stereotypes of all time, Uncle Sam and John Bull.

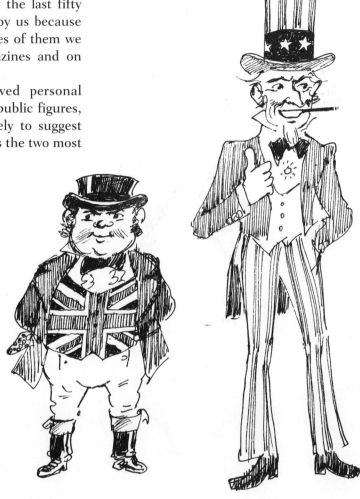

A century separates the creation of Uncle Sam (c.1812) and John Bull (c.1712), the one epitomizing the US government and the other the average British citizen.

The great dictators of the 20th century are rather better known by their cartoon images than their real faces.

Hitler *Mussolini* *Stalin* *Mao*

MODERN TRENDS

The modern trend in caricature is to fix on one or two obvious physical characteristics and subordinate everything else to the effect these create. Presenting an absolute minimum likeness can only work, of course, if an audience is very familiar with the figures depicted. In the following examples, aimed at a British market, note that the caricatures of the two lesser known figures, Murdoch and Le Pen, are more carefully drawn than the others.

British Prime Minister Tony Blair and his wife, Cherie.

Former US President Bill Clinton.

Australian media tycoon Rupert Murdoch.

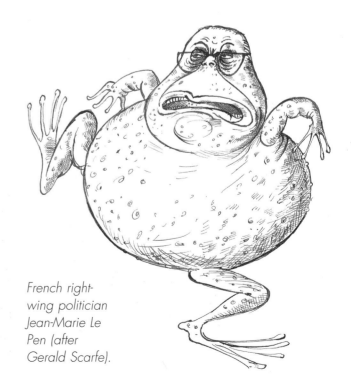

French right-wing politician Jean-Marie Le Pen (after Gerald Scarfe).

BUILDING A CARICATURE

The process of turning a perfectly normal-looking person into a cartoon figure to accentuate their traits is the same whether the subject is familiar to millions of households or just one. It can be a fun exercise. The subject I have chosen here is my eldest son. His features are perfectly normal, but as I know quite a lot about him I can accentuate certain areas to bring out his personality to the casual observer. Let's begin the process.

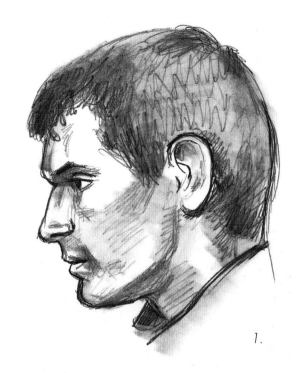

1. It is a good idea first to draw the person you wish to caricature several times, to get to know the shapes of their features and how these relate to each other.

1.

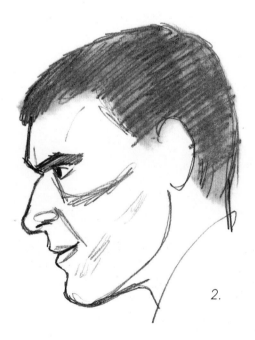

2.

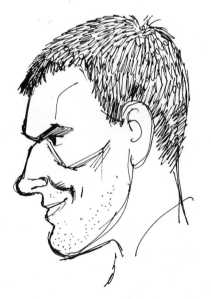

1.

3.

2. I have slightly exaggerated his way of staring intensely, his bony physiognomy, strong jaw. I've also tried to suggest his height (6ft 4in).

3. Here I begin to produce something like a caricature. Notice how I have made him grin, although he wasn't doing this when I drew him. People who know him are familiar with his broad, up-turning grin, intense stare, large bony forehead, nose, cheekbones and jaw, and these are the characteristics I have tried to bring out.

EXPERIMENTING

I could have taken that final illustration further and gone on until all superfluous lines had been deleted. You can do this more effectively if you know your subject well. You need knowledge to be able to build into your caricature attitudes, movements and favourite expressions, in order to inject a bit of humour as well as get across a likeness with a minimum of detail.

Here are two examples for you to experiment with and see how far you can take the exaggeration before the subject becomes unrecognizable. Try to capture the obvious features first and then the general effect of the head or face.

Don't try caricaturing your friends, unless you don't mind losing them or they agree. If you can't get the subject you want to pose for you, try to obtain good photographs of them. These won't provide quite such good reference, but as long as you draw on your knowledge of the person as well, they should be adequate.

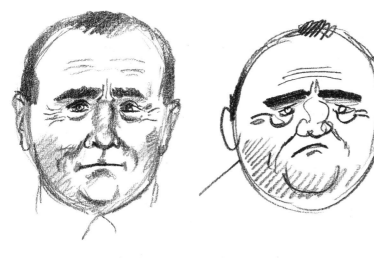

Normal

Exaggerated

Identifiying Features:
1. Round head
2. Fat chin
3. Grim mouth
4. Heavy, anxious eyebrows
5. Little eyes with bags
6. Blobby or broken nose
7. Wrinkles and unshaven chin

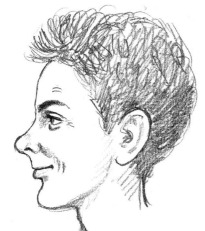

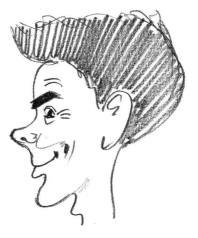

Identifiying Features:
1. Round-ended, turned-up nose
2. Bright eye
3. Thick eyebrows
4. Big hair on top
5. Chin
6. Cheeky grin

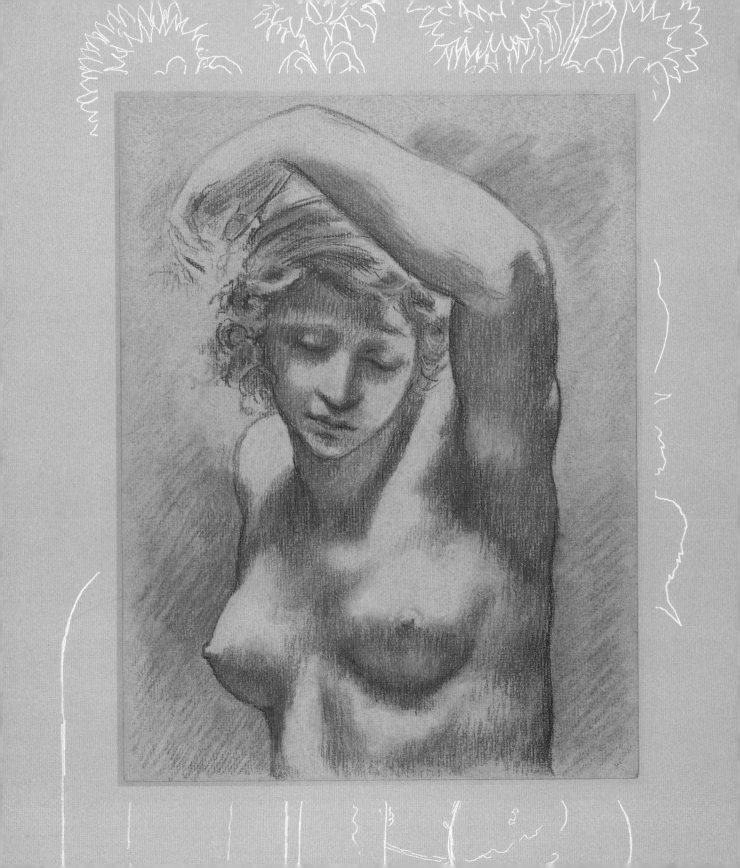

STYLES AND TECHNIQUES

To develop an individual style and method of working, you have to experiment. This is quite easy, given the wide range of materials and implements available. Next, we consider different implements and papers and the effects that can be achieved with them – for example, various types of pencil, as well as pen and ink, line and wash, chalk, pastel and charcoal. We also look at scraperboard, a technique not used very much these days, and some rather interesting if labour-intensive ways of making marks on paper.

In addition we look at some of the approaches to the art of drawing taken by different artists at different times. Some of these may seem alien or too different from the way of working you are used to. Don't be concerned if this is the case. Experimentation gives us the opportunity to discover new techniques and approaches, and to incorporate them in our work. You may find a technique that particularly suits your manner of drawing still-life, or figures. Try your hand at as many as you can, and see if you can invent a new style. The main point is to have some fun.

IMPLEMENTS AND MATERIALS

The implements we draw with are important, as is the material we draw on. A keen artist will draw with anything and make it work to his advantage. Artists have to draw, no matter the situation they are in. If nothing else is available, they'll use sticks in sand, coal on whitewashed walls, coloured mud on flat rocks – anything to be able to draw. If you don't have a wide range of equipment at your disposal, don't let that stop you. Use whatever is to hand. However, if at all possible, supply yourself with the best materials you can afford. If you try as many new tools and materials as you can, you will discover what suits you best. Here are some obvious basic implements.

PENCIL

The simplest and most universal tool of the artist is the humble pencil, which is very versatile. It ranges from very hard to very soft and black (H, HB, B, 2B, etc.) and there are differing thickness. Depending on the type you choose, pencil can be used very precisely and also very loosely.

You should have at least three degrees of blackness, such as an HB (average hardness and blackness), 2B (soft and black) and 4B (very soft and black).

For working on a toned surface, you might like to try white carbon pencil.

GRAPHITE

Graphite pencils are thicker than ordinary pencils and come in an ordinary wooden casing or as solid graphite sticks with a thin plastic covering. The graphite in the plastic coating is thicker, more solid and lasts longer, but the wooden casing probably feels better. The solid stick is very versatile because of the actual breadth of the drawing edge, enabling you to draw a line a quarter of an inch thick, or even thicker, and also very fine lines. Graphite also comes in various grades, from hard to very soft and black.

CHARCOAL

Charcoal pencils are excellent when you need to produce dimensional images on toned paper and are less messy than sticks of charcoal and chalk.

However, the sticks are more versatile because you can use the long edge as well as the point. Drawings in this type of media need 'fixing' with spray-can fixative to stop them getting rubbed off, but if interleaved with pieces of paper they can be kept without smudging.

CHALK

This is a cheaper and longer-lasting alternative to white conté or white pastel.

PEN

Push-pens or dip-pens come with a fine pointed nib, either stiff or flexible, depending on what you wish to achieve. Modern fine-pointed graphic pens are easier to use and less messy but not so versatile, producing a line of unvarying thickness. Try both types.

The ink for dip-pens is black 'Indian ink' or drawing ink; this can be permanent or water-soluble.

BRUSH

A number 0 or number 2 nylon brush is satisfactory for drawing. For applying washes of tone, a number 6 or number 10 brush, either in sablette or sable or any other material capable of producing a good point, is recommended.

PAPER AND BOARD

Any decent smooth cartridge paper is suitable for drawing. A rougher surface gives a more broken line and greater texture. Try out as many different papers as you can. For brushwork, use a modestly priced watercolour paper to start with.

Scraperboard has a layer of china clay which is thick enough to allow dry paint to be scraped off but thin enough not to crack off. It comes in black and white. White scraperboard is the more versatile of the two, and allows the ink to be scraped with a sharp point or edge when it is dry, to produce interesting textures or lines. The black version has a thin layer of black ink printed evenly over the whole surface, which can be scraped away to produce a reverse drawing resembling a woodcut or engraving. The more unusual techniques involving scraperboard are dealt with later in this section.

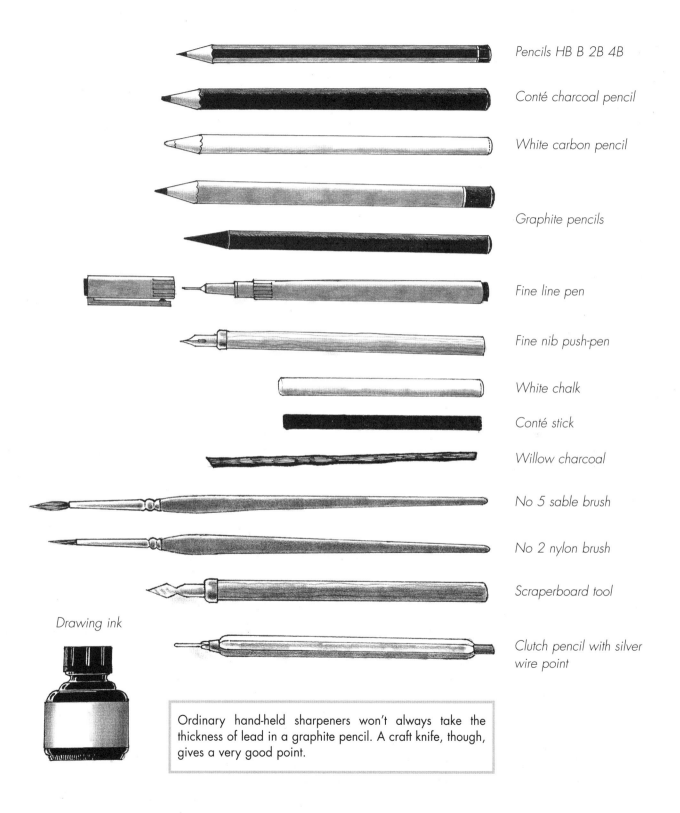

Pencils HB B 2B 4B

Conté charcoal pencil

White carbon pencil

Graphite pencils

Fine line pen

Fine nib push-pen

White chalk

Conté stick

Willow charcoal

No 5 sable brush

No 2 nylon brush

Scraperboard tool

Clutch pencil with silver wire point

Drawing ink

Ordinary hand-held sharpeners won't always take the thickness of lead in a graphite pencil. A craft knife, though, gives a very good point.

PENCIL DRAWING

Pencil can be used in many ways. When it was invented – sometime in the 17th century – it revolutionized artists' techniques because of the enormous variety of skilful effects that could be produced with it, and soon came to replace well established drawing implements such as silver-point.

The production of pencils in different grades of hardness and blackness greatly enhanced the medium's versatility. Now it became easy to draw in a variety of ways: delicately or vigorously, precisely or vaguely, with linear effect or with strong or soft tonal effects.

Here we have several types of pencil drawing, from the carefully precise to the impulsively messy, from powerful, vigorous mark making to soft, sensitive shades of tone.

Michelangelo (right) is a good starting point for ways of using pencil. His work was extremely skilful and as you can see from this drawing his anatomical knowledge was second to none. The careful shading of each of the muscle groups in the body gives an almost sculptural effect, which is not so surprising when you consider that sculpture was his first love. To draw like this takes time and patience and careful analysis of the figure you are drawing.

Titian's drawing, however, is quite different. His knowledge of colour was so good that even his drawings look as though they were painted. He is obviously feeling for texture and movement in the space and not worried about defining anything too tightly. The lines merge together to make a powerful tactile group.

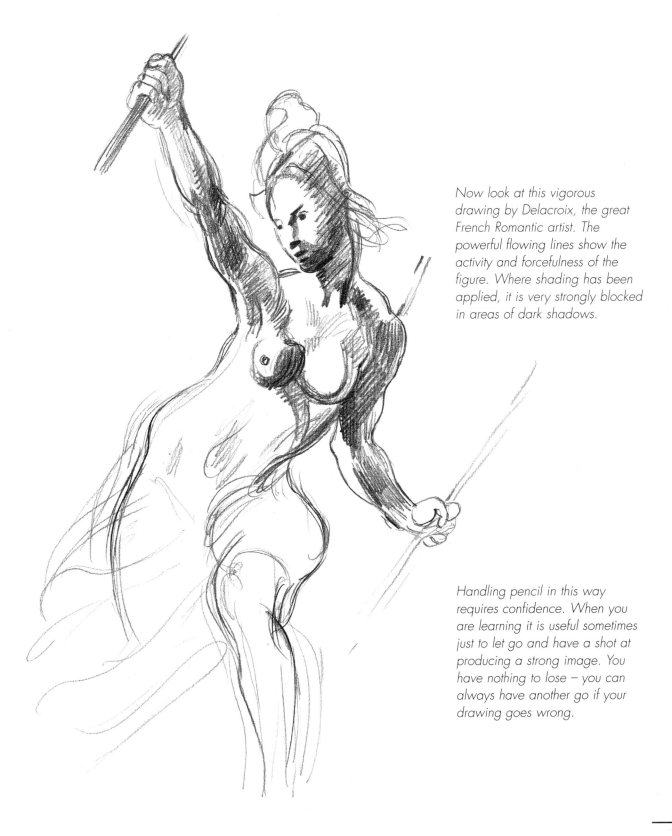

Now look at this vigorous drawing by Delacroix, the great French Romantic artist. The powerful flowing lines show the activity and forcefulness of the figure. Where shading has been applied, it is very strongly blocked in areas of dark shadows.

Handling pencil in this way requires confidence. When you are learning it is useful sometimes just to let go and have a shot at producing a strong image. You have nothing to lose – you can always have another go if your drawing goes wrong.

PRECISION

In these examples, the pencil is used almost scientifically with the line taking pre-eminence. Sometimes it is used to produce an exact representation of form, sometimes to show the flow and simplicity of a movement.

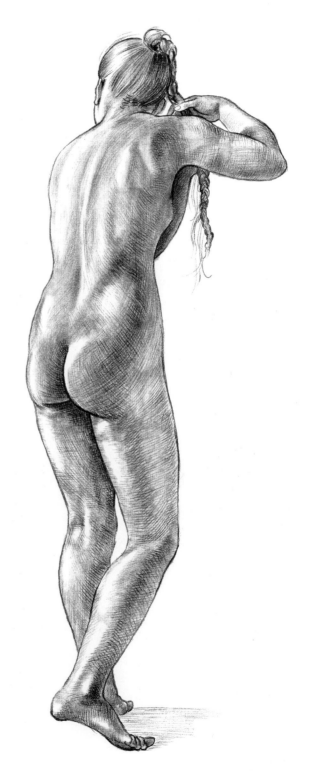

This meticulous pencil drawing, by the German Julius Schnorr von Carolsfeld, is one of the most perfect drawings in this style I've ever seen. The result is quite stupendous, even though this is just a copy and probably doesn't have the precision of the original. Every line is visible. The tonal shading which follows the contours of the limbs is exquisitely observed. This is not at all easy to do and getting the repeated marks to line up correctly requires great discipline. It is worth practising this kind of drawing because it will increase your skill at manipulating the pencil and test your ability to concentrate.

THE SIMPLE OUTLINE

In different ways, all the drawings on this page use a simple outline. Such simplicity serves to 'fix' the main shape of the drawing, ensuring the effect of the additional detailed shading.

A much more economical method of drawing has been used for two of the drawings here, but note that this has not been at the expense of the information offered about the subjects depicted.

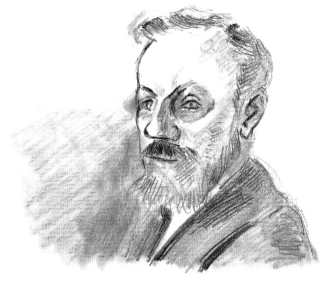

Both Matisse (copy of a self-portrait, above) and Victor Ambrus (left) appear to have used several different grades of pencil for these drawings; some lines are very soft and black, others much less so. Knowing how far to go is an art in itself. Ambrus has achieved balance by outlining the main shape of the dog with a soft grey line and then adding details of the curly hair and dark ears, head and nose with darker, crisper lines.

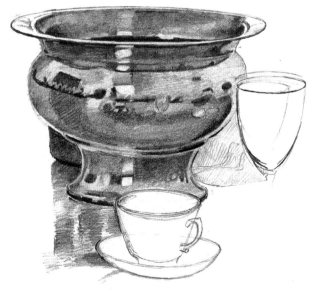

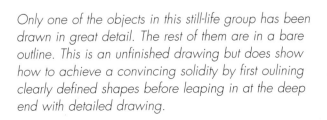

Only one of the objects in this still-life group has been drawn in great detail. The rest of them are in a bare outline. This is an unfinished drawing but does show how to achieve a convincing solidity by first oulining clearly defined shapes before leaping in at the deep end with detailed drawing.

PEN AND INK

Pen and ink is special, in that once you've put the line down it is indelible and can't be erased. This really puts the artist on his mettle because, unless he can use a mass of fine lines to build a form, he has to get the lines 'right' first time.

Once you get a taste for using ink, it can be very addictive. The tension of knowing that you can't change what you have drawn is challenging. When it goes well, it can be exhilarating.

This copy of a Raphael is more heavily shaded in a variety of cross-hatching, giving increased solidity to the figures despite the slightly fairy-tale imagery. The movement is conveyed well, and the body of the rider looks quite substantial as he cuts down the dragon. The odd bits of background lightly put in give even more strength to the figures of knight, horse and dragon.

Leonardo probably did the original of this as a study for a painting. Drawn fairly sketchily in simple line, it shows a young woman with a unicorn, a popular courtly device of the time. The lines are sensitive and loose but the whole hangs together beautifully with the minimal of drawing. The curving lines suggest the shape and materiality of the parts of the picture, the dress softly creased and folded, the face and hand rounded but firm, the tree slightly feathery-looking. The use of minimal shading in a few oblique lines, to suggest areas of tone, is just enough to convey the artist's intentions.

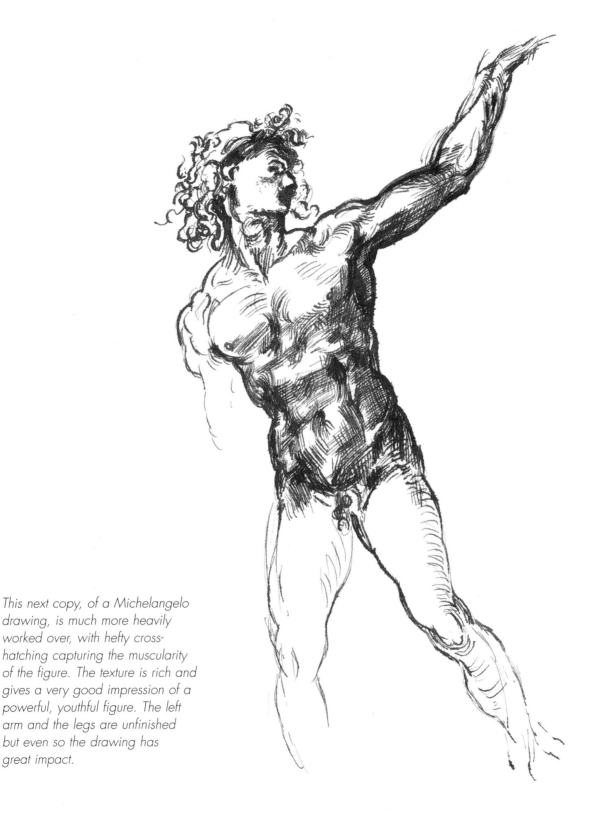

This next copy, of a Michelangelo drawing, is much more heavily worked over, with hefty cross-hatching capturing the muscularity of the figure. The texture is rich and gives a very good impression of a powerful, youthful figure. The left arm and the legs are unfinished but even so the drawing has great impact.

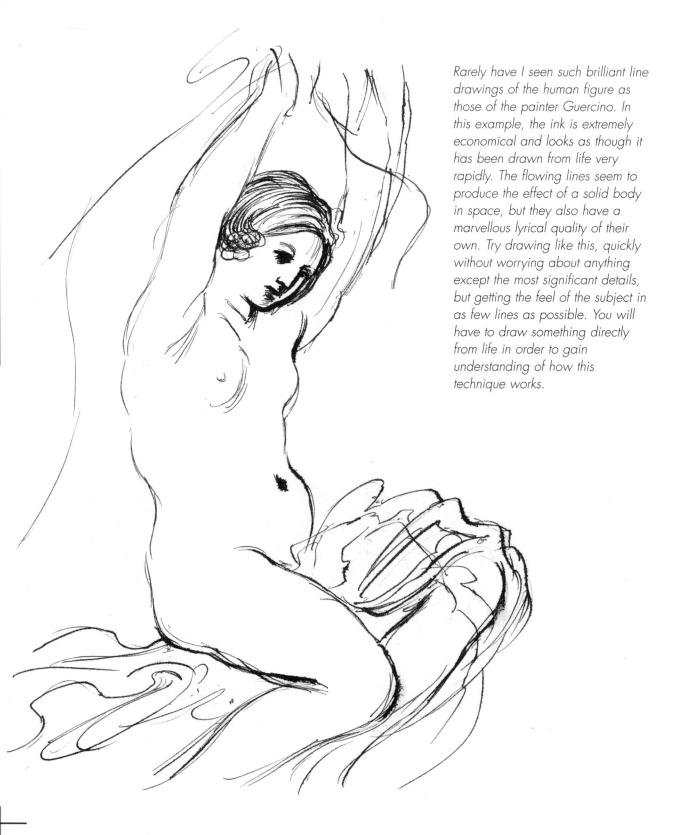

Rarely have I seen such brilliant line drawings of the human figure as those of the painter Guercino. In this example, the ink is extremely economical and looks as though it has been drawn from life very rapidly. The flowing lines seem to produce the effect of a solid body in space, but they also have a marvellous lyrical quality of their own. Try drawing like this, quickly without worrying about anything except the most significant details, but getting the feel of the subject in as few lines as possible. You will have to draw something directly from life in order to gain understanding of how this technique works.

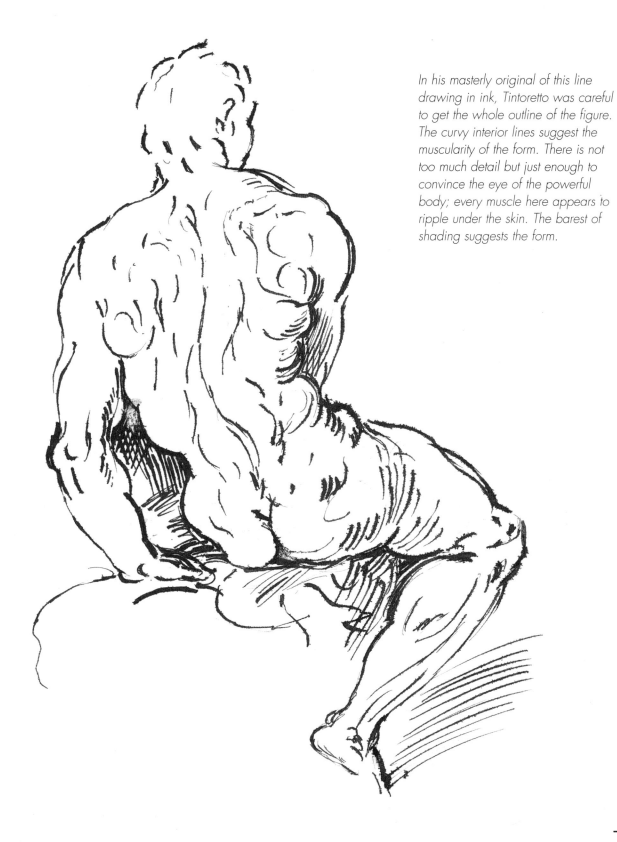

In his masterly original of this line drawing in ink, Tintoretto was careful to get the whole outline of the figure. The curvy interior lines suggest the muscularity of the form. There is not too much detail but just enough to convince the eye of the powerful body; every muscle here appears to ripple under the skin. The barest of shading suggests the form.

PEN AND INK: PRACTICE

The drawings on this page show what can be achieved with pens of different nib thickness. The series of heads shows the effect that can be achieved with a fine nib. The mass of lines going in many directions give a definite impression of solidity as well as depth of shadows and light.

The figure of the boy is drawn with a felt tip pen. This is not the most sensitive of tools but as long as you don't expect too much from it as a medium, it does enable you to draw quickly and effectively.

The thickness of felt tip pen limits your options so far as size is concerned. As you can see here, you have to draw bigger or reduce areas of tone to their simplest.

This copy of a head by Matisse is remarkably freely drawn and yet the multiple lines build up into a dense texture of materiality that looks very convincing.

The heads of the boy and girl show the importance of background when attempting to describe the way form builds around a rounded object. Some areas have been left clear to suggest light catching the hair, ears and nose, and these stand out against the cross-hatched background tone. To practise this technique, try it on small areas initially. The aim is to learn to control your pen strokes so that you can lay them closely together without them becoming jumbled. You will need several attempts to make the lines go only over the areas you want them to. Try drawing in the main shape with pencil first, and then ink over it so that you have pencil lines to draw up to.

This set of women's heads gives you a chance to try different methods of using line in pen and ink. All methods are possible and can be used to good effect. Think about your lines first, before laying them down in pencil. Look at my notes first before you begin to attempt to draw them.

1.

2.

1. With its fairly solid black lines and simplification of form, this drawing resembles a woodcut. Just a fine line suggests roundness of form.

2. Curved, loosely drawn lines without any tone are used here, to give maximum effect for minimal drawing. A flexible pen nib is necessary to get slightly broader and finer lines alternating. Note the simplicity of the facial features.

3.

4.

3. Even the outlined frame adds to the decorative effect of this drawing. The intensely layered curls on the head make a pattern rather than a realistic effect. The face is sharply drawn but without much attempt at form. The large areas of white shoulder and neck and blank background help to emphasize the decorative quality of the drawn parts.

4. The face here is again economically drawn: just two black eyes, and mere touches for the nose and mouth. The hair outlining the face and neck, though, has been rendered as a jungle-like mass of black lines overlaying each other. Slightly more formal lines in the background allow the hair to fade into the paper and emphasize the paleness of the face.

5.

6.

5. This drawing is also mostly concerned with the decorative effect of the hair, crossed by the carefully delineated pearl headdress, all flatly drawn with the clear sharp lines reminiscent of an engraving. The dots that make up the background are carefully spaced to ensure that one area is not darker than another. Against this darker background the sharply drawn profile and eyes appear almost in silhouette.

No attempt has been made to produce depth of form. The joy of drawing like this comes in making patterns of the lines and dots, and because this can't be hurried, it is very therapeutic.

6. This head is similar to the third one, in that the hair and collar of the dress are carefully built up patterns to suggest an ornate hairstyle and an elegant negligée. The difference between the two drawings is mainly in the background. In this drawing there is no obvious perspective. The squares within squares suggest there must be depth behind the head.

LINE AND WASH

Now we move on to look at the effects that can be obtained by using a mixture of pen and brush with ink. The lines are usually drawn first to get the main shape of the subject in, then a brush loaded with ink and water is used to float across certain areas to suggest shadow, and fill in most of the background to give depth.

A good-quality paper is necessary for this type of drawing; try either a watercolour or a very heavy cartridge. Don't make it so wet that the paper takes ages to dry.

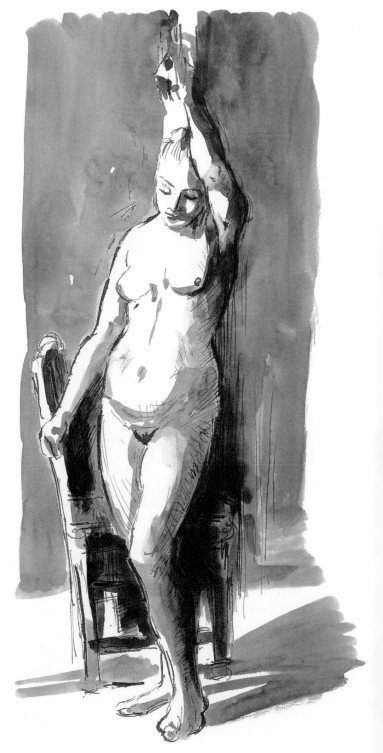

This copy of a Rembrandt is very dramatic in its use of light and shade.

When using line and wash in landscape drawing, the handling of the wash is particularly important, because its different tonal values suggest space receding into the picture plane. Here we look at three drawings by Claude Lorrain.

This sensitive pen line drawing of part of an old Roman ruin has a light wash of watery ink to suggest the sun shining from behind the stones. The wash has been kept uniform. The outlines of the stone blocks give you lines to draw up to.

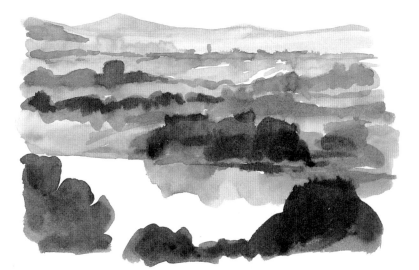

These two deer are fairly loosely drawn in black chalk. A variety of tones of wash has been freely splashed across the animals to suggest form and substance.

This purely wash drawing of the Tiber at Rome has a few small speckles of pen work near the horizon. The tones vary from very pale in the distance to gradually darkening as we approach the foreground, which is darkest of all. The dark tone is relieved by the white patch of the river, reflecting the light sky with a suggestion of trees reflected in a softer tone. A brilliant sketch.

Master landscape painter Claude Lorrain gives a real lesson in how to draw nature in this study of a tree. Executed with much feeling but great economy, the whole drawing is done in brushwork. To try this you need three different sizes of brush (try Nos. 0 or 1, and 6 and 10), all of them with good points. Put in the lightest areas first (very dilute ink), then the medium tones (more ink less water), and then the very darkest (not quite solid ink).

Notice how Lorrain doesn't try to draw each leaf, but makes interesting blobs and scrawls with the tip of the brush to suggest a leafy canopy. With the heavier tones he allows the brush to cover larger areas and in less detail. He blocks in some very dark areas with the darkest tone, and returns to the point of the brush to describe branches and some clumps of leaf.

CHALK ON TONED PAPER

The use of toned paper can bring an extra dimension to a drawing and is very effective at producing a three-dimensional effect of light and shade. Whether you are drawing with chalk, pastel or charcoal it is very important to remember that the paper itself is in effect an implement, providing all the tones between the extremes of light and dark. You must resist the temptation to completely obliterate the toned paper in your enthusiasm to cover the whole area with chalk marks. Study the following examples.

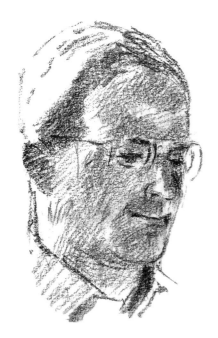

This head is drawn simply in a medium-toned chalk on a light paper. Here the challenge is not to overdo the details. The tones of the chalk marks are used to suggest areas of the head, and definite marks have been kept to a minimum.

The mid-tone of the paper has been used to great effect in this copy of Carpaccio's drawing of a Venetian merchant. Small marks of white chalk pick out the parts of garments, face and hair that catch the light. No attempt has been made to join up these marks. The dark chalk has been used similarly: as little as the artist felt he could get away with. The medium tone of the paper becomes the solid body that registers the bright lights falling on the figure. The darkest tones give the weight and the outline of the head, ensuring that it doesn't just disappear in a host of small marks.

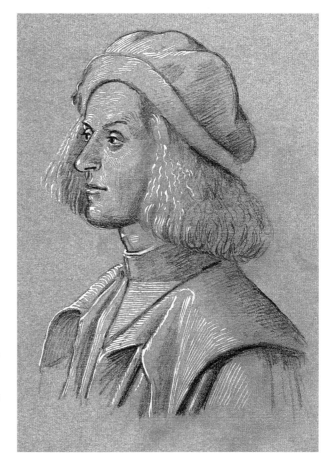

In Watteau's picture of a goddess, the dark outline emphasizes the figure and limbs, as do the patches of bright light on the upper facing surfaces. As we have seen on the previous spread, the toned paper makes white so effective and reduces the area you have to cover in chalk.

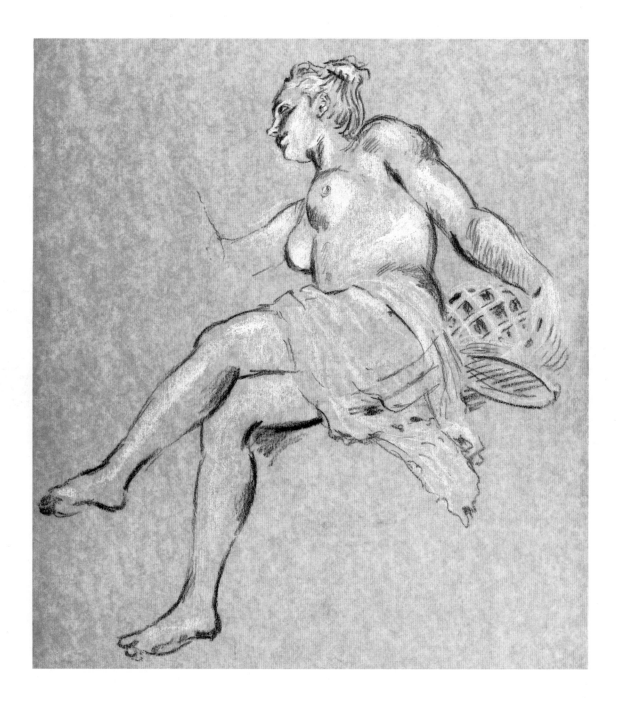

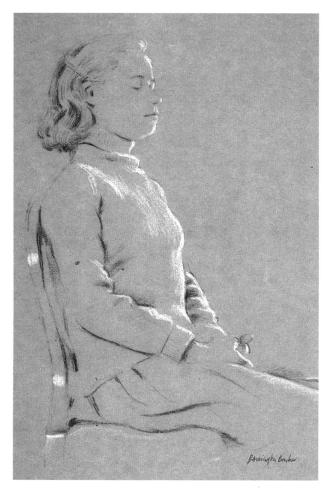

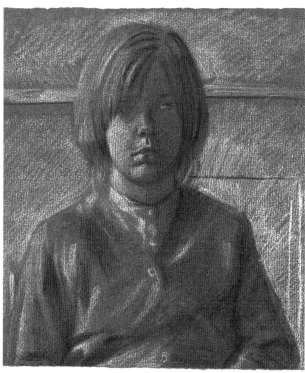

These two drawings were executed in white and dark chalk on medium-toned paper. The approach taken with the drawing on the left is about as economical as you can get. The form of the surface of the girl's face and figure is barely hinted at down one side, with just the slightest amount of chalk. A similar effect is achieved on the other side, this time in dark chalk. The uncovered toned paper does a good deal of the rest of the work.

The above drawing takes the use of dark and light much further, creating a substantial picture. In places the white chalk is piled on and elsewhere is barely visible. The dark chalk is handled in the same way. More of the toned paper is covered, but its contribution to the overall effect of the drawing is not diminished for that.

The French neo-classicist master Pierre Paul Prud'hon was a brilliant worker in the medium of chalk on toned paper. In these copies of examples of his work, he shows us two very effective ways of using light and dark tones to suggest form.

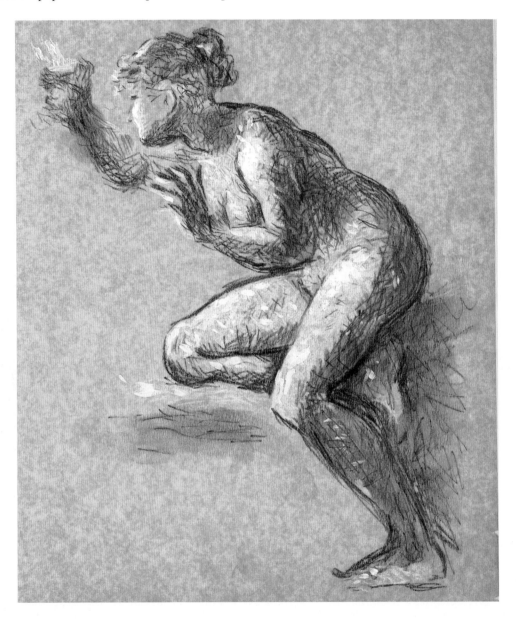

In this drawing of Psyche, marks have been made with dark and light chalk, creating a texture of light which is rather impressionistic. The lines, which are mostly quite short, go in all directions. The impression created is of a figure in the dark, and this helped by the medium tone of the paper.

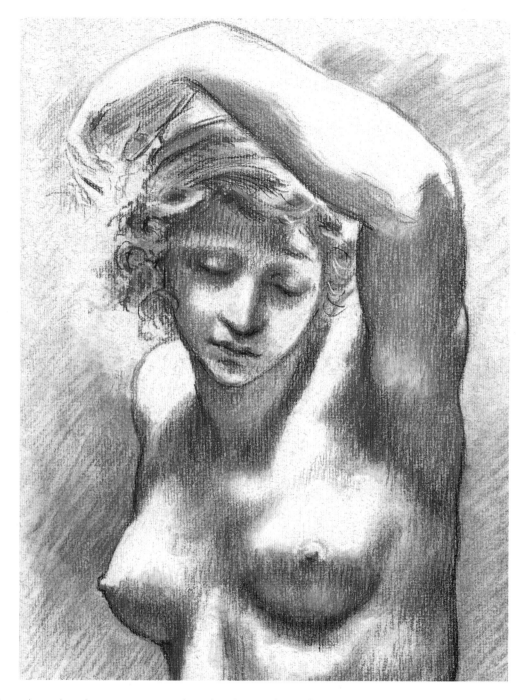

The chalk marks in this close up are very disciplined.
A whole range of tones is built from the carefully
controlled marks, which present the form as though lit
from above. Here, too, the middle tone is mostly
covered over with gradations of black and white.

SCRAPERBOARD TECHNIQUE

Scraperboard drawing was used during the early days of photographic reproduction in newspapers as a response to the needs of advertisers, who wanted to show their wares and products to best advantage but were limited by the poor quality of the printing processes then available. The technique gave very clear, precise definition to images, and so became the means of rendering illustrated advertisements for newsprint. Over time, of course, the printed reproduction of photographs improved so much that it has become another art technique. Scraperboard does have some qualities of its own, however. It is similar in some respects to wood engraving, wood cuts or engraving on metal, although because of the ease of drawing it is more flexible and less time-consuming.

In this drawing the boatman appearing across a misty lake or river was first sketched in pencil, then blocked out in large areas of ink. The figure of the man, the oars and the atmospherics were done in diluted ink to make a paler tone. The boat was drawn in black ink.

Using a scraperboard tool, lines were carefully scratched across the tonal areas, reducing their tonal qualities further. Some areas have few or no scratched lines, giving a darker tone and an effect of dimensionality.

You can see in the two examples below how scraperboard technique lends itself to a certain formalized way of drawing. The scratch marks can be made to look very decorative. The Christmas card drawing and lettering is in a very similar technique and has been produced using both scraperboard and pen and ink. The main effort is taken up with making the shapes decorative and giving the key lines a textural quality; this is achieved by using either a brush or the side of a flexible nib.

The top illustration was first drawn in black ink. The areas of ink were then gone over using the scraper tool to reduce the heaviness of the shaded areas and clean up the edges to achieve the shape required.

The Christmas card drawing below is mainly thick brushline with a few lines in pen added afterwards to provide details. The scraper tool was then used to sharpen up the outline and the spaces between the areas of black.

Using the technique
Scraperboard technique is similar to cross-hatching with a pencil, although of course with the former you are drawing white on black. The china clay surface of the board can be scratched over several times if it is not cut too deeply. Any areas requiring strengthening or correction can be filled in with ink. Correcting lines using this technique is very easy: you just scratch out the wrong bits and then redraw.

MERRY CHRISTMAS

BLOTTING TECHNIQUE

First used by illustrators in the 1950s, this technique was made famous by Andy Warhol in his fashion illustrations. The idea is to take a piece of ordinary cartridge paper, or blotting paper – either will achieve the same effect – and fold it in half. After drawing each line in ink you blot it into the opposite side of the page (see illustrations below). You have to take a painstaking approach, blotting as you build up the drawing, because otherwise the ink dries too quickly. A dip-pen is the best tool, because modern graphic pens don't produce ink that is wet enough.

1. Draw a line.

3. Draw your next line and repeat the procedure, folding your paper over to blot the ink on the opposite side.

2. Fold paper over to blot the ink on the opposite side.

Producing an effect

Generally it is best to draw only a few lines at a time and then blot them immediately. If you draw too many lines before blotting them the ink will dry and the point of using this technique will be lost. However, you have to experiment with timings and weight of line, because sometimes a pleasing effect can result from an unpromising start. In the last drawing on the opposite page, for example, the multiple lines on the face dried so quickly that the blotted version looks much less tonal than the original. However, I liked the effect and didn't try to change it. You have to decide how you want your finished drawing to look.

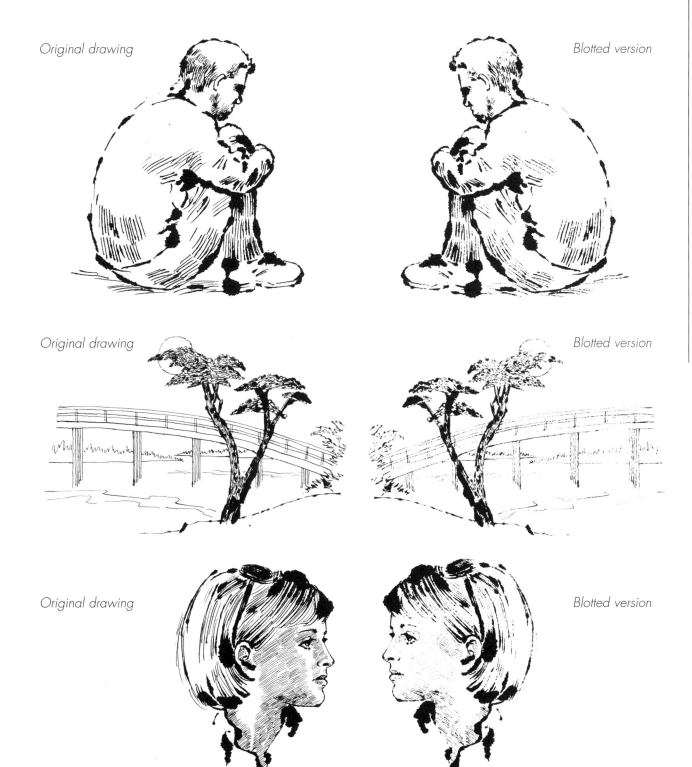

Original drawing

Blotted version

Original drawing

Blotted version

Original drawing

Blotted version

CARD-EDGE TECHNIQUE

This technique was invented at about the same time as the blotting technique we've just looked at. The first step is to cut out small pieces of card. The edges of these are then dipped into soft wet paint (gouache designer colours are best) and used to draw lines onto a blank sheet. The effect is initially very strong, becoming fainter and fainter as the paint gets used up or dries.

Like blotting technique, it is a slow process and you cannot produce much in the way of curved shapes, but the end result can be very powerful. In terms of how it is used and the effects that can be achieved with it, it is rather similar to painting with a palette knife.

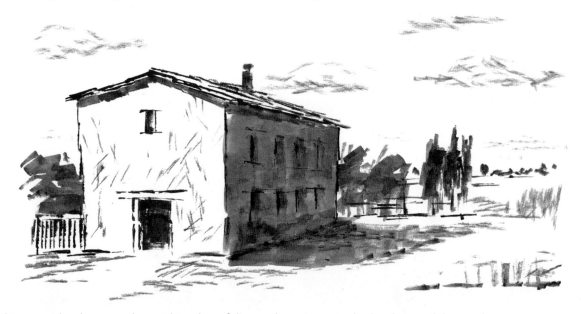

In this example, the gouache on the edge of the card was almost dry when it was used to paint the clouds and front surface of the house. For the roof and dark trees in the background the card was very wet and full of paint.

New horizons

The use of gouache paint to make a drawing is not an attempt to introduce you to painting, although I would be surprised if you were not interested in doing that as well as drawing. Merely it illustrates a point I have already made, that you should feel free to draw with whatever takes your fancy. An artist cannot be limited by notions of what is proper for him or her to use as a medium. Ultimately the choice is yours. When exercising this choice, try to be inquisitive and adventurous. Any use of a new medium will help your drawing, because it makes you re-assess how you actually produce the finished article. Don't confine yourself to only one medium, even if you prefer it over all others. Your life as an artist is an ever-expanding view of the universe, and if you do confine yourself you will find your artistic horizons narrowing and your work becoming predictable and repetitive. Don't be afraid of what you don't know. Once you start working with a new medium, you will be surprised how quickly you appreciate its qualities and find ways of adapting them to your purpose.

SILVERPOINT TECHNIQUE

The last and probably, for most people, the least likely technique to be attempted is silverpoint drawing, the classic method used in the times before pencils were invented. Many drawings by Renaissance artists were made in this way. Anybody interested in producing very precise drawings should try this most refined and effective technique.

First you have to buy a piece of silver wire (try a jeweller or someone who deals in precious metals) about a millimetre thick and about three inches long. This is either held in a wooden handle, taped to it or – the better option – within a clutch-action propelling pencil that takes wire of this thickness. Then you cover a piece of cartridge paper (use fairly thick paper because it is less likely to buckle) with a wash of permanent white gouache designer paint; the coat must cover the whole surface and mustn't be either too thick or too watery. When the white paint has dried, you draw onto it with the silver wire; ensure that the end of the wire is smooth and rounded to prevent it tearing the paper. Don't press too hard. The silver deposits a very fine silky line, like a pencil, but lasts much longer. Silverpoint is a rewarding material to draw with. I thoroughly recommend that you make the effort to try it.

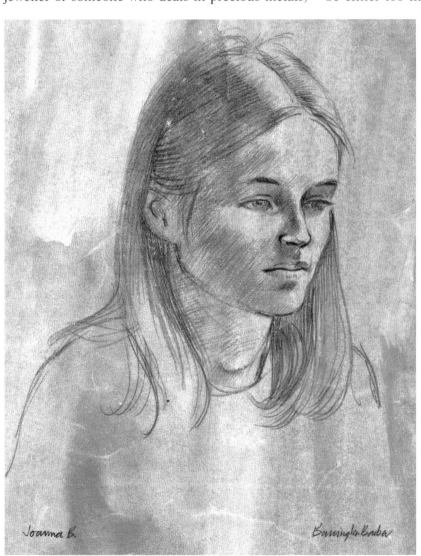

Joanna B. Burrington Barber

To use silverpoint you need to prepare a background to draw onto. I drew this example onto white paint with a bit of reddish-brown mixed in.

ART APPRECIATION

There are other ways to improve your drawing abilities apart from practising. One approach that is pleasurable as well as instructive is to go to as many exhibitions of drawings and paintings as you can. Even if it means travelling a fair distance, this is very worthwhile. Not only does it widen your education in art by making you familiar with first-rate artists, but you will also begin to refine your own perceptions, finding higher levels to aim for in your own work. Make sure you don't only look at work by historic masters. Visit galleries that show the work of current artists, because it is always very interesting to see what your contemporaries are doing and often fuels ideas for new directions in your own work.

The combination of your own drawing and appreciating the art around you can be great fun as well as uplifting. In any country, there are large urban centres where the nation's art is gathered for the public to view, but you also find colonies of artists tucked away in all sorts of small towns and villages, and their work is worth looking at. Finally, of course, prints and books are very good sources of art appreciation. If you can't afford to buy them, there are libraries where they can be studied for free.

WHAT DO YOU SEE?

When viewing the work of other artists, try to analyze what makes it so attractive to you. Ask yourself questions. Don't be ashamed or coy if some of your answers suggest that your response is of a religious or spiritual nature. These are often the truest reasons why we like a work and should be acknowledged. Whatever the chord that is struck when you perceive a work, recognition of it will lead you towards understanding your own work and the direction it might take.

There is room for all sorts of artists in this world and one of the great freedoms of modern art practitioners is that they have completely redefined the reasons behind art. They may not be right, or you may not agree with them, but the freedom to find your own way towards art appreciation is of tremendous value.

When looking at art, question your own perceptions. Is it the subject matter? Is it the technical brilliance of the artist? Is it the colour? Is it the form? Is it the medium used to produce the work? Is it the subtler ideas behind the form? Is it because it reminds you of someone? All these questions are valid. Many more will undoubtedly occur to you. The main point is to discover your true response to a picture that attracts you. Sometimes the answer is very simple, but sometimes the appreciation lies much deeper within yourself and will take some unearthing. Persevere and your reward will be considerable.

Don't try to look at everything. Wait until something really arouses your attention, and then give it your full attention. Spend at least three minutes just looking in detail at everything in the picture, without comment. Then any questions about what is in front of you will serve to clarify your understanding.

When looking at reproductions of famous works, notice where these works are held. If it is somewhere near enough for you to visit, do so. No matter how good the quality of a reproduction, the original possesses an extra dimension, and this will leap out at you as soon as you set eyes on the actual work. It is rather like discovering an old friend and seeing them totally afresh. First-hand knowledge of an original also helps to inform you of what is missing when you try to draw from a print of it. Without that knowledge you could not begin to make up for the lack.

INDEX